BUILDINC
DERBYSHIRE
A GUIDE

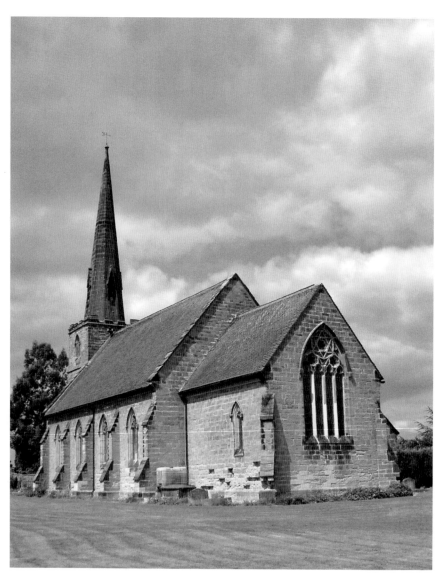

St Mary's church, Coton-in-the-Elms (1846).

BUILDINGS IN
DERBYSHIRE
A GUIDE

RICHARD STONE

AMBERLEY

For Dylan, Maxim, and Darcy

First published 2011

Amberley Publishing
The Hill, Stroud
Gloucestershire GL5 4EP

www.amberleybooks.com

British Library Cataloguing in Publication Data.
A catalogue record for this book is available from the British Library.

ISBN 978-1-4456-0320-9

Typesetting and Origination by Amberley Publishing.
Printed in Great Britain.

CONTENTS

List of Illustrations

12 *Buildings in Derbyshire*

Acknowledgements

I am grateful to Chris Edwards, BA (Hons), BArch (Hons), Registered Architect (ARB), MPhil, MBA (Distinction), PG Cert PPHE, for his helpful comments on an early draft. Any mistakes are entirely my own.

To avoid issues of copyright, all photographs were taken from public rights of way, and where this was not possible I have used images from pre-1940 postcards. In all cases, particularly with private houses, I have tried to exercise discretion and sincerely hope no one whose property is included finds this intrusive. I am reassured by the fact that all those I spoke to in the course of research for this book welcomed my interest and were happy for me to take photographs. And of course, since the advent of Google Maps Street View and Google Earth, there is nothing here that is not readily available in high resolution online, both at street level and in aerial view, a mere mouseclick away. Additional illustration by User Design (Thomas Bohm), www.userdesign.co.uk.

My thanks to Karen Lanchester for the cover photograph.

Churches are not always open (it is always a good idea to check if you are encouraged to visit). I am indebted to those who turned keys and to everyone I met along the way who shared their knowledge and enthusiasm.

1
ARCHITECTURE IS LIKE FROZEN MUSIC
The Building Blocks of Derbyshire

There was a time deep in prehistory when what we ate, what we wore and what we lived in was entirely dependent on what we could catch, find and make. The limestone caves of Derbyshire, notably at Cresswell Crags, but also at nearby Markland Grips and along the scarps of the Dove and Manifold valleys, have yielded traces of occupation dating back over 20,000 years. Selectively, and over millennia, mankind took a momentous decision. Probably beginning in the Middle East around 11,000 BC, the hunter-gatherer life was abandoned in favour of farming. It was a profound, Garden-of-Eden-apple-tasting change, and no easy choice. Anthropologists studying modern-day hunter-gatherer economies report a way of life in harmony with nature, environmentally friendly, healthy, relatively relaxed, and culturally sophisticated, despite practitioners being driven to territorial margins by land claimed for cultivation. Agriculture is incompatible with the hunter-gatherer lifestyle. Both routines are subject to the seasonal vagaries of nature, but farming builds in an element of insurance, enabling wealth to be accrued in the form of land, stock, supplies and personal comforts to balance out lean years. Successfully pursued, agriculture brought a prosperity that translated into power and social inequality. Importantly, farming introduced the concept of land ownership. Hunter-gatherers belong to the land, but farmers believe the land belongs to them, and as value is added by cultivation, that land has to be protected, denied to others, fought over if necessary, and handed on intact to heirs.

The advent of farming in England, around 6,000 years ago, marked the beginning of a gradual but fundamental shift in lifestyles and attitudes. Society became more hierarchical and politically complex. With settlement came the first permanent homesteads. Monuments appeared in the landscape. Barrows containing the remains of the dead were raised on prominent hilltop sites as visible statements of ancestral territorial ties. Of these dwellings, nothing remains beyond the merest archaeological shadows, but the uplands of Derbyshire are littered with cairns, tumuli and ritual sites of the period. West of Youlgreave is Arbor Low, an

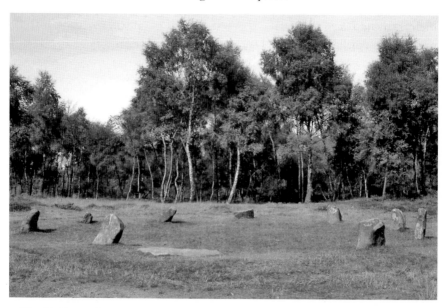

1. Nine Ladies on Stanton Moor – a stone circle of weatherworn gritstone slabs dating from around 1500 BC.

impressive henge monument of fifty recumbent stones encircled by a ditch and bank measuring over 800 feet in circumference. A number of smaller stone circles include the Nine Ladies on Stanton Moor, a group of upright, weatherworn gritstone slabs, none more than waist height. Although less dramatic than those at Arbor Low, they are equally atmospheric.

It could be argued that architecture in Derbyshire begins with these enigmatic monuments, continuing in later prehistory with the construction of several hillforts (excavation of the largest and best preserved, crowning Mam Tor near Castleton, uncovered hut platforms with hearths and large quantities of pottery) and developing sophistication with the advanced construction techniques introduced under Roman rule. Roman military sites in Derbyshire, where initial timber buildings were rebuilt in stone, include Derventio (Little Chester, Derby), Ardotalia (Melandra Castle, Glossop), and Navio (Brough). Evidence for baths associated with the Roman station of Aquae Arnemetiae (Buxton) was revealed during construction of The Crescent in the 1780s, but nothing on the lavish scale of the domestic villas of southern England, with their tiled roofs, underfloor heating, bathhouses and spectacular mosaic floors has yet been discovered in Derbyshire. In any case, this world vanishes within a generation or two during the first half of the fifth century, and the architecture of Anglo-Saxon England represented a fresh start.

Early medieval domestic buildings were predominantly timber. The wealthiest in society might employ the services of a housewright. Families generally built

their own *grubanhaüs* (literally 'pit-house') consisting of a low, gabled structure raised above a shallow, rectangular pit. Wooden buildings leave little archaeological trace. Stone construction was largely reserved for church buildings following widespread conversion to Christianity during the seventh century. During this period, quarried as opposed to field-picked stone began to be used, and the technique of burning limestone to produce lime and mixing it with sand to make a durable mortar was developed.

Anglo-Saxon stonework is generally rough-hewn. The use of alternating vertical and horizontal stone strips to strengthen corners and also to form door surrounds, a technique known as 'long-and-short' work, is typical. Doorways of the period tend to be small and round-headed, and windows ('wind-eyes') narrow slits often carved from a single block, although openings crowned by slender lintels and occasionally with triangular or round-headed tops also occur. Two-light bell-openings recessed beneath round arches in the Norman tower of St Leonard's church, Thorpe, suggest Anglo-Saxon masons were involved in construction. Herringbone-pattern masonry is more commonly associated with Norman architecture, but also occurs in Anglo-Saxon stonework. Although the Normans imported both stone and craftsmen from France, it may well have been local masons pressed into service by their new overlords who were responsible for the stretches of herringbone walling and other characteristic Anglo-Saxon features incorporated in Norman buildings. Ample evidence of homegrown sculptural skill can be found in a number of surviving free-standing crosses (notably at St Lawrence's church, Eyam and All Saints' church, Bakewell) and in carved stones incorporated in later walling at St Mary's church, Wirksworth. Crosses marked rallying points for worship before churches were built. St Mary's church, Wirksworth, also houses the extraordinary Wirksworth Slab, an intricately carved coffin lid depicting scenes from the life of Christ and dating from around AD 800.

There are examples of long-and-short work at the south-east corner of the nave of St Michael, Stanton-by-Bridge; around a window above the chancel at St Giles' church, Sandiacre; and at the north-eastern corner of the nave of All Saints' church, Bradbourne. The Anglo-Saxon window at Sandiacre indicates that what is now the chancel wall was once the eastern end of a simple church occupying the same footprint as the later Norman nave. Just how much of the rest of the fabric of St Giles' church is Anglo-Saxon is difficult to ascertain, but much of the masonry, including the base of the sturdy tower, may be pre-Conquest. At Bradbourne, stonework bonded to the long-and-short work looks contemporary and may also be Anglo-Saxon. At St Wystan's church, Repton, clues indicate Anglo-Saxon walling in the chancel, north transept and parts of the crossing. In the nave of All Saints' church, Aston-on-Trent, the lower courses of quoins show evidence of long-and-short work, and a fragment of a pre-Conquest cross has been built into the wall. A doorway and a (now blocked) small round-headed

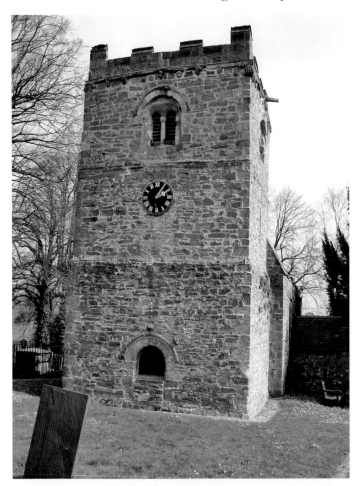

Left: 2. Two-light belfry windows in the tower of St Leonard's church, Thorpe, suggest Anglo-Saxon masons were involved in construction.

Below: 3. The Wirksworth Slab (*c.* 800) – a section of an intricately carved coffin lid depicting scenes from the life of Christ – is evidence of high-quality Anglo-Saxon sculptural skill.

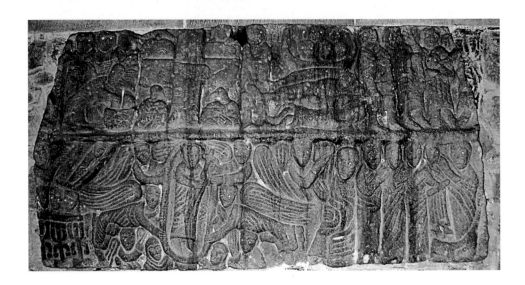

4. Anglo-Saxon period long-and-short work at the south-east corner of the nave of St Michael's church, Stanton-by-Bridge.

window high up on the south side of the nave at St Laurence's church, Walton-on-Trent, survive from an earlier Anglo-Saxon church. At St John's church, Ault Hucknall, a simple low arch between the chancel and sanctuary, and a small window with an incised semicircular top in the west front above the north aisle, suggest early medieval origins.

Anglo-Saxon architecture was ruthlessly obliterated in the decades that followed the Norman Conquest. The victors of Hastings emphasised their

5. Long-and-short work at the north-east corner of the nave of All Saints' church, Bradbourne.

6. Nave quoins at All Saints' church, Aston-on-Trent, indicate long-and-short work. A fragment of an Anglo-Saxon cross has also been incorporated in the masonry.

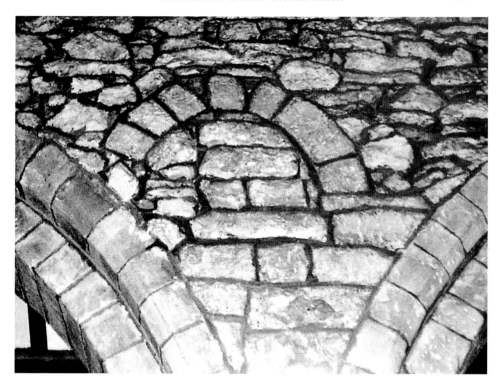

Above: 7. A blocked window now in the nave of St Laurence's church, Walton-on-Trent, survives from an earlier Anglo-Saxon building.

Right: 8. This small window is one of a number of features in the church of St John the Baptist, Ault Hucknall, suggesting early medieval origins.

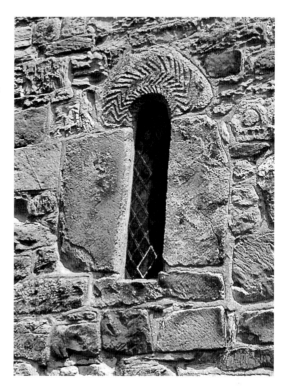

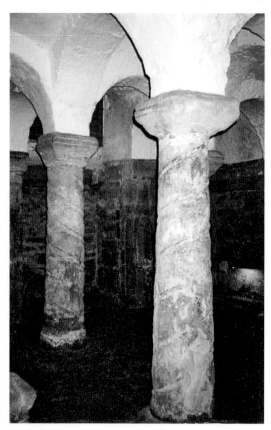

9. The Anglo-Saxon crypt at
St Wystan's church, Repton –
constructed in the eighth century
as a mausoleum for the Mercian
royal family – has a roof of nine
domed bays supported by four
sandstone columns.

superiority and imposed their culture on a vanquished people by sweeping away
symbols of previous nationhood. So thorough was the process of eradication and
replacement that all we are left with are scattered architectural fragments that can
tentatively be classified as pre-Norman. Nationally, the most complete surviving
Anglo-Saxon structures are a handful of crypts. Derbyshire has a remarkable
example at St Wystan's church, Repton. Accidentally rediscovered by workmen
in 1779, it was constructed in the eighth century as a mausoleum for the Mercian
royal family, and modified in AD 840 to receive the body of King Wiglaf. The
small chamber, just 16 feet across, is divided into nine domed bays supported
by four circular columns, each decorated with a thin spiral band. The building's
dignified, understated elegance is testament to the reverence accorded by the
Mercians to their kings. After Wiglaf's son, Wystan, was murdered in AD 849,
rumours of miracles spread quickly. Wystan's canonisation by popular acclaim
followed. Repton crypt, where his body had been laid to rest, became a place
of pilgrimage. Clearly this was no passing fad. An additional entrance was cut
through the 3-foot-thick walls of the crypt, and steps were inserted, allowing
visitors to process around the holy relics. Wystan's cult was still powerful when

his remains were moved to Evesham Abbey by permission of King Cnut in 1019, triggering Repton crypt's slide into neglect and ultimately its abandonment.

No doubt there is more Anglo-Saxon fabric in Derbyshire than so far identified, but the important element of continuity that gives meaning to a sequence is missing. In order to trace an unbroken evolutionary architectural succession through to today, we must begin in Norman Derbyshire. Chronology is important. With the benefit of hindsight, it is possible to identify characteristics that typify different architectural phases. Over time, as tastes and fashions change, references to earlier elements are made and ideas re-emerge to be reinterpreted for a new age.

Parish churches, central to local life, served a wide range of secular as well as religious purposes. In 1287, when Edward I wanted to investigate the lead trade in Derbyshire, it was to St Oswald's church, Ashbourne, that people were summoned. Large gatherings might meet in the nave and smaller groups in the church porch, a common venue for business transactions. In the days when simple consent between the man and woman concerned was all that the law required, the porch was also where marriages frequently took place. Derbyshire's medieval churches were mainly lay foundations – private churches built by upwardly mobile lords of the manor, often alongside the manor house as part of a manorial complex, as is the case at Norbury. It was customary for the rector, the recipient of parish tithes, to maintain the chancel, while the laity, represented by churchwardens, took responsibility for the upkeep of the nave. Churchwardens have been around since at least 1127, and are the country's oldest democratically elected officials. This division of responsibility between rector and parishioners is the reason why chancel and nave in a church are frequently of different dates, and the extent to which both have been rebuilt over the centuries reflects fluctuating fortunes and relative prosperity in the district. In the pre-Reformation Church, most rectors were clergymen. After the break with Rome, there were many lay rectors who appointed stipendiary vicars.

Before the Reformation, it was common for those who could afford to do so, either individually (wealthy nobles, successful burgesses) or collectively (members of craft guilds etc.), to endow chantry chapels where masses would be sung for their souls. Four separate chantry chapels occupy aisles flanking the chancel of Our Lady and All Saints' church, Chesterfield. Tideswell, Ashbourne, and Wirksworth also have examples. Driven by a mix of piety, local pride and a sense of ownership, and if the money could be found, each generation left a mark on its parish church. Paradoxically, some of the most intact survivals of medieval church architecture, so valued today for their untouched original features, may well signify the hardship and comparative poverty of times when additions and makeovers were unaffordable.

In Chatsworth House, Haddon Hall, Hardwick Hall, Kedleston Hall, Bolsover Castle, Melbourne Hall, Sudbury Hall, Renishaw Hall, Calke Abbey,

Barlborough Hall, Carnfield Hall, Catton Hall, Eyam Hall, Tissington Hall and others, Derbyshire has the finest collection of country houses in England. Elizabeth Talbot, Countess of Shrewsbury, better known as Bess of Hardwick, was responsible for the building of Hardwick Hall. In Elizabethan Derbyshire, as in the country at large, around 10 per cent of all households were headed by women. At one end of the social scale, widowhood might lead to extreme poverty. For the wealthy, it was an opportunity to exercise a level of independence and choice that frequently found expression in architecture.

Wealth was generated by land ownership and was largely concentrated in the hands of a rich elite. For the ordinary folk of medieval Derbyshire, working

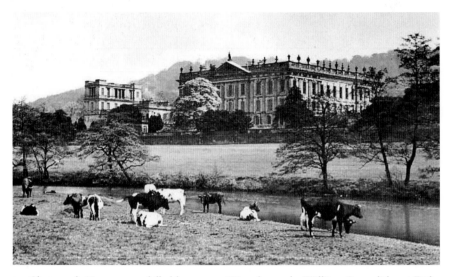

10. Chatsworth House, remodelled between 1688 and 1702 by William Cavendish, 1st Duke of Devonshire.

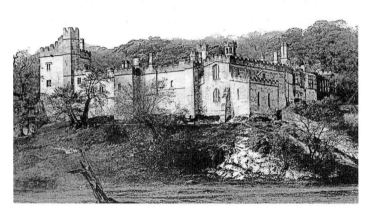

11. Haddon Hall, the result of piecemeal development throughout the medieval period.

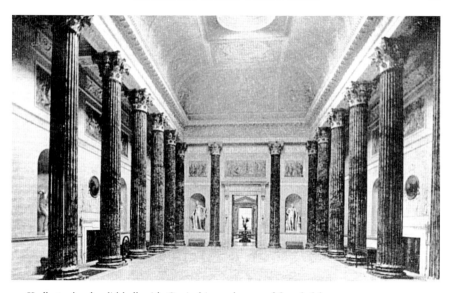

12. Kedleston's splendid hall with Corinthian columns of fluted alabaster.

the land was a daily routine, a communal exercise carried out in three or four large open arable fields. Each field was divided into strips (commonly an acre – a furlong, or 220 yards, in length, and a chain, or 22 yards, in width – was the amount of land that could be ploughed in a day). The strips were shared between the lord of the manor and tenant villagers who received an allotment in return for labour or rent. Crops were cultivated in rotation, with one field left fallow each season. Meadow and common land sustained livestock. This was planned countryside. Villagers lived in a nucleated settlement, their cottages often clustered around a village green that in uncertain times provided a place of safety for livestock. Many of these village greens remain. Cooperation was the key to success. Everyone was a stakeholder in an interdependent and highly structured society, and was required to play their part in ploughing, planting and harvesting. Change began when the ravages of the Black Death made an impact in the latter half of the fourteenth century. Established practices depended upon a ready supply of manual labour. Suddenly this was in short supply, and land was more plentiful. People turned from arable to less labour-intensive pastoral farming. Open fields began to be enclosed – one, two or three strips at a time – to contain livestock, creating long, thin fields. Throughout the Peak District, and spectacularly at Chelmorton, this pattern of piecemeal enclosure can be seen fossilised in stone-walled field boundaries surviving today. People who had cultivated an allocation of strips scattered in open fields acquired additional land that could be consolidated into a discreet holding or farm. Over time, open fields and commons continued to disappear, enclosed either by communal agreement or by autonomous landowners and converted into private ownership. Those

remaining were mopped up by a series of Acts of Parliament in the eighteenth and nineteenth centuries.

Parliamentary Enclosure extinguished common rights and customary tenurial arrangements based on historical precedent. Allocations of land to commoners in lieu of lost privileges were frequently too meagre to be worthwhile and were either sold or bundled into local charities. Those who benefited from Parliamentary Enclosure acquired compact blocks of land that could be turned into viable farms. Enclosure transformed the Derbyshire countryside. Those who could afford to do so migrated to new farmsteads at the centre of their holdings. Small-scale pastoral farming allowed time for other work. To make ends meet, smallholders often worked part-time as lead miners, weavers, and in other crafts and enterprises that could be fitted conveniently into the weekly routine of tending livestock. Many farmers continued to live in villages, walking to work in the fields daily. In the White Peak, dual-purpose two-storey field barns used to overwinter livestock and store hay were built to accommodate this way of life. Most are eighteenth century but some are undoubtedly much older. Together these unique structures provide a glimpse of centuries-old building techniques in rural Derbyshire. New barns were made from whatever suitable materials came to hand: rough, irregular limestone blocks or 'rubble', with sandstone quoins and stone-flag roofs. In recent years many became redundant and fell victim to neglect, their fabric recycled into walls or garden features. Recognising the historic importance of the 120 or so field barns in their own locality alone, contributors to the Bonsall Field Barn Project have demonstrated how these buildings can be restored and brought back to useful life in a variety of ways that meet contemporary needs, for example as camping barns.

Urbanisation came comparatively late and then only slowly to Derbyshire. Growth, driven by the Industrial Revolution, began to widen the gulf between town and country. Derby developed a distinctively urban culture during the eighteenth century. The population grew rapidly and the pace of life quickened. A newspaper, the *Derby Mercury*, was launched. Trade directories were published, detailing a wide variety of consumer goods and merchandise that catered for increasingly sophisticated tastes. Land was developed speculatively, with an eye to rental. In Derby, a cramped town centre was cleared and renovated, creating a more spacious commercial townscape. Social space was provided in the form of the Assembly Rooms, while in rural Derbyshire even significant towns such as Ashbourne had only inns in which to hold social events until the mid-nineteenth century. Chesterfield's urban escalation did not take off until the arrival of the railway in 1841.

Improved communications – beginning with an expanding canal network towards the close of the eighteenth century, followed by the railways in the mid-nineteenth – made materials such as Welsh and Lake District slate and Lancashire brick available locally, and allowed the export of Derbyshire stone for building

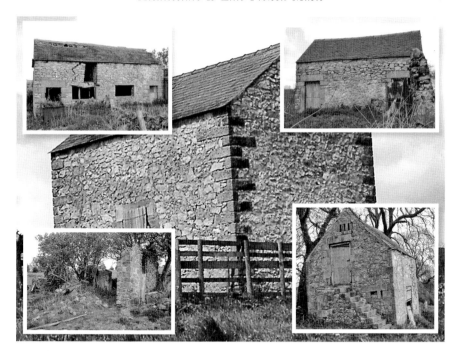

13. Field barns near Bonsall in various stages of repair provide evidence of local construction techniques. Built mainly of irregular limestone 'rubble' with sandstone quoins, the barns were used to house cattle in winter and to store hay.

projects far and wide. In Derbyshire, as elsewhere, design and materials became increasingly universal. Widely available pattern books popularised the Italian renaissance designs of Andrea Palladio (1508–80). Houses with rectangular ground plans, smooth external surfaces, severely symmetrical elevations, hipped roofs, dropped keystones, wedge-shaped lintels carved to imitate keystones, and doorways embellished with pediments and columns, or pilasters, came to define Georgian elegance for the well-to-do.

Agricultural advances in the eighteenth and early nineteenth centuries made land more valuable. Farming became increasingly commercialised. The social standing of agriculture was raised from a yeoman occupation to one in which the aristocracy became directly involved. George III ('Farmer' George) declared agriculture, 'That greatest of all manufactures … beyond doubt the foundation of every other art, business, and profession.' Farming was suddenly not only socially acceptable among the upper classes; it was seen as a patriotic duty. For the yeoman farmer living hand-to-mouth and from season to season, experimenting with new methods was not an option, but the wealthy aristocracy could afford to innovate and take risks. Capital investment in new 'model farms' followed; these were enterprises that served as practical examples to tenant farmers by demonstrating the latest agricultural ideas. Model farms were purpose-built, with cartshed, cattle

14. Ireton Farm, Kedleston, the first 'model farm' in Derbyshire (1813). A typical Georgian farmhouse, but with an interesting Neoclassical addition.

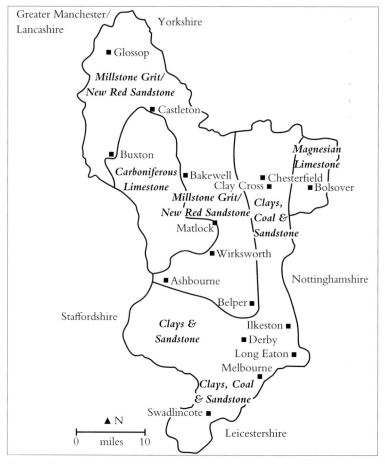

15. Rich natural resources of stone and clay have helped shape the buildings of Derbyshire.

byre, dairy, pig sties, manure heap, means of threshing, granary, fodder barn, stable, etc., arranged in a quadrangular block for maximum production-line, high-input, high-output efficiency. The first model farm in Derbyshire was Ireton Farm, Kedleston (1815–17). Built as a 'home farm' to supply Kedleston Hall, it displays an attention to detail that underlines the importance and status of the new agriculture. A characteristically symmetrical, well-proportioned Georgian brick farmhouse has a striking Neoclassical, rendered, pavilion-like extension with a hipped roof, plain triangular pediment, and, beneath a row of blank ovals, a series of evenly spaced round-headed windows and doorways divided by pilasters that combine to give the effect of an arcade. Other model farms followed, including Home Farm at Chatsworth, designed by another leading architect, Decimus Burton (1800–81). Among the less well off, particularly in rural areas, vernacular design remained largely immune to fashion.

County boundaries are an arbitrary constraint on historians. Parts of the Staffordshire Moorlands are indistinguishable from Derbyshire's Peak District. Eastern Derbyshire shades imperceptibly into Nottinghamshire. And yet there is a coherence that goes beyond administrative convenience. Derbyshire is rich in natural building resources. Few areas are without suitable clay for brick making and the south of the county has particularly abundant deposits. Elsewhere there is stone: carboniferous limestone in the White Peak; an arc of new red sandstone, including millstone grit, forming the Dark Peak circling the north; and creamy, honey-hued magnesian limestone in the far north-east. Within a framework of national influences, these assets combined with topography, the requirements of local farming practices and social structures to produce architectural variations that are distinctively Derbyshire.

2

Be Bold, Be Bold,
and Everywhere Be Bold
Norman Derbyshire (1066–c. 1190)

The Battle of Hastings overturned English society. The period immediately after the Conquest was spent consolidating Norman control. Architecture was focused on security, and the main strategic weapon was the castle. The most common form was a 'motte', or artificial mound, with a tower or 'keep' on top, set within one or two ditched compounds or 'baileys', containing stables and domestic buildings surrounded by curtain walls. A simpler type of stronghold, known as a 'ringwork', made use of natural contours, high ground and lofty promontories, sometimes with the addition of an earth bank, and consisted of a bailey with a fortified gatehouse keep integrated into the curtain wall. Over time, initial timber defences were replaced in stone. Norman castles were not pretty, but for a people living among enemies, they were functional and psychologically effective. In a land of mainly single-storey buildings, soaring tower keeps were unequivocal assertions of ascendancy, dominating the surrounding countryside.

Leading the subjugation of Derbyshire were William Peveril and Henry de Ferrers, both of whom were given large estates as tenants-in-chief of King William. Superbly located for their purpose, Peveril Castle (Castleton), on a craggy roost above Cavedale, and Duffield Castle, occupying a less spectacular but equally commanding site overlooking the Derwent Valley, became their respective headquarters. With an abundance of readily available material, Peveril Castle may have been built of stone from the beginning. The walls of a triangular inner bailey and square keep – built in the 1170s by Henry II when Peveril Castle was an important royal administrative centre – remain reasonably intact from the early ringwork castle. Stretches of herringbone masonry and fragments of Roman tile (presumably from the nearby fort at Navio) are visible in the curtain wall. An outer bailey reached to the precipitous sides of the site. Rebuilding has largely overwritten the Norman architectural record at Bolsover Castle and Haddon

Hall, both former Peveril strongholds, although parts of the curtain wall survive in the gardens at Bolsover Castle. Haddon's tower keep is now slotted into the north-eastern corner of adjoining ranges, part of the later manor house built by the Vernon Family. Of Duffield Castle, destroyed in 1266, nothing remains except the low motte on Castle Hill and the keep's foundations. The remnants of these grand buildings make clear statements about the status of their owners. When constructed, the keep at Duffield, approximately 95 feet square and with walls 15 feet thick, was comparable in size to the White Tower at the core of the Tower of London.

Extensive quarrying of the rocky eminence above Bottle Brook near Coxbench and opportunistic recycling (check the field walls in the vicinity) has left little evidence of Ralph de Buron's Horsley Castle beyond a few courses of stonework now hidden in woodland, marking the northern footings of the keep. The Earl of Chester Hugh d'Avranches' stronghold, which put the 'castle' in Castle Donington and guarded a strategically important crossing of the River Trent, was demolished in the closing years of the sixteenth century and the stone was reused at Donington Hall, Langley Priory, and in several village houses. Although many Norman keeps have disappeared, ramparts, mottes and associated bailey earthworks often remain observable landscape features, for example at Castle Knob; Castle Gresley, the former headquarters of the Norman Gresley family; Hope Motte, Hope; and Castle Hills, Pilsbury, which guarded a river crossing in the upper Dove Valley north of Hartington.

Norman castles were symbols of physical subjugation. A massive church-building programme that began once peace was secured represented cultural and spiritual takeover. By the end of the twelfth century, virtually all Anglo-Saxon

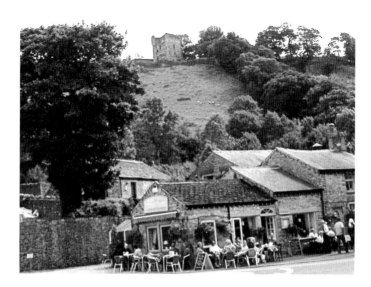

16. The square keep of Peveril Castle occupies a commanding position overlooking Castleton.

Buildings in Derbyshire

17. A few courses of stonework hidden in woodland are all that remain of Horsley Castle.

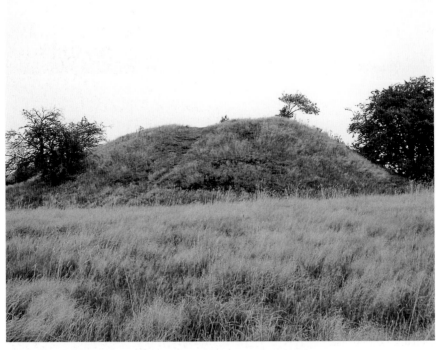

18. Castle Knob, the motte of a vanished Norman castle, is a prominent feature in the landscape of Castle Gresley.

religious buildings had been replaced. Nothing on the same scale has been experienced since. One contemporary commentator summed up what was perhaps a commonly held view of the adequacy of Anglo-Saxon churches: 'I hate small buildings … he destroys well who builds something better.' Perhaps we may detect, in the sheer fervour with which the religious agenda was pursued, an element of atonement for the bloodshed and ruthless aggression with which conquest had been achieved. This was a profoundly religious age and fear of eternal damnation was deeply ingrained.

Norman church architecture – characterised by semicircular arches, tunnel vaults, substantial piers, slender columns or 'colonettes', which are ornamental rather than structural, and plain wall elevations relieved by intersecting blank arcading – is 'Romanesque', influenced by the eleventh-century revival of classical precedents in France. Narrow slit windows – as in the tower of All Saints' church, Ockbrook, often angled or 'splayed' as at Steetley chapel and in the clerestory of St Lawrence's church, Whitwell, to maximise the light cast inside – are typical. Vigorous decorative detail – including a zigzag pattern of 'chevrons', stylised heads of birds and other beasts known as 'beakheads', raised series of blocks or

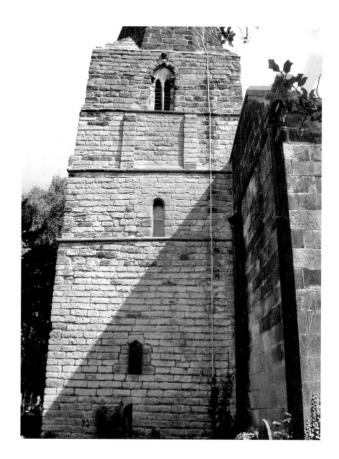

19. Narrow windows typical of the Norman Romanesque period in the tower of All Saints' church, Ockbrook. The broached steeple is a later addition.

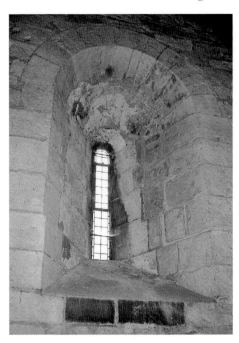

20. Window opening at All Saints' chapel, Steetley, splayed on the inside to maximise interior light.

cylinders known as 'billets', and cable motifs resembling a twisted cord – reflect the assimilation of Anglo-Saxon and Scandinavian traditions into Romanesque style.

St Michael's church, Kniveton, has a plain Norman doorway. A central 'keystone' locks the individual wedge-shaped stones, or 'voussoirs', of a semicircular arch in place. A more richly sculpted doorway at All Saints' church, Bradbourne, has a single colonette on each side, two rows of voussoirs depicting animals, and an outer arch of well-worn stylised beakheads biting a roll moulding. This doorway is set in a mainly Norman tower (the castellated top is a later addition) that has chevron-decorated bell-openings with protective dripstone moulding carved with billet decoration, and a projecting course of supporting masonry known as a corbel table featuring a rogues' gallery of faces bursting from the stone. St Lawrence's church, Whitwell, has a corbel table running around a fully preserved Norman nave with an original row of splayed windows piercing an upper storey, a feature known as a clerestory. All Saints' chapel, Steetley – faithfully restored from a ruinous state to an accurate representation of Norman splendour between 1876 and 1880 by architect J. L. Pearson (1817–97) – also retains an animated corbel table. Inside the building are 'capitals' (blocks of stone forming the tops of columns) with figurative carvings of Adam and Eve, St George and the Dragon, and a two-headed lion.

Grimacing faces and grotesque beasts adorning churches astonish modern sensibilities. We can only guess at their meaning, and speculate on the robust earthiness and vitality of the society that produced them. Norman capitals at

21. Wedge-shaped stones or 'voussoirs' form a typical rounded arch above the Norman doorway of St Michael's church, Kniveton.

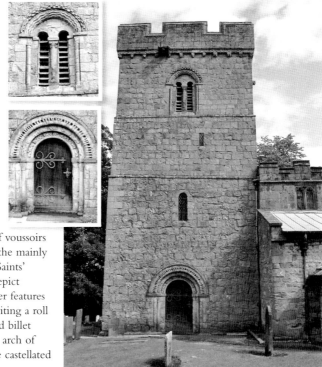

22. Two inner orders of voussoirs above the doorway in the mainly Norman tower of All Saints' church, Bradbourne, depict animals. The outer order features weathered beakheads biting a roll moulding. Chevron and billet moulding decorate the arch of the belfry window. The castellated top is a later addition.

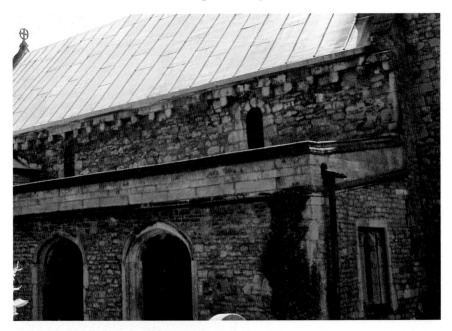

23. St Lawrence's church, Whitwell, has a Norman nave with a series of projecting supports or 'corbels' at the eaves. Upper-level windows, splayed on the inside, form a clerestory. The side aisle is a late fourteenth-century addition.

24. All Saints' chapel, Steetley, authentically restored 1876–80, has a corbel table sculpted with a variety of abstract patterns and animated heads.

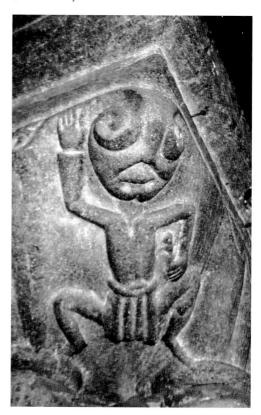

25. Know as 'the Sandiacre imp', this capering figure is carved on a capital of the Norman chancel arch at St Giles' church, Sandiacre.

St Michael and St Mary's church, Melbourne, feature an array of arresting images, including a grinning cat and a man pulling a dog's tail. Capitals supporting the chancel arch at St Giles' church, Sandiacre, sport a wraith-like figure in a long, pleated dress, and a capering figure in a loincloth popularly dubbed 'the Sandiacre imp'. St James' church, Bonsall, has its own peculiar sprite, a strange creature carved towards the foot of an octagonal pillar in the north aisle. Singularly surprising is a corbel in the Norman arcade of St James' church, Brassington, showing a male figure in an explicit 'mooning' pose.

'Tympana', filling the space between a door lintel and the arch above, were also exploited decoratively. An example in the Norman doorway of St Bartholomew's church, Hognaston, shows a bishop with his pastoral staff accompanied by a menagerie of animals. Other tympana of the period can be found at Holy Trinity church, Ashford-in-the-Water; St Peter's church, Parwich; St Mary's church, Tissington; St John's church, Ault Hucknall; All Saints' church, Findern; St Giles' church, Marston Montgomery; St Michael's church, Stanton-by-Dale; All Saints' church, Kedleston; St Michael's church, Willington; and St Michael's church, Alsop-en-le-Dale. A tympanum in a secular setting at St Bride's Farm, around a mile west of Melbourne, is explained by the fact that this private house and

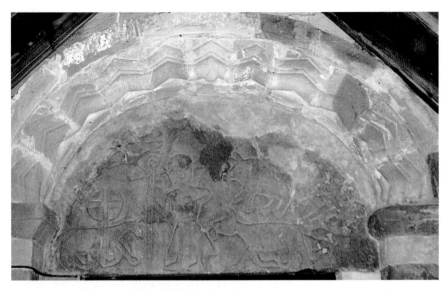

26. Beneath an arch decorated with chevrons, the tympanum of the Norman doorway at St Bartholomew's church, Hognaston, depicts a bishop and an assortment of animals.

associated barn conversions are built around the shell of a medieval chapel that once belonged to the Benedictine monks of nearby Burton Abbey.

Norman Romanesque architecture of cathedral-like grandeur is on display at the church of St Michael and St Mary, Melbourne. Bold chevrons crown a west doorway flanked by four orders of colonettes. Inside, immense circular piers, almost 4 feet in diameter, march sturdily down the aisles. In order to achieve greater height than the spacing of the columns would normally allow, the arches they support squinch inward at their bases, giving a horseshoe-like profile. More chevrons zigzag like lightning bolts around these arches. Broad cushion capitals in the six-bay nave arcade feature a variety of ornaments, from simple scallop incisions to rams' heads and volutes. A clerestory and upper wall passage allow privileged access from a private gallery to an upper chancel (removed in the seventeenth century), a feature commonly found in cathedrals but exceptional in a parish church. Melbourne is such an unusually ambitious church that the case for a royal foundation, possibly by Henry I soon after his accession in 1100, can convincingly be made.

St James' church, Brassington, has a compact Norman south arcade of three arches carried on circular pillars, with characteristic examples of both scallop and waterleaf (a plain, unribbed, tapering, upright leaf) decoration on the capitals. Stout chevrons leap around the chancel arch of St Edmund's church, Castleton. Blank arcading can be found on tub-shaped Norman fonts in All Saints' church, Ashover; St Michael's church, Church Broughton; St Peter's church, Somersal Herbert; and All Saints' church, Ockbrook. However, architectural use of arcading

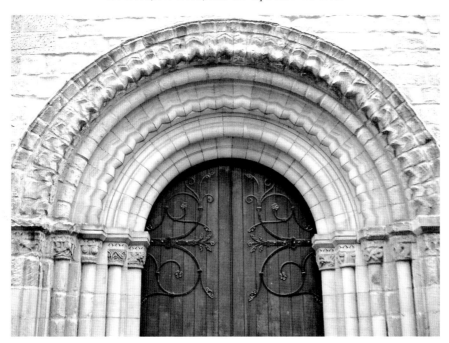

27. Four orders of colonettes with elaborately carved capitals and roll-moulded arches surround the west doorway of Melbourne parish church.

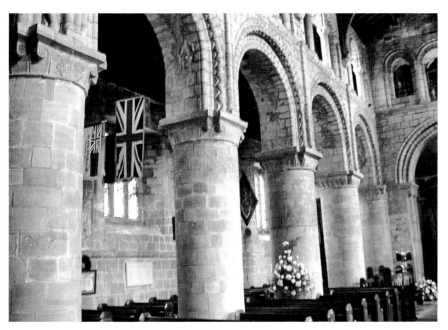

28. Massive circular piers in the nave of St Michael and St Mary, Melbourne, have broad cushion capitals featuring projecting scrolls or 'volutes', rams' heads, and simple scallop patterns. Chevrons decorate single-stepped arches. Above is a clerestory and wall passage.

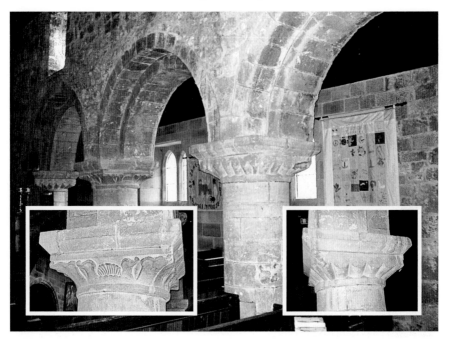

29. The Norman arcade of St James' church, Brassington, has single-stepped arches and capitals decorated with waterleaf (bottom left) and scallop (bottom right) patterns.

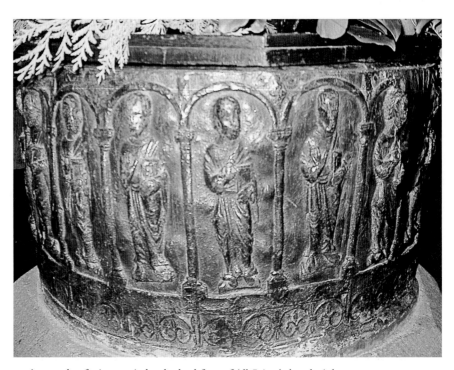

30. An arcade of saints encircles the lead font of All Saints' church, Ashover.

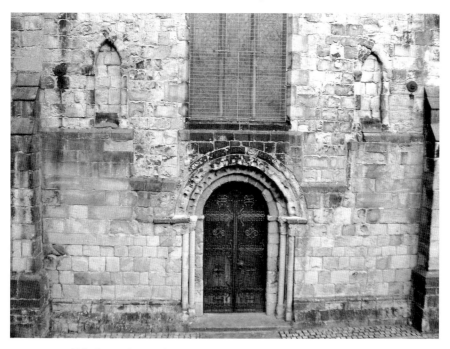

31. Vestiges of blank arcading with chevron decoration can be seen on either side of a later window at All Saints' church, Bakewell. Worn beakheads embellish the arch of the Norman west doorway, which also has two orders of colonettes.

is rare in Derbyshire. In an echo at All Saints' church, Bakewell, the remnants of an arcade of intersecting arches with chevron decoration – interrupted by the insertion of a later window – sit above a Norman west doorway embellished with weather-beaten beakhead decoration. The first arch of a blank arcade that once encircled the chancel of Melbourne church is all that remains after the remodelling of the east end of the church in the early seventeenth century.

Norman arches became progressively more elaborate in section, adding lightness in the form of stepped and chamfered profiles without sacrificing strength. The plain unmoulded style represented by St John's church, Ault Hucknall, gave way over time to the single-stepped shapes in evidence at St Lawrence's church, Whitwell, St Mary's church, Tissington, and St James' church, Brassington. Double-stepped forms followed, as at St Laurence's church, Walton-on-Trent, and St Chad's church, Longford. Single-chamfered variations are found at All Saints' church, Wingerworth. Later double-chamfers are on show in the nave at All Saints' church, Youlgreave. By the end of the Romanesque period, plain, circular piers had begun to evolve more imaginative keel-shaped profiles.

By transferring the weight it carries more efficiently, an arch is stronger than a flat beam or lintel. The design of arches framing doorways and windows

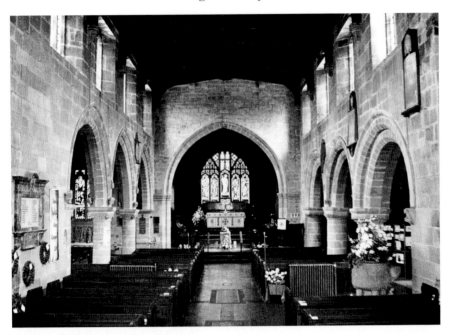

32. All Saints' church, Youlgreave. The double-chamfered arches of the nave are rounded in the south arcade but pointed in the north. The introduction of more efficient pointed arches marked the transition from Romanesque to Early Gothic style. The east window of the chancel is by William Morris & Company to a design by Edward Burne-Jones.

– or projected into a vault to form a roof interior – is the key to understanding medieval architecture. Round-headed arches of the Norman Romanesque period are single-centred semicircles. Vaults of the period are half-cylinders usually described as 'tunnel' or 'barrel' vaults. Where two intersect they create a 'groined' or 'cross' vault. Vaulting gives a visually pleasing effect and increases interior space, but the need for tunnel vaults to have continuously supporting walls, and for every stone to be precisely cut and fitted, restricted their application to small spaces, as in the covered west porch or 'narthex' at St Michael and St Mary's, Melbourne. A narthex served as a kind of ante-nave in early churches, and was where new converts gathered. In later medieval times, the area was often set aside for use by penitents or the women of a parish. Complicated geometry constrained the use of groin vaults to essentially square spaces, and the even distribution of structural pressure meant walls could not safely be pierced, for example to allow for windows. The problem of spanning large, rectangular areas was overcome by the twin developments of pointed arches and 'rib' vaulting.

　　Pointed arches are two-centred, combining two segments of a circle. Pressure is directed either side of the centre, defining points where outward thrust can be transferred to external buttresses. Self-supporting stone ribs, based on two transverse pointed arches crossing in an 'X' pattern, externally buttressed

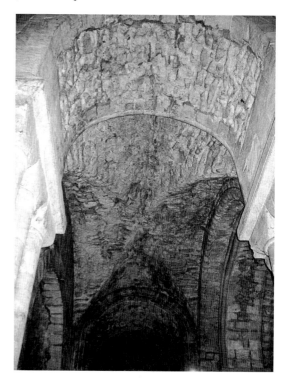

Right: 33. Tunnel vault above the narthex of Melbourne parish church.

Below: 34. Double-stepped arches of the late Romanesque period in the north arcade of the nave at St Chad's church, Longford, contrast with later Early Gothic pointed arches in the south arcade.

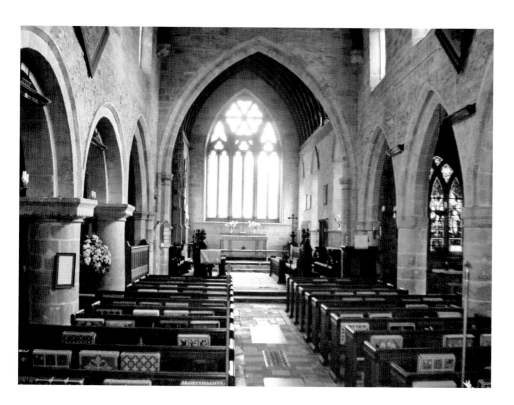

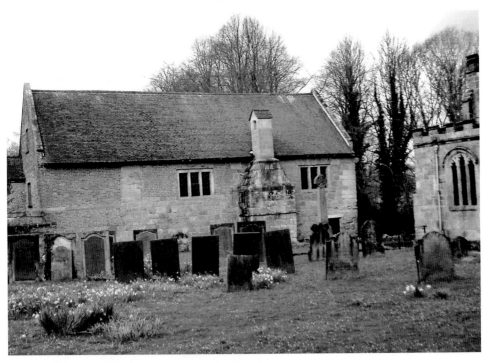

35. Although much altered, Norbury Manor dates its origins to the thirteenth-century and affords an idea of how a Norman lord or prosperous merchant lived. The two-storey construction had storage space on the ground floor, with living quarters in a communal hall above.

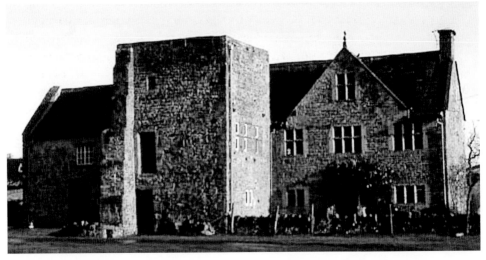

36. A medieval gatehouse tower is incorporated in Cherry Orchard Farm, Fenny Bentley.

where necessary, will carry the weight-bearing load of a vault independent of the masonry infill, allowing the spaces between to be left open or closed in any direction. This method of vaulting simplified construction, cutting down by as much as 70 per cent the quantity of stone to be cut accurately, as well as reducing the amount of temporary timber centring needed to support an arch under construction. Ribbed vaults could span large areas. Their lightness enabled a transition to slimmer piers with more elaborate profiles. By the close of the twelfth century, a trimmer, more elegant architecture, now defined as 'Gothic' (by Thomas Rickman in 1817), began to replace the weight and solidity of Norman Romanesque style.

All Saints' church, Youlgreave, and St Chad's church, Longford, both built at the turn of the thirteenth century, reflect the transition from Romanesque to Early Gothic style. At Youlgreave, double-chamfered arches in the nave are carried on large circular piers and are rounded in the south arcade but pointed in the north arcade. Scalloped capitals in the south arcade give way across the aisle to more elaborate designs with 'volutes', and the half pier or 'respond' at the west end of the north arcade is keel-shaped. At Longford, stout circular pillars with scallop capitals and double-stepped rounded arches in the north arcade contrast with slimmer piers, more ornate capitals, and pointed arches in the south arcade.

There is little domestic Norman architecture nationally, and nothing in Derbyshire. The Old Manor at Norbury, dating from the mid-thirteenth century, although with later additions and alterations (the large, stepped, external chimneystack on the east wall was probably not built before the fifteenth century), offers a glimpse of the type of property that might belong to a manorial lord or wealthy merchant of the Norman period. The basic two-storey construction, strikingly unusual when it was introduced, has a ground floor for storage beneath living quarters in a communal hall. External stairs led to an upper-storey entrance. Access between the storeys was internal. This is a house designed with security in mind for both occupants and belongings. Further evidence that robbery was a constant threat, and that for generations after the Conquest, tension between Norman and Saxon lingered, can be seen in a medieval three-storey gatehouse tower now incorporated in Cherry Orchard Farm, Fenny Bentley.

3
DOWN THE ARCHES
OF THE YEARS
Gothic Derbyshire (*c.* 1190–*c.* 1540)

The emergence of Early Gothic architecture around 1190, sometimes referred to as Early English but fundamentally a style imported from France, completed the transition from Romanesque and marked the advent of a recognisably different construction method. Every element was elongated. Taller, slimmer pillars, with clustered columns, octagonal profiles or deeply cut keel-shaped mouldings, replaced stout, round piers. Arches were pointed rather than semicircular. Elegant lancet openings transformed windows from mere slits. Staged towers and graceful steeples soared heavenwards. And all was symbolic. Lancet windows and pointed arches represented two hands in prayer; skyline-piercing spires embodied heavenly aspiration.

Decorative carving based on stylised foliage became popular, including incised 'stiff-leaf' patterns, projecting leaf-like 'crockets', and a raised pyramidal ornament resembling a four-petalled flower known as 'dogtooth'. Sedilia at St Leonard's church, Monyash, have dogtooth decoration around the arches, and sculpted stiff-leaf capitals. There are good examples of stiff-leaf carving on the capitals surmounting the clustered columns of the nave at St Oswald's church, Ashbourne. Projecting drip mouldings above tower windows at All Saints' church, Breadsall, have dogtooth decoration. Fragments of a dogtooth pattern that once formed a thin encircling band survive at St Mary's church, Weston-on-Trent.

In a series of freeze-frame architectural snapshots, St James' church, Barlborough, All Saints' church, Wingerworth, and the church of St Peter and St Paul, Eckington, have elements capturing the crossover. In Barlborough church, the capitals of the nave arcade have Romanesque waterleaf decoration, while those of the chancel arch have Early Gothic stiff-leaf carving. A plain, unmoulded, round-headed Romanesque arch at Wingerworth church leads to a chancel lit by Early Gothic lancet windows. Eckington's church tower has a Norman doorway with a series of Early Gothic lancet windows perforating the upper stages.

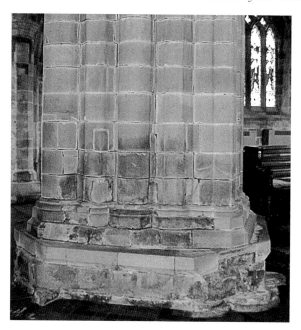

Above left: 37. Early Gothic octagonal pier, St Mary's church, Wirksworth.

Above right: 38. Early Gothic clustered pier, St Mary's church, Wirksworth.

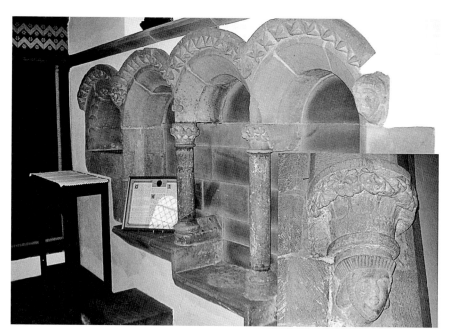

39. The arches of the sedilia at St Leonard's church, Monyash, have typical Early Gothic dogtooth ornament with stylised stiff-leaf carving on the capitals. The impost from which the chancel arch springs (inset) also carries stiff-leaf carving.

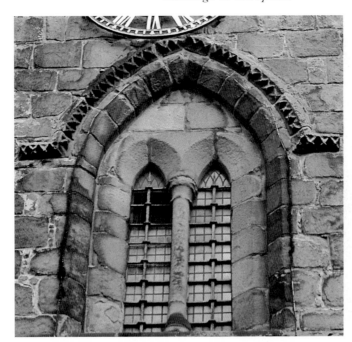

40. Dogtooth decoration on the projecting drip moulding above the windows in the tower of All Saints' church, Breadsall.

By the time the chancel of St Oswald's church, Ashbourne, was consecrated in 1241, the move to Early Gothic was absolute. North and south walls of the chancel still have three pairs of original lancet windows. Local sandstone of greyish-brown hues with subtle pink overtones gives St Oswald's a distinctive appearance, and the ambitious scale of Ashbourne's parish church set a standard that the emerging urban centres of Wirksworth and Chesterfield sought to equal.

Medieval churches were stage sets of religious theatre, full of colourful imagery. A taste for showy creativity emerged in the middle of the thirteenth century, initiating a new phase of Gothic architecture known as Decorated style. Many brightly illustrated interiors have been lost, painted over by Puritan reformers in the sixteenth and seventeenth centuries, or scraped back to austerity in the Victorian period. Characteristic of the Decorated Gothic style was an ornament known as 'ballflower', resembling three petals wrapped around a sphere. There are excellent restored examples around the doorway of St Werburgh's church, Spondon. A stone reading table or 'missal bracket' built into the chancel wall of St Werburgh's church is a peculiarly Derbyshire feature found elsewhere at St Mary's church, Chaddesden, St Michael's church, Crich, St Helen's church, Etwall, All Saints' church, Mickleover, and St Michael's church, Taddington. The missal or book of the mass (the *liber missalis*) contained the liturgy and ceremonial instructions.

Exploitation of the visual possibilities introduced by the availability of stained glass in the thirteenth century was limited by single, narrow lancet windows. This led to combinations of two, three or more lancets arranged in a stepped series to

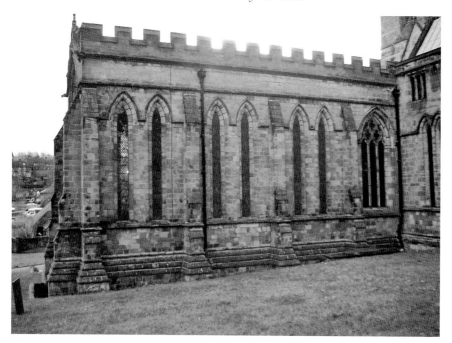

Above: 41. Early Gothic lancet windows in the chancel of St Oswald's church, Ashbourne.

Right: 42. Restored ballflower decoration typical of the Decorated Gothic period, St Werburgh's church, Spondon.

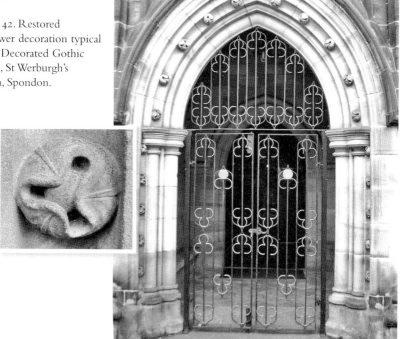

provide a broader window surface. From this development, it was a small move to larger, more versatile single windows divided by stone mullions, and with ribs or 'tracery' of increasing complexity in the upper portion. From stepped lancets (see the restored east window of St Mary's church, Weston-on-Trent, and the south transept of St John's church, Chelmorton) emerged paired lancets with trefoil or quatrefoil openings cut through a solid window head – a technique known as plate tracery – which were in turn followed by single 'Y' shapes and, in larger windows, intersecting 'Y' ribs. The south window of the south transept at St Oswald's church, Ashbourne, has six mullions flaring into criss-crossing ribs with a quatrefoil at the peak. By the early fourteenth century, windows had evolved even more flamboyant curvilinear tracery and reticulated latticework variations, incorporating circles drawn into sinuous 'S' or 'ogee' shapes, giving a net-like appearance.

Bubonic Plague – the Black Death – reached England in 1348. A first wave was followed by further outbreaks in subsequent decades. Up to half the population died. People's faith was challenged. With labour shortages and skills in short supply, much building work was halted. When construction did recommence, the

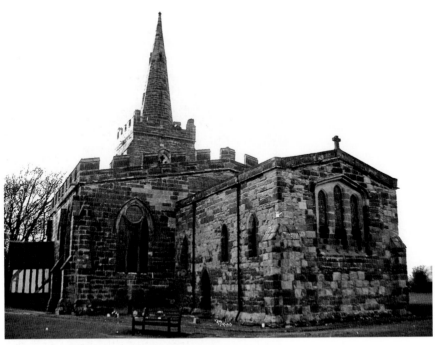

43. St Mary's church, Weston-on-Trent, shows the development of lancet widows from single slits (in the chancel walls) to stepped series (the east window, a modern version but in authentic style) and then to larger windows divided by stone ribs (east end of the south aisle). A spire recessed behind battlements is a feature common to many Derbyshire churches. A timber-framed porch is a seventeenth-century addition.

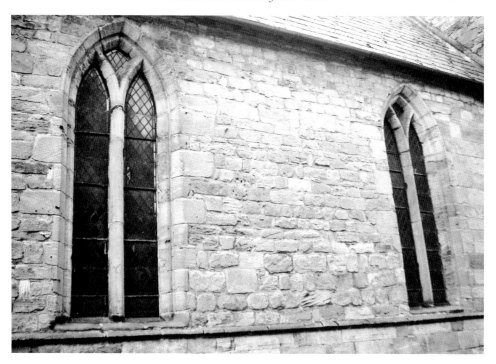

Above: 44. Simple 'Y'-tracery typical of the early Decorated Gothic period at All Saints' church, Sawley.

Right: 45. Intersecting tracery of the mid-Decorated Gothic period in the south transept of St Oswald's church, Ashbourne.

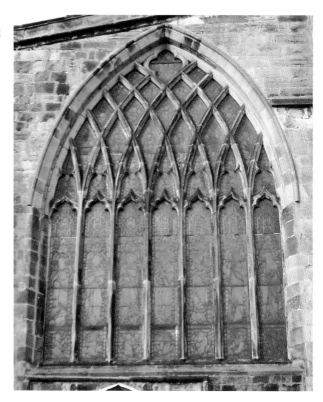

exuberant embellishments of Decorated Gothic no longer seemed appropriate. A new, simpler architectural style known as 'Perpendicular Gothic' emerged to match the sobriety of a nation in mourning. Continental influences were largely discarded. Perpendicular Gothic was the first truly vernacular English architecture. Octagonal piers suited the fresh, more linear style and remained popular, but the ornamental excesses of Decorated Gothic were toned down, limited to the addition of crockets on the sides of steeples and spirelets (added according to folklore to prevent the Devil from sliding down). Windows in the chancel of St Mary and St Barlok, Norbury, and in the chancel of St John's church, Tideswell, anticipated the step change to the larger openings with flattened tops (either four-centred arches or straight-headed) that became typical of Perpendicular Gothic style. Chancels at both churches evoke the same sense of scale with windows that show signs of flattening but without the definitive panel tracery. Perpendicular architecture shone light into Derbyshire's parish churches. Alongside larger windows, clerestories were added, as at All Saints' church, Aston-on-Trent, and at All Saints' church, Sawley, increasing the feeling of space and airiness.

The leading exponent of Perpendicular Gothic during the second half of the fourteenth century was Derbyshire-born Henry Yeveley (c. 1325–1400). As a young man, Yeveley moved to London, and in a distinguished career rose to become England's architect-in-chief, working on cathedrals, churches, palaces, castles, bridges, and royal monuments. In the same way that innovative rib vaulting techniques had enabled stone roofs to span wider spaces from around 1190, in the Perpendicular period, new carpentry methods emerged to overcome the constraints of horizontal tie-beam construction. Most spectacular and impressive was the hammerbeam roof, in which support is provided by short projecting hammerbeams carried on upright hammer-posts – in effect a timber version of stone vaulting. Carpenter Hugh Herland, working for Henry Yevele, built what was probably the first hammerbeam roof in the world in 1394 for Richard II, at Westminster Hall. As a technique, it did not catch on in medieval Derbyshire. A restored fifteenth-century roof in Padley chapel near Grindleford, with two sets of the original hammerbeams on either side of a central tie-beam, is a rare example. Occupying the former gatehouse of Padley Hall, the chapel is all that survives of the former Fitzherbert Manor, a medieval hall house that developed piecemeal in the fourteenth century with rooms set around a central courtyard. Foundations, and the remains of a central hearth, show where the great hall once stood at the heart of the manorial complex. The ends of the hammerbeams in Padley chapel have been decorated with angels, a practice common enough elsewhere in England to give rise to the alternative name 'angel roof'.

Did Henry Yevele leave a legacy in Derbyshire? As a young man learning his trade in the family stonemasonry business, based just across the county border in Uttoxeter, Staffordshire, he must surely have worked in the local area.

46. The spacious chancel of St Mary and St Barlok, Norbury – memorably described as 'a lantern in stone' – anticipates the change to larger windows from the mid-fourteenth century.

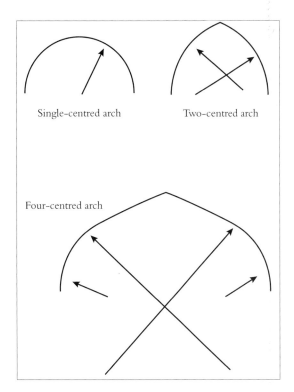

Single-centred arch Two-centred arch

Four-centred arch

47. Semicircular or round-headed arches of the Norman Romanesque period are single-centred; more efficient pointed arches that introduced the Early Gothic period are two-centred; four-centred arches are typical of Perpendicular Gothic architecture.

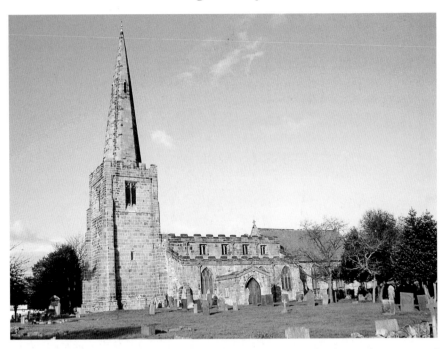

48. All Saints' church, Sawley. A Norman church remodelled in the thirteenth century and again in the Perpendicular period, when a clerestory was added to increase light in the nave and battlements were added to the tower.

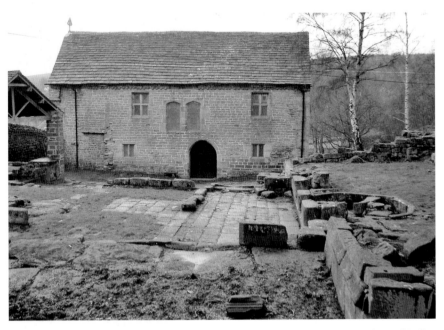

49. A gatehouse containing a Roman Catholic chapel is all that remains standing of Padley Hall, the former Fitzherbert medieval manor near Grindleford.

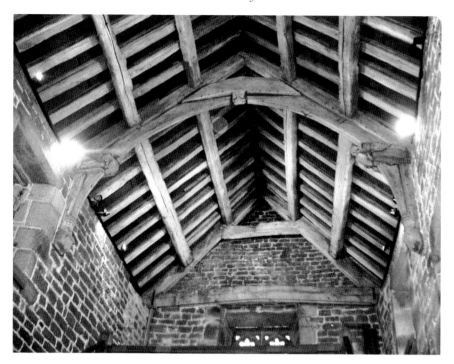

Above: 50. Hammerbeam roof, Padley chapel.

Right: 51. Angel detail from one of two sets of original hammerbeams at Padley chapel.

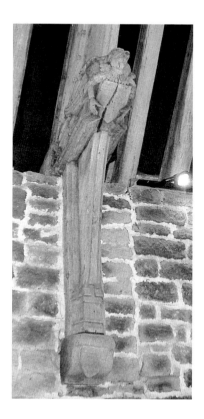

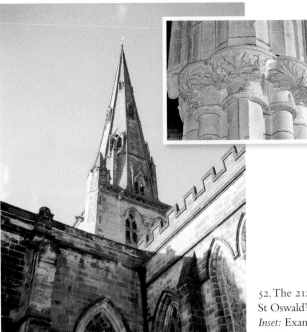

52. The 212-foot-high spire of
St Oswald's church, Ashbourne.
Inset: Example of stiff-leaf carving
on the capitals of a clustered pier.

It is tempting to see his hand in the nave, 212-foot-high spire, and other mid-fourteenth-century flourishes at St Oswald's church, Ashbourne.

Increasing use of lead, a plentiful commodity in Derbyshire, to seal roofs led to flatter rooflines on churches, matching the period fashion for shallower arches. The steep pitch of an earlier roofline often shows in tower masonry. Although it is difficult to unpick medieval alterations from further changes made during restoration in the 1870s, St Mary's church, Wirksworth, is a good example of how flat-profile, lead-sealed roofs were concealed behind battlements to improve and dramatise the silhouette.

By the time Perpendicular Gothic arrived, the great era of church building in the county was over. Examples of the style tend to be alterations and additions to existing structures. Battlemented towers crowned by a spires dating from this period are a distinctive feature of Derbyshire churches – not unique to the county but far more common here than anywhere else. Derbyshire churches with this attribute include St Alkmund's church, Duffield; All Saints' church, Sawley; the church of St Laurence and St James, Long Eaton; St Matthew's church, Pentrich; St James' church, Bonsall; St John's church, Chelmorton; St Michael's church, Crich; St Andrew's church, Twyford; St Leonard's church, Monyash; the church of St Peter and St Paul, Eckington; St Werburgh's church, Spondon; St Mary's church, Weston-on-Trent; St Mary's church, Newton Solney; St Wystan's church, Repton; and St Cuthbert's church, Doveridge.

53. St Mary's church, Wirksworth. In the Perpendicular period, the walls of the nave were raised to allow a clerestory to be inserted and the roof was flattened and concealed behind a battlemented parapet. The steep pitch of an earlier roof shows clearly in the masonry of the tower.

St Cuthbert's church, Doveridge, is one of several Derbyshire churches where development through the various phases of Gothic architecture is well illustrated in the fabric. Individual and paired lancet windows with dogtooth decoration in the tower and lancet windows in the sidewalls of the chancel are Early Gothic. Flowing Y-tracery in the south aisle windows of the nave and reticulated tracery in the north aisle windows of the nave span the period of Decorated Gothic. And the flattened arch and panel tracery of the east window date from the Perpendicular period, when the walls of the nave were raised, the roofline was flattened, a clerestory was inserted, and battlements plus an octagonal spire were added to the tower.

At St Giles' church, Sandiacre, an Early Gothic spire crowns a Norman (or possibly late Anglo-Saxon) tower. A spacious Decorated Gothic chancel was added to the Norman nave in the mid-fourteenth century (see the round-headed south doorway with three orders of colonettes, the round-headed, slightly splayed windows in the nave that have since been extended downwards, and the chancel arch). Different masonry and an altered roofline are clearly visible and show that a low clerestory was added to the nave in the Perpendicular period. The complex,

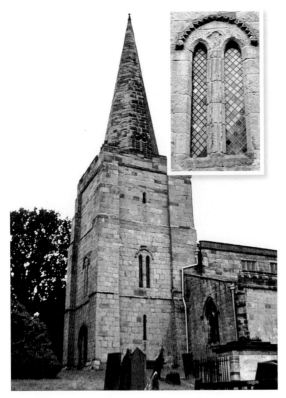

Left: 54. St Cuthbert's church, Doveridge, is one of several Derbyshire churches that exemplify different phases of Gothic architecture. Paired lancet windows with dogtooth decoration in the tower are Early Gothic. An octagonal spire and battlements were added in the fourteenth century.

Below: 55. Masonry at St Cuthbert's church, Doveridge, reveals where the walls were raised and a clerestory added (*c.* 1500) above the nave beneath a shallow pitched roof. Lancet windows in the sidewalls of the chancel are Early Gothic, reticulated tracery in the windows of the side aisle is late Decorated Gothic, and the clerestory is Perpendicular Gothic.

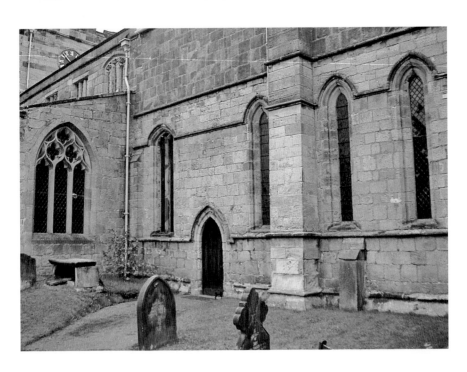

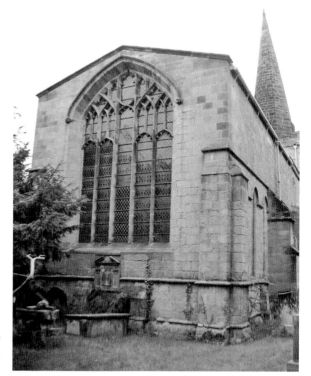

Right: 56. A Perpendicular Gothic east window at St Cuthbert's church, Doveridge, was inserted after the walls of the chancel were raised around 1500.

Below: 57. The tower of St Cuthbert's church, Doveridge, shows where the pitch of the roof was altered around 1500.

fluid window tracery of St Giles' church is among the best to be seen anywhere in England. Together with a series of tall, crocketed pinnacles rising proudly above the chancel buttresses – mirrored by a splendidly ornate three-stall sedilia in the sanctuary – they represent almost the last flourishes of Decorated style in Derbyshire. St Giles' soaring pinnacles add a graceful finish and create a striking outline, but they are also practical, adding weight to the buttresses to counteract outward thrust. At St Mary's church, Chaddesden, which was founded by Henry Chaddesden (an archdeacon at Leicester) and constructed around 1357, in the immediate aftermath of the Black Death, the builders persevered with Decorated Gothic tracery similar in style to that of the chancel at Sandiacre (see the original windows in the north aisle and sides of the chancel – the other windows are nineteenth-century replacements on the same theme) and with crocketed ogee arches on the sedilia. Perpendicular Gothic was preferred when a tower was added, and alterations were made to the west end of the church.

Architectural innovations pioneered in churches transferred to medieval secular structures. Bakewell Town Bridge (*c.* 1300) is carried on pointed arches supported by plain ribs. Eight chamfered ribs support the pointed arches of Swarkestone Causeway, also built around 1300. Chamfering served no practical purpose and the results are not on show but hidden beneath the structure. Aesthetics must

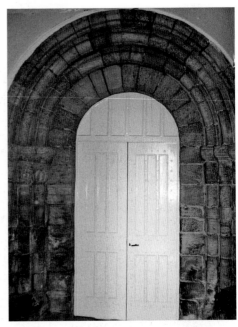

Above left: 58. St Giles' church, Sandiacre. An Early Gothic octagonal spire is broached on a square tower of Norman or possibly Anglo-Saxon provenance.

Above right: 59. Round-headed Norman south doorway, St Giles' church, Sandiacre.

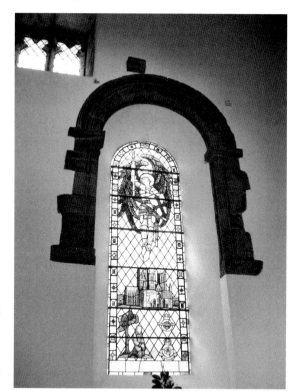

Right: 60. A splayed Norman window in the nave of St Giles' church, Sandiacre, has been extended downwards in a later period.

Below: 61. A new chancel was added to an earlier nave at St Giles' church, Sandiacre, in the Decorated Gothic period. The masonry of the nave reveals where a clerestory was inserted and the roofline was altered in the Perpendicular Gothic period.

 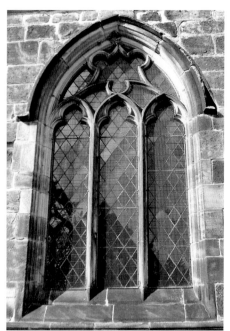

Above left: 62. Flamboyant curvilinear Decorated Gothic window tracery in the chancel of St Giles' church, Sandiacre, is among the finest in England. Crocketed pinnacles above the buttresses help transfer outward thrust.

Above right: 63. St Mary's church, Chaddesden, has curvilinear window tracery of the Decorated Gothic period.

have played a part in the mason's decision. The same pride in workmanship is on display in the chamfered ribs of two semicircular arches (essentially tunnel vaults) of Monk's Bridge, Egginton, built around 1270, that survive alongside later replacement segmental arches. Segmental arches are single-centred segments of a large circle. Their advantage over semicircular and pointed arches is that the span can be changed without adjusting the height of the arch, so that fewer piers are required and a flatter profile achieved, eliminating the traditional humpback shape and enabling roadways to be kept level. Use of segmental arches in bridge design developed in the fifteenth century and rapidly became standard practice. A medieval packhorse bridge at Cromford has pointed arches on the downstream side and segmental arches when viewed from upstream – an unusual combination of styles that resulted from an existing bridge being widened in a later period.

Medieval Derbyshire presented two very different faces. At one end of the scale were the castles and barn-like manorial halls of the gentry, the churches and precincts of the more significant monastic foundations (Dale Abbey, Darley Abbey, Beauchief Abbey, Breadsall Priory, Repton Priory, Calke Priory, Gresley Priory,

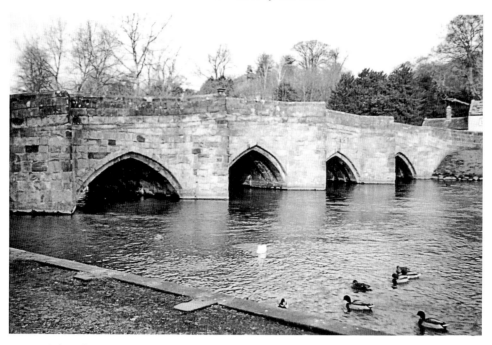

64. Bakewell Town Bridge (*c.* 1300) is carried on pointed arches with plain ribs.

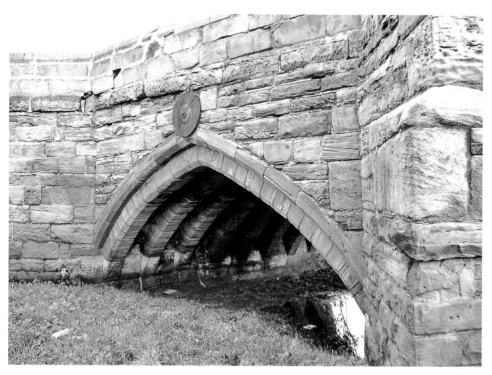

65. Eight chamfered ribs support the pointed arches of Swarkestone Causeway.

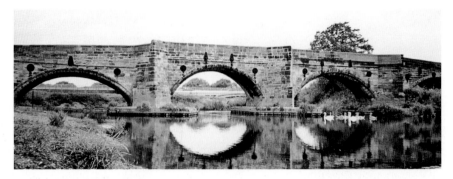

66. Two semicircular arches survive from the original Monk's Bridge, Egginton (*c.* 1270), alongside later segmental arches.

and in Derby, King's Mead Priory and the Priory of St James and the Dominican Friary), the preceptories, local headquarters of the Knights Hospitaller (Arleston House, Barrow-on-Trent; Stydd, Yeaveley) and the Knights of St Lazarus (Locko), and ambitious parish churches. All of this stood in stark contrast to the squalid hovels occupied by the majority of the population. Even in towns – and only half a dozen places in medieval Derbyshire had any pretence to urban characteristics (Derby, Chesterfield, Wirksworth, Ashbourne, and, to a lesser extent, Bakewell and Castleton) – homes were ramshackle affairs. Derbyshire, however, presented a better face to the world than most of England. The ready availability of stone in central and northern parts of the county allowed even the humblest shelters to have roughly coursed walls of rubble. Gaps in the unfinished stonework were filled with moss and daubs of clay, dung, or earth. In the south of the county, where stone was scarcer, walls might be of 'cob', a kind of mud or clay concrete strengthened with straw or horsehair, and built up in thick layers. Windows were the narrowest of slits, entrances commonly protected by little more than sackcloth, and roofs thatched with straw or a covering of turf, heather or bracken, depending on what material was most readily available. A yeoman or tenant farmer might have a longhouse, a more substantial but still a low, single-storey building, divided by a central passage separating livestock from the domestic living space and central hearth. Natural contours were utilised to provide drainage via a shallow central channel.

As defence became a diminishing priority, castles were either slowly abandoned (Peveril Castle), or evolved more comfortable features (Bolsover Castle, Haddon Hall). The Gresley family deserted a timber motte and bailey castle at Castle Knob in favour of a new manor house close to the River Trent at Drakelow (it was demolished in the 1950s). A show might be made of features such as battlements and arrow loops, but this was as much about decoration and status (castellation required a licence from the Crown), or perhaps a reference to military service by family members, as the ability to withstand a serious siege. Nevertheless, the strength to withstand a peasant mob was useful security. During the disturbances

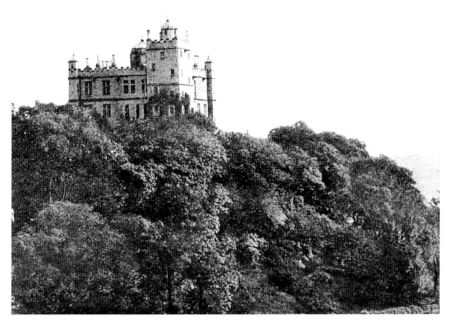

67. Bolsover Castle was extensively rebuilt during the seventeenth century in medieval style, complete with turrets and battlements but with comfortable living also in mind.

triggered by the Poll Tax of 1381 and fuelled by a variety of economic and social grievances, Breadsall Priory was torched and Horsley Castle was temporarily occupied by protestors.

At the centre of life for medieval aristocracy was the great hall. Lesser gentry occupied timber-framed hall houses. Halls were open to the rafters; windows were unglazed slits with shutters. A fire burning in an open hearth provided warmth. Smoke found its own escape through the eaves and roof thatch. Lords of the manor lived a communal existence alongside servants and retainers. Furniture was minimal. Everyone ate and slept in the hall. Dirt floors were strewn with straw or aromatic plants. A raised dais at one end of the open hall kept the lord and his family above the worst of the mess. At the opposite end of the hall to the dais, a pantry for food, a buttery for drink, and a kitchen with its own cooking fire were separated by a covered cross passage, with the main entrance at one end and a back door at the other. The passage and service area were hidden from view and draughts were initially minimised by screens, a feature that developed over time into a permanent partition. The halls of the wealthiest might have a minstrels' gallery set above this screens passage.

A move towards greater privacy is discernible from the end of the thirteenth century. In monasteries, abbots moved from communal dormitories into personal lodgings. Partly this was the result of changes in the way revenue was raised by

the Crown, which made separating the abbot's household a tax-efficient measure, but the tendency was already apparent and financial incentives merely accelerated an emerging trend. Private upper rooms or 'solars', accessed either from the dais or via external steps, were added to manorial halls, beginning a trend for sleeping upstairs that has become second nature. Initially the space beneath the solar was utilised for storage, but as domestic security increased this room was also converted for private family use. As a room for quiet conversation, or *parler* in Norman-French, it gave us our 'parlour' and provided a blueprint for more modest two-storey houses with a simple parlour and hall/living room/kitchen below a bedroom. During the fourteenth century, it became fashionable to add further rooms to manorial homes, extending the solar and undercroft/parlour into a private wing at right angles to the hall, creating an L-shaped plan. Larders, breweries and other rooms – added to the kitchen with guest rooms above – were built on at the other end of the hall to form a matching wing. Stone-flagged or cobbled floors replaced beaten earth. More expensive dressed and squared masonry blocks known as 'ashlar' was preferred to rubble stonework. Larger windows were inserted to light the dais, drawing attention to the seigneurial family. Hearths were moved from a central position to sidewalls, above which fire hoods of wattle and daub were suspended to direct smoke. In the fifteenth century, the addition of external chimneystacks with flues leading from an enclosed fireplace became a common feature. Adding a chimney allowed halls to be divided into upper and lower storeys.

Modest houses remained small and rectangular but by the end of the fifteenth century, at the grander end of the scale, the evolution of side wings and more elaborate projecting entrance porches produced the E-plan manor house. Extensions to the rear of the side wings delivered H-plan layouts. Filling in the arms of the 'H' with a gatehouse and further structures created quadrangular-plan buildings with internal courtyards. Haddon Hall, set around two courtyards, is an excellent example of this sequential development. A great hall at the centre retains its screens passage and minstrels' gallery with pantry, buttery/larder and later service rooms beyond, and a solar accessed from the upper end of the great hall has been extended into a suite of private apartments. A similar piecemeal development pattern took place at Codnor Castle, a fortified manor begun by Henry de Grey in the early years of the thirteenth century and added to until around 1500, since when gradual decline set in, leaving just a few fragile remnants of a once great house. The ground plans of Haddon Hall and Codnor Castle are the product of evolution across centuries. By contrast, Wingfield Manor at South Wingfield, built for Ralph, Lord Cromwell, in the 1440s, was specifically designed to an enclosed, two-courtyard layout.

Haddon Hall is an exceptional survival. Constantly updated and remodelled until 1640, it was then virtually mothballed until the early twentieth century. Elsewhere in Derbyshire, a small number of medieval hall houses lie hidden inside

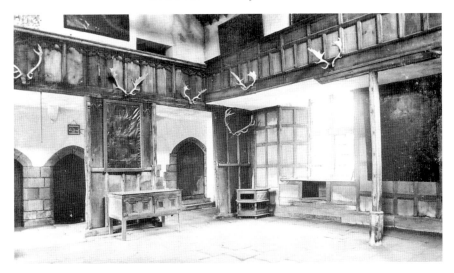

68. The great hall at Haddon with minstrels' gallery above a screens passage, and service rooms, including a pantry and buttery, beyond.

later phases of construction. Layout, fabric, and smoke-blackened roof beams can all offer clues. Exposed timbers on the east side of a thatched cottage in Burton Road, Repton, are a hint that a nineteenth-century brick skin hides something much older, in this case an early fourteenth-century hall house. Roston Hall, Roston, a two-storey timber-framed building subsequently encased in brick, contains a medieval hall at its core, as does Manor Farm, The Green, Hasland, Chesterfield, now at the centre of a residential development. A date of 1621 on a tie-beam in the main range of South Sitch, Idridgehay – a thatched, gable-roofed, close-studded, timber-framed house set on a stone plinth – almost certainly records a comprehensive makeover that has masked the ghost of an earlier hall house. When converted, it would still have been among the first two-storey domestic dwellings in Derbyshire. A medieval open hall house on the corner of King's Mill Lane and Main Street, Weston-on-Trent, was divided into three cottages in the seventeenth century and has undergone subsequent changes in more recent times. Uncoursed rubble is mixed with ashlar and brick in the present house. A lack of mortices in surviving original beams is convincing evidence that the original walls were of cob.

Codnor Castle, Haddon Hall, Wingfield Manor and more modest country houses such as Eastwood Hall, Ashover, and Barton Hall, Barton Blount, were fortified manor houses designed primarily for comfort. Wingfield Manor, however, proved its defensive credentials in the Civil War, holding out against a sustained artillery bombardment. The last Royalist stronghold in Derbyshire to fall, it was then slighted and is now a ruin with part restored as a farmhouse. The much smaller Eastwood Hall (formerly New Hall), near Ashover, was blown up

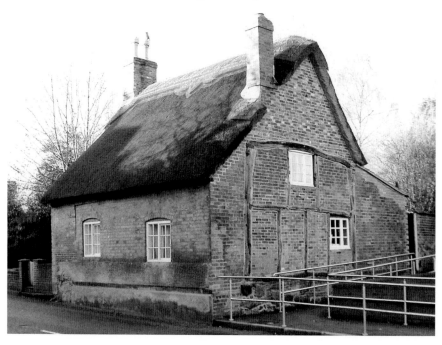

69. An early fourteenth-century timber-framed medieval hall is concealed within the later brick façade of this thatched cottage in Repton.

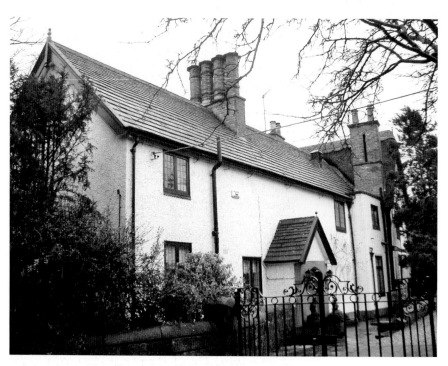

70. A medieval open hall house lies at the heart of South Sitch, Idridgehay.

Above: 71. A lack of mortices in the timber frame of this ordinary-looking and much altered property in Weston-on-Trent suggests origins as a medieval hall house with cob walls.

Right: 72. The remains of sixteenth-century Eastwood Hall near Ashover, blown up by Parliamentary forces in 1646 during the Civil War.

73. Typical timeless Derbyshire: thick walls of irregular coursed masonry, low-pitched roofs with graded flags, raised gables terminating in kneeler blocks, low rectangular mullioned windows, and simple square-headed doorways with heavy lintels.

74. The Bull's Head, Monyash: roughly coursed masonry, three-light mullion windows, raised gables with kneeler blocks, and square-headed doorway with a heavy lintel.

in 1646 by Parliamentarian forces, allegedly not so much to destroy its defensive potential as to punish the owner, Immanuel Bourne, rector of Ashover and a Royalist sympathiser, for hiding the lead font from his parish church in order to prevent it being melted down for musket shot. Eastwood Hall Cottage, built in the late eighteenth century, reuses some of the original stone and the west wall of the former hall. The remains of a tower, with sixteenth-century doorways and mullion-and-transom windows, are now largely obscured by encroaching ivy. Barton Hall at Barton Blount survived being garrisoned in the Civil War, but the medieval origins of the house are disguised by later alterations.

Derbyshire's rich natural resources made stone the traditional building material: fine-grained sandstone and limestone in the county's heart; gritstone further north and west; sandstone in the east. Buildings from the late medieval and early modern periods typically featured thick walls of irregular coursed masonry; low-pitched (around 30 degrees) gable-ended roofs with the gables raised and terminating in 'kneeler' blocks; thin sandstone flags or gritstone slates, carefully graded in diminishing sizes towards the ridge and pegged in place with oak dowels; low, rectangular, mullioned windows of two or more lights with straight dripstones on larger houses; simple square-headed doors with heavy lintels; and windows and doors with tooled or smoothly finished gritstone surrounds. Thatch, now a relative rarity in the county and largely restricted to the south-west and the north-east, was once much more common. Local straw (old varieties of corn grew much taller than modern varieties) was generally used rather than the reed routinely used today, and the ridge and edges were sealed with a mud or clay daub. A steep pitch (around 50 degrees) on old houses often provides a clue that thatch has been replaced by modern slate or tile.

LET US THINK THAT WE BUILD FOREVER
Tudor, Elizabethan and Jacobean Derbyshire
(c. 1540–c. 1640)

Ready supplies of stone and a relative shortage of timber across much of the county means Derbyshire does not have the same quantity of timber-framed houses as, for instance, the neighbouring West Midlands counties. Among the best known is Ye Olde Dolphin Inn, Queen Street, Derby. Part of the building (the Full Street frontage is a later extension) is believed to date from around 1530. Was it the area's relative unfamiliarity with timber building that contributed to the use of unseasoned timber in the 228-foot-tall spire of Chesterfield's parish church? When cloaked in 32 tons of lead plates, laid herringbone style, the spire twisted and tilted to produce Derbyshire's most recognisable and unusual silhouette.

An impressive and even larger timber-framed late fourteenth-century or early fifteenth-century building occupying a former burgage plot on Low Pavement, Chesterfield, was discovered behind a later casing in 1974. Formerly the Peacock Inn, it now houses a tourist information and heritage centre. It was probably built as a headquarters for the Guild of St Mary, and the size and quality of the structure is a testament to Chesterfield's prosperity in the Middle Ages.

Somersal Hall, Somersal Herbert, built by John Fitzherbert in 1564, is arguably the finest example of timber framing in Derbyshire. The stark black-and-white exterior so familiar in houses of this type today is a modern touch; originally, oak beams would have been left to weather into a light silvery-grey and the lath and plaster infill would have been colour-washed pale ochre or limed off-white.

The unsavoury and more noxious trades typical of a medieval town were often concentrated in a particular area. Chesterfield's Shambles, built on the footprint of a former butchery district, with a central alleyway running from Market Place to Packers Row, retain something of their original character, but only the sixteenth-century timber-framed and jettied Royal Oak public house has any real age.

There are two basic types of timber-framed house. In post and truss construction, triangular roof trusses are supported on a box-frame consisting of upright wall posts with tie-beams set horizontally and wall plates running lengthways, reinforced

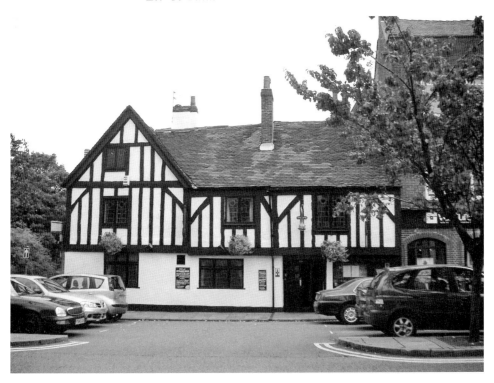

Above: 75. Ye Olde Dolphin Inn, Derby, is one of the county's oldest timber-framed buildings. Parts are believed to date from around 1530.

Right: 76. The twisted spire of Chesterfield parish church, possibly Derbyshire's most recognisable silhouette.

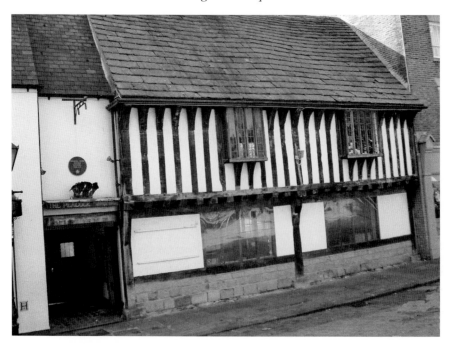

77. This timber-framed building on Low Pavement, Chesterfield (*c.* 1500), was discovered behind a later casing in 1974. It was probably built as the headquarters of a prosperous local guild.

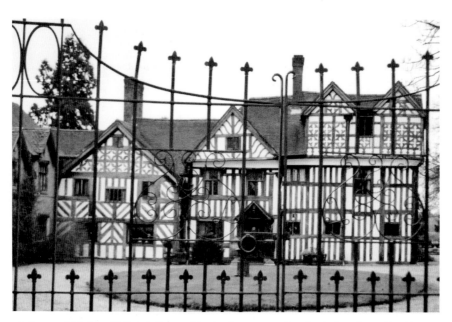

78. Somersal Herbert Hall (1564), arguably the finest example of a timber-framed building in Derbyshire. The stark black and white is a relatively modern touch. Originally the oak timbers would have been left to weather silvery-grey; the plaster infill would have been either colour-washed a pale ochre or limed off-white.

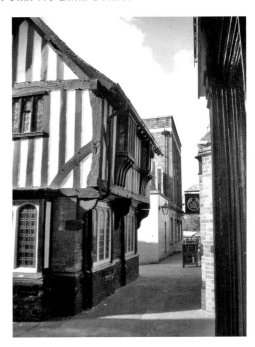

79. The Royal Oak, Chesterfield. A
sixteenth-century timber-framed and
jettied public house in the Shambles, a
former butchery district.

by diagonal braces. Squared timber studs – tenoned between horizontal header
beams and ground sills laid on a stone course foundation to prevent damp rising
through the end grain – form a skeleton for the walls and a natural casing into
which windows can be inserted. A variety of methods and materials were used
to fill the spaces between timber studs. Most widespread was wattle and daub, in
which woven lathe and rod panels were covered with clay or dung mixed with
straw or horsehair, and rendered with lime plaster. Timber of structural quality was
a scarce and expensive commodity. The more timber used, the closer the studding
and the finer the decorative flourishes, the greater the visible display of wealth.
Above a ground floor now encased in brick, Wakelyn Hall, Hilton, has a rich
fretwork of lozenges, circles and squares, creating an ostentatious display of late
Tudor prosperity and status. Tree-ring dating of beams at Wakelyn Hall provided
a felling date of 1573, securely placing the building in the Elizabethan era. Unlike
H-plan houses with earlier origins that developed piecemeal, with additions around
a medieval hall core, Wakelyn Hall was built in a single stage but to the same end
design, with a central hall separated from the kitchen by a screens passage, and a
projecting wing containing the parlour at the opposite end of the building. Lower
Street Farm, Doveridge – a prosperous yeoman's early sixteenth-century, two-
storey, close-studded, box-framed farmhouse – is lavish in its use of timber, and
spacious compared to the Picturesque, but far more modest, Brookside Cottage
nearby. Brookside was once three separate dwellings housing agricultural labourers
and their families, each with a low attic above a single ground-floor room.

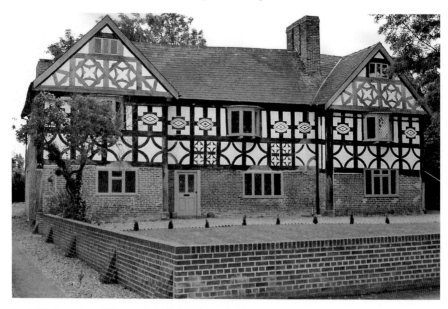

80. Wakelyn Hall, Hilton. An Elizabethan, H-plan, box-framed house with ornamental timberwork.

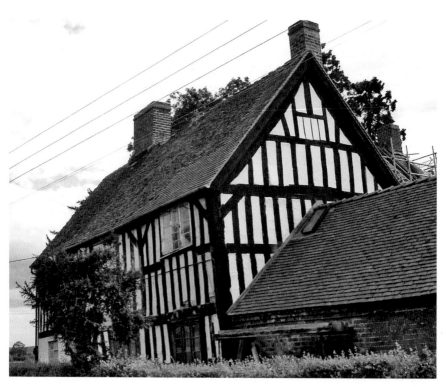

81. Lower Street Farm, Doveridge. An early sixteenth-century box-framed farmhouse with close timber studding.

82. Brookside Cottage, Doveridge, was once three separate dwellings.

Initial preparation of building timbers (almost always oak, but in exceptional cases black poplar, ash or elm) was carried out in the woods where the trees were felled. Trunks were either cleft along the grain by hammering in wedges, or hand-sawn (on trestles or, increasingly from the sixteenth century, over saw-pits), before being roughly squared with an adze. Finishing, and the cutting of joints, took place in carpentry shops. Components were delivered to site prefabricated and marked with carpenters' numerals indicating how they fitted together and in which section of the building. High tannic acid content in all but the most thoroughly seasoned oak corrodes iron quickly, and until galvanised nails became available in the eighteenth century, joints were secured with tightly fitting oak pegs or 'trashnails' driven into pre-drilled holes.

Single-storey, box-framed timber buildings were relatively straightforward to construct. Adding upper storeys – made possible by the installation of fireplaces with chimneys – posed problems for medieval carpenters. Floor joists in thick-walled Norman keeps were enormous, often more than twelve inches square. In domestic houses, beams of this size were not feasible although the beams they used were nevertheless substantial, generally around eight inches by five inches. Floor joists were laid broad side down, and the whippiness that resulted has been suggested as the reason why projecting jetties (from the French *jeté*, meaning 'thrown out') were introduced. The fact that jetties begin to disappear as design features around 1600, at a time when carpentry techniques improved and it became standard practice to lay joists narrow side down, lends support to this theory. A shortage of timber of sufficient length to stretch the full height of a two- or three-storey building, the practical benefits of additional internal floor

space, and weather protection for the lower storey, may also have contributed to jetty design. Given their Picturesque attraction, we might also consider how far fashion and aesthetics played a part in the continued popularity of an oversailing upper storey. A prominent jetty on a sixteenth-century timber-framed building on Low Pavement, Chesterfield – formerly the Falcon Inn and now occupied by a branch of Barnsley Building Society – has been deliberately retained with incongruous Tuscan columns added for support in the Georgian period. Tree-ring dating of timbers in the Old Manor House, Hartshorne, which has a jettied upper storey, revealed felling dates between 1618 and 1622. A jetty at the timber-framed east end of Waldley Manor Farm near Doveridge survives from the 1630s, although the rest of the house has been significantly altered. These dates point to a conservative approach to architecture in Derbyshire, but also hint at a deliberate design choice.

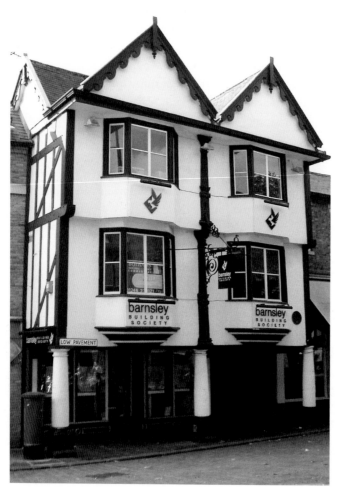

83. A prominent sixteenth-century jetty on the former Falcon Inn, Chesterfield – now incongruously supported by Georgian-period Tuscan columns.

The remains of a jetty are visible in Poplar Farmhouse, Dale, above a timber-framed sixteenth-century fragment now contained within a much later brick building. Many of Derbyshire's jettied buildings have been lost, or their frontages disguised. A jetty on the Gingerbread Shop, St John Street, Ashbourne, lay hidden behind a Mock Tudor façade for many years before being rediscovered and revealed. Vestiges of a jetty are visible beneath Victorian roughcast render at the Limelight restaurant, Victoria Square, Ashbourne, which still has exposed timbers visible at the side of the building facing into Tiger Yard.

Cruck truss construction is an alternative to box-framing as a means of providing a timber skeleton. In this method, pairs of curving timbers or 'blades' are jointed in an inverted 'V' to create 'crucks', and linked by a ridge beam against which the rafters rest. Crucks are strengthened by a horizontal tie-beam, and if necessary, given extra support by adding a collar and yoke. To ensure matching timbers, a naturally curving tree trunk was split. Almost all cruck blades are oak, but black poplar, almost as durable and even more fire resistant (black poplar was the material of choice for gunpowder boxes in the seventeenth and eighteenth centuries), was also used. Restricted width and limited height is a major drawback with cruck construction. Space at the base of the cruck is limited (to around 5½ yards, the equivalent of a 'perch', a common medieval measurement). Modifications allowing greater headroom, included 'open cruck' designs, in which

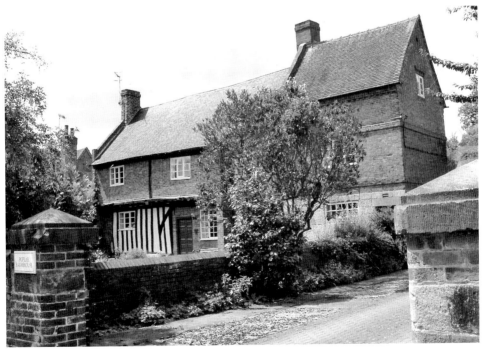

84. Echoes of a jetty show above a timber-framed fragment at Poplar Farmhouse, Dale.

Above left: 85. The jetty of Ashbourne Gingerbread Shop lay hidden for many years behind a mock-Tudor façade.

Above right: 86. Remains of a jetty are evident beneath a thick layer of Victorian render at the Limelight restaurant, Ashbourne. *Inset:* Timbers of the original box-framed building are visible at the side of the building in Tiger Yard.

the tie-beam is omitted, and a 'base cruck' variation, in which the blades do not meet but are jointed at either end of a tie-beam. In a raised cruck, the blades are set on low walls. In early medieval open halls, the number of crucks was an indicator of status, and it has been suggested that chevron-shaped stripes denoting rank in the army originate from this connection. Five crucks dividing a hall into four bays, with a raised dais in a bay at one end and a service area occupying the fourth bay, was a typical size for a medieval manorial lord.

Crucks often lie hidden within a later veneer. A fifteenth-century example was uncovered in 1971, when a tiny cottage was demolished on the corner of St John Street and St Mary's Gate, Wirksworth. The blades of a single truss have been conserved as a historic feature. A similar cruck in the gable of a cottage in Chellaston has been preserved in the sidewall of the adjoining Corner Pin public house. Ash Lane Farm, West Handley, Chesterfield, is a delightfully restored thatch-roofed, cruck-framed farmhouse. Cruck blades may be visible in gables, as in the aptly named Cruck Cottage, High Street, Melbourne, a former farmhouse divided into cottages in the 1820s, and in a barn in Parwich. In these examples, the blades rest on a stone base, providing, as an old saying has it, a 'good pair of shoes' – necessary to prevent damp penetrating and rotting the timber.

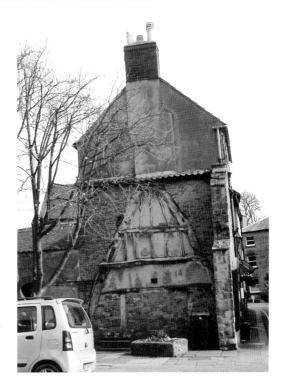

87. The cruck blades of a fifteenth-century cottage discovered at Wirksworth in 1971 and preserved as a historic feature.

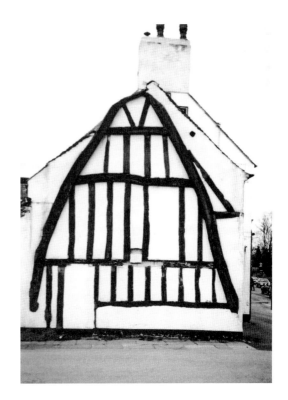

88. A cruck truss from a demolished cottage can be seen at the side of the Corner Pin, Chellaston.

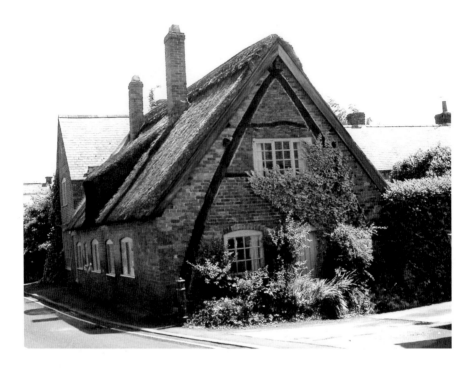

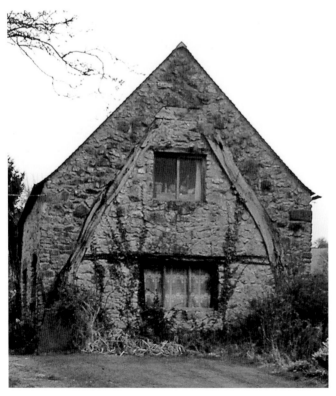

Above: 89. Cruck Cottage, Melbourne. A converted former farmhouse.

Left: 90. Reused cruck blades on show in a newly built barn at Parwich.

Henry VIII's divorce from Catherine of Aragon, his subsequent marriage to Anne Boleyn in 1533, and the rift that ensued with the Pope, began a flurry of legislation that brought about the dissolution of the monasteries. Reformation of the Church drew a line beneath the colour and ritual associated with the Roman Catholic liturgical tradition. Rich furnishings, including carved and gilded rood screens, elaborate monuments and associated ceremonial trappings, were swept away, denigrated as symbols of idolatry. Many agreed with official accusations of 'manifest sin' and 'abominable living' and allegations of the self-serving mismanagement of ecclesiastical property. Effectively, the Church was nationalised and its assets privatised. Monastic estates transferred to the Crown and were sold off or rented out to the nobility, country landowners, farmers, and wealthy but previously landless merchants, lawyers and those with connections at court. Many church buildings were demolished and plundered for scrap. Lead was stripped from roofs, walls were quarried for building stone, and glass was removed.

Thomas Thacker, steward to statesman Thomas Cromwell, acquired Repton Priory after the religious community was dissolved. His son, Gilbert, assembled a crew of workmen and demolished the priory church and most of the associated buildings in a single day in the mid-1550s when rumour spread that Queen Mary was minded to re-establish the priory. He claimed, that he 'would destroy the nest, for fear the birds would build again'. Sold on in 1557 to Sir John Port, who established Repton School on the site, all that remained standing of the former priory was the gatehouse, the prior's personal lodgings and a former

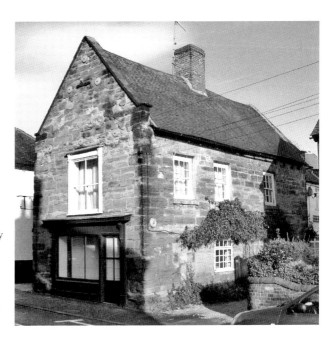

91. Stone House, Repton (c. 1600). Neatly cut masonry indicates stone recycled from Repton Priory. Raised gables with kneeler blocks are characteristic of Derbyshire.

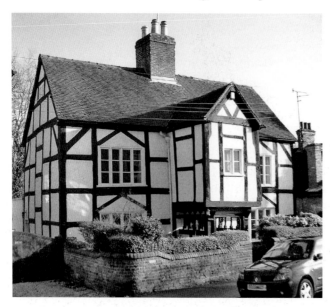

92. The timber-framed Tudor Lodge, Repton, is set on a plinth of stone that may reuse masonry recovered from the former priory after it was dissolved.

guesthouse. Dressed stone, always in demand, would have been recycled. Stone House (*c.* 1600), a former village bakery set gable end to Repton's High Street, probably incorporates masonry from the priory, and the stone plinth of nearby timber-framed Tudor Lodge with its two-storey porch may have similar origins. In the eighteenth century, the priory gatehouse was rebuilt to serve as a tithe barn, leaving only an arch of the medieval building standing.

The nave of Gresley Priory church, Church Gresley, became the parish church of St George and St Mary after the Reformation. All Saints', the tiny semi-detached parish church of Dale, may have been the infirmary attached to Dale Abbey, while the former abbey gatehouse found a new purpose as a lock-up. Most impressive of the remaining fragments of Dale Abbey is the frame of the chancel window, still soaring to its full height with hints of elaborate Decorated Gothic tracery. Reused masonry is visible in Dale's older village houses. The fabric of Dale Abbey was still being 'quarried' more than two centuries later, when stone was taken to help build the Moravian settlement at Ockbrook. Fine medieval stained glass from Dale Abbey was refitted at St Matthew's church, Morley.

Of Darley Abbey, only one building, a gabled, two-storey, heavily buttressed stone structure, possibly once the abbey guesthouse and now converted into the Abbey Inn, survives. Other stone buildings in Abbey Lane may mark the boundary walls of the abbey precinct. Extensive rebuilding in several phases disguises the medieval heart of Arleston House, Barrow-on-Trent. A chancel wall, with striking Early Gothic lancet windows, survives from the chapel of the Knights Hospitaller at Stydd, near Yeaveley. Breadsall Priory was rented out as a farm and only vestiges of the monastic building survive in the basement of a later house.

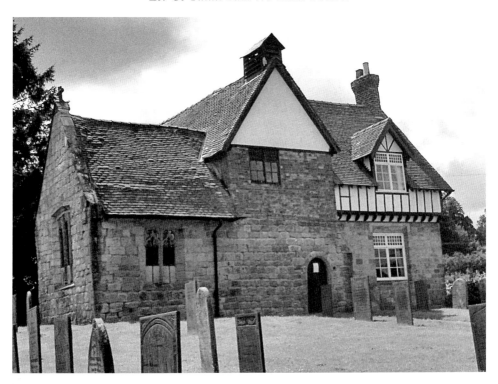

Above: 93. The semi-detached All Saints' church, Dale, probably served as the infirmary of Dale Abbey.

Right: 94. The ruins of the chancel east window of Dale Abbey church – with traces of elaborate Decorated Gothic tracery – remain an impressive sight.

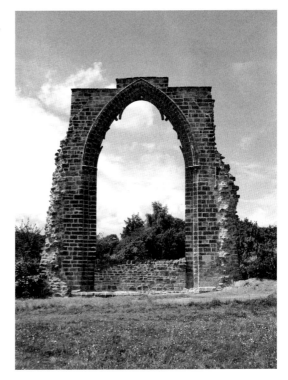

95. The Abbey Inn, Darley Abbey. A heavily buttressed, two-storey medieval building was possibly once the abbey guesthouse.

96. Centuries of extensive rebuilding disguise the medieval heart of Arleston House, Barrow-on-Trent.

97. The Early Gothic lancet windows from the chancel of Stydd chapel are the remains of a preceptory belonging to the Knights Hospitaller, near Yeaveley.

Reformation of the Church in England reconfigured society. Most towns and villages in Derbyshire had an alehouse used by locals, but it was the monasteries with their brewhouses that had traditionally provided hospitality for travellers. Dissolution of the religious houses created a demand for hostelries offering a wider range of services that was met by a rise in the number of inns. 'Public' houses mirrored developments in domestic houses. Drinks were served in what would have been the hall/living room, important guests were entertained in the parlour, and accommodation was provided on an upper storey.

Those who profited from the Reformation by acquiring Church estates were expected to take on some of the charitable and educational responsibilities formerly undertaken by the Church, secular benefaction replacing ecclesiastical patronage. Anthony Gell's bedehouses beside St Mary's church, Wirksworth (*c.* 1584), Queen Elizabeth's Grammar School, Church Street, Ashbourne (*c.* 1585), Owlfield's almshouses, Church Street, Ashbourne (*c.* 1620), and Pegge's almshouses, Church Street, Ashbourne (1669) are among the foundations that resulted. All are stone-built with typical Derbyshire period symmetry, mullion or mullion-and-transom windows, and plain gabled ends. The former Queen Elizabeth's Grammar School, Ashbourne, presents an ashlar façade, but the stonework behind is of more economical coursed rubble. Four small central gables rise above the original schoolroom. Larger gables at each end mark the rooms of a schoolmaster and his assistant. An upper storey was added to Owlfield's almshouses in 1848, using matching local sandstone that has not yet weathered sufficiently to blend completely. Pegge's almshouses, a row of four dwellings, remain single-storey.

98. Anthony Gell's bedehouses, Wirksworth (1584), restored as Gell's flats in 1963. Two-storey coursed stone rubble with three-light mullioned windows, gritstone slates and raised stone gables with small kneeler blocks.

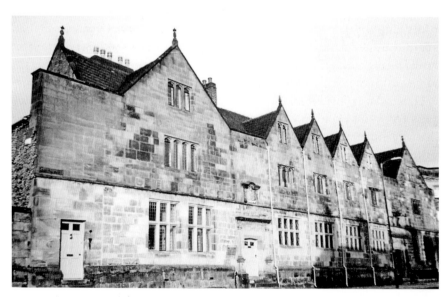

99. The former Queen Elizabeth's Grammar School, Ashbourne (*c.* 1585), now converted into apartments. Behind an ashlar façade, the building is more typical coursed rubble. Four small central gables mark the original schoolroom with the master's and assistant's rooms either side.

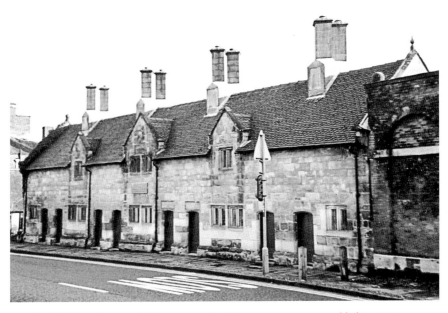

100. Owlfield's almshouses, Ashbourne (*c.* 1620). An upper storey was added in 1848.

Gritstone and limestone houses with plain gabled roofs and low mullion-and-transom windows beneath straight 'label' dripstones remained typical of sixteenth-century Derbyshire manor houses. Babington House, Wirksworth, sitting in the quarry that provided the limestone from which it was largely built – extraction levelling the site at the same time – is an example of a solid local tradition that persevered into the seventeenth century. Emerging architectural features that became popular during the Elizabethan period include projecting oriel windows, cantilevered out from an upper floor main room (fashionable examples were added to light the long gallery at Haddon Hall around 1600), and oak panelling, commonly carved to look like pleated cloth, a style now called 'linenfold' but known to the Elizabethans as *lignum undulatum* ('wavy woodwork').

What arguably made the greatest impact on the architecture of the period was the introduction of brick, which enabled innovations even in areas where the prevalence of stone ensured that tried and tested traditions continued. There was no standard size, but in general Tudor bricks were smaller than modern equivalents (around 9 x 4½ x 2 inches). Although bricks were imported from the Low Countries – the lands around the low-lying delta formed by the Rhine and Meuse, where a tradition of brick building was already established, many merely shipped as an expedient ballast cargo by merchant vessels – a small-scale local industry soon thrived. Most areas have suitable clays, and bricks were made on site. Local mineral variations and controlled firing produced a range of terracotta

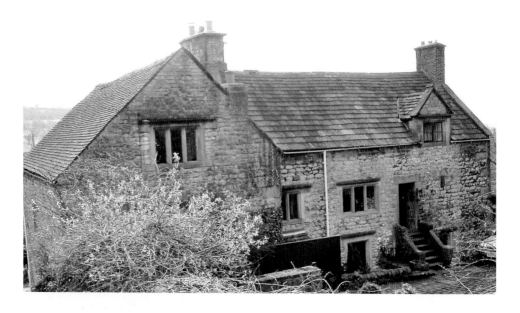

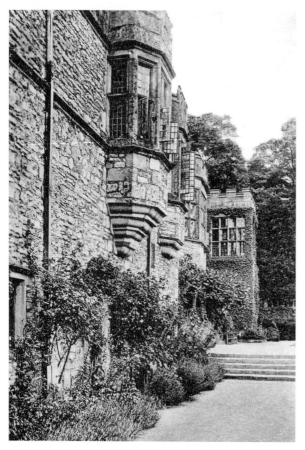

Above: 101. Limestone quarried to level the site was used to build Babington House, Wirksworth (*c.* 1630), in a traditional style of coursed rubble, mullioned windows beneath label dripstones, and a plain gabled roof with gabled dormers.

Left: 102. Newly fashionable oriel windows were added (*c.* 1600) to light the long gallery of Haddon Hall.

103. Oak linenfold panelling carved to resemble pleated cloth was an emerging feature of Elizabethan period style.

hues from light golden browns to rich red and dark russet tones, as well as blue variations, allowing decorative contrasting patterns. For small batches, simple turf clamp kilns sufficed. Larger quantities required more substantial beehive-shaped clay kilns, enabling repeat firings. Brick was a convenient material for the chimneystacks that were added to timber-framed buildings as newly fashionable fireplaces began to replace open hearths, and also for 'nogging', an alternative infill to wattle and daub between timber struts.

In new properties of a modest scale, the hearth became the principal feature, practically placed between the two main downstairs rooms, in the space occupied in earlier designs by a cross passage. Replacing a through passage and creating a lobby entrance enabled back-to-back hearths to share a single flue, the chimneystack emerging offset from the centre of the roof in line with the doorway, marking the division between the hall/living room/parlour and the kitchen/service area. Among many examples of this house plan are Lower Street Farm, Doveridge (*c.* 1525); Olde House, Town Head, Eyam (*c.* 1615); and Old Hall Farm, Youlgreave (*c.* 1630). The Thack, Riddings, a thatched and rendered sixteenth-century building with exposed chamfered beams inside, was renamed the Moulders Arms around 1800 when the local ironworks began to dominate village life, but it is still affectionately known to regulars by its original name. It

has an offset stack typical of an early lobby-entrance house, supplemented by
later additions at the gables. By the close of the seventeenth century, fireplaces at
each end of rectangular buildings, with stacks rising at the gables, were standard.
This design was adopted for the Seven Stars, Riddings (1702), almost opposite
the Moulders Arms, and supposedly on the site of a chapel of ease. The practice
of party-wall fireplaces was adopted from the mid-seventeenth century when
Continental-style terraced cottages were introduced. The so-called 'plague
cottages' at Eyam are a period example.

As a basic domestic building material, brick took time to become popular
despite its obvious practical advantages. Bricks are relatively cheap to produce,
convenient to handle, exceptionally durable, and fire-resistant, an important
advantage in towns where close-packed dwellings were tinderboxes of timber and
thatch at constant risk from a chance spark. As bricklaying techniques developed,
they enabled houses to be built higher and with more spacious rooms. The oldest
surviving brick building in Derbyshire is John Overton's tower, built as personal
lodgings after Overton's appointment as Prior of Repton in 1437, when it would
have presented a dominating presence, flamboyantly different and fashionable for
its time. Corbelled turrets at the angles and billet cornice detailing demonstrate

104. Old Hall Farm, Youlgreave (*c.* 1630). A typical well-to-do Derbyshire farmhouse and
granary of coursed limestone with gritstone dressings and mullion-and-transom windows
with label dripstones, a graded stone slate roof, and raised gables with kneeler blocks. A large
off-centre chimneystack indicates a lobby-entrance design plan.

105. Moulders Arms, Riddings, a thatched and rendered sixteenth-century building with raised gables and kneeler blocks. A chimneystack slightly offset from the centre of the roof marks a shared flue between two downstairs rooms. Stacks at each gable end – a popular arrangement from around 1700 – are a later addition.

106. By 1702, when the Seven Stars, Riddings, was built, it was standard practice to place fireplaces at each end of a building, with stacks rising at the gables.

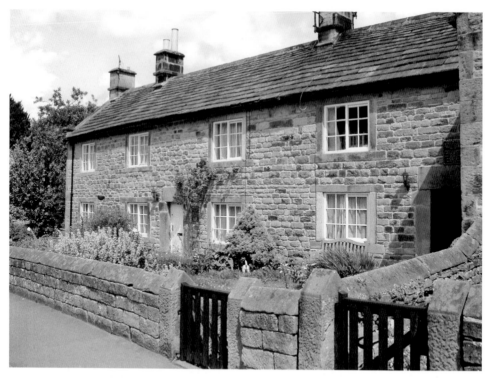

107. Seventeenth-century cottages at Eyam of coursed rubble with stone slate roofs and party-wall fireplaces.

the eye-catching possibilities of brickwork. Overton's tower, now part of Repton School and somewhat lost in the centre of a range of later buildings, is one of the few survivals of the priory's dissolution. Fifteenth-century brickwork at Barton Hall, Barton Blount, has largely been replaced over the years and its gatehouse has been sheathed in stone.

Among a variety of brick-bonding techniques (regular patterns of laying bricks to expose either the long face or 'stretcher', or the end of the block, known as the 'header'), the most common are Flemish Bond (alternate headers and stretchers in each course), English Bond (alternating courses of headers and stretchers), and Stretcher Bond (stretchers only in every course). Stretcher Bond is a relatively recent method, introduced along with cavity-wall and wall-tie construction methods. Bricklayers constructing a wall with a single brick skin in earlier periods often used 'snap headers' (i.e. cut bricks) to maintain the appearance of a double-skin bond. A regular pattern of laying bricks not only gives an attractive appearance, it also provides strength and stability.

The decorative potential of brick found expression in intricate chimneys. At Hardwick Hall, and its near contemporary Barlborough Hall, the chimneys rise discreetly from flues concealed in internal walls. Tall spiral-pattern chimneys using

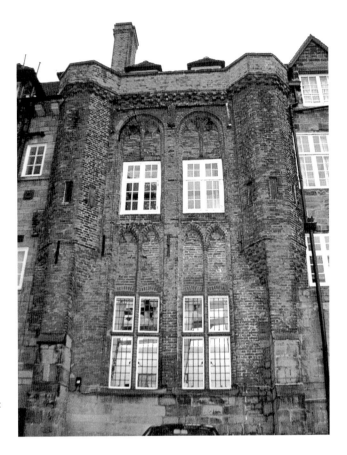

108. Prior John
Overton's tower,
Repton (1437)
– now at the centre
of a later range of
buildings forming
part of Repton
School – is the oldest
brick building in
Derbyshire.

carved and shaped bricks laid in inventive patterns and crowning solid projecting
stacks are more typical of the period. Chimneys advertised the presence of
fireplaces, still something of a luxury in sixteenth-century Derbyshire, and offered
an obvious way to flaunt wealth and status. Original Tudor-period octagonal pots
on brick stacks with stone quoins still rise above the south front of a largely
rebuilt Longford Hall.

Increasing wealth among an elite – many of them *nouveau riche* – coupled with
unprecedented domestic stability, gave rise to ever grander houses. Pretensions
to military style began to be dropped, and in the latter part of the sixteenth
century we begin to see the origins of the great country house of later periods.
A display of hospitality was essential to social prestige. Money was poured into
so-called 'prodigy' houses. Low-pitched or flat, concealed roofs – an invention of
Renaissance Italy that became a defining feature of English Perpendicular Gothic
church architecture – became increasingly popular in secular designs for grand
houses of the sixteenth and early seventeenth centuries, including at Hardwick
Hall and Tissington Hall.

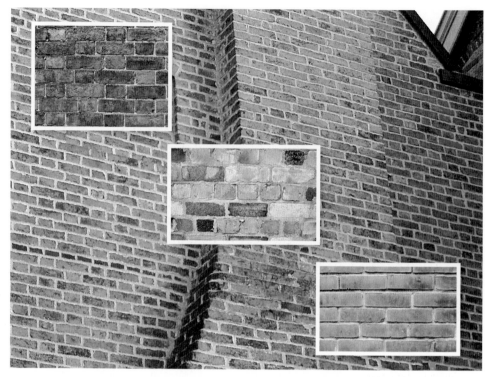

109. Brick-bonding techniques provide strength and stability as well as having an attractive appearance. Common bonds include Flemish (top left), English (centre) and stretcher (bottom right).

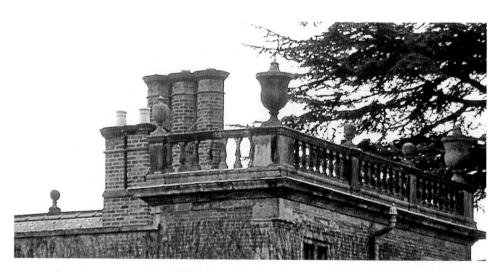

110. Prominent octagonal-brick Tudor-period chimneystacks at Longford Hall.

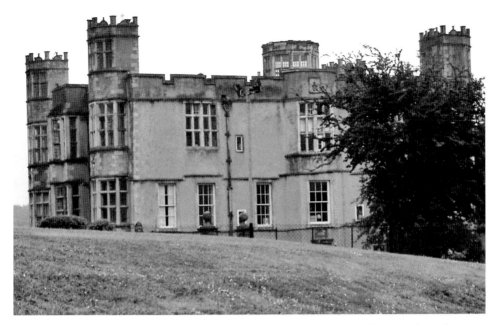

111. Barlborough Hall, built for Sir Francis Rodes, probably to plans drawn up by Robert Smythson (1583). Unusually for the Elizabethan period, the house is square in plan, and the chimneys rise inconspicuously from flues concealed in internal walls. The original windows (some were altered in the early nineteenth century), including bays in the canted three-storey towers at the angles and those in a cupola, are mullion-and-transom design.

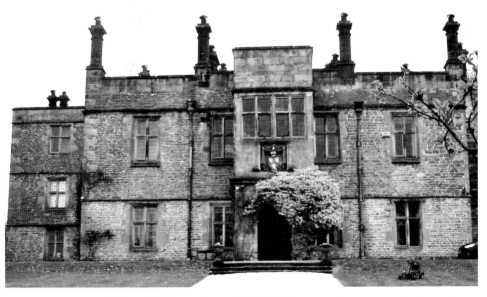

112. Tissington Hall (*c.* 1619). Flat roofs concealed behind a parapet became popular for grand country houses in the sixteenth and early seventeenth centuries.

Curved 'Dutch' gables with a crowning pediment were the height of Jacobean fashion. An example survives on the much-modified façade of what is now Ryan's Bar in St Peter's churchyard, Derby. The style was used to good effect by John Smythson (d. 1634) and his successors when they built the terrace and riding house ranges of staterooms for Sir William Cavendish at Bolsover Castle in the 1630s. Cavendish's father, Sir Charles, had begun to create a medieval fantasy at Bolsover in 1612, using architecture to summon a fairytale vision of chivalry and romance. Stepped gables, fashionable elsewhere, never really caught on in Derbyshire. A rare example of the style can be seen above a former gateway in the grounds of Risley Hall, where the individual 'steps' are crowned with ridge-backed copings.

The Jacobean House on Derby's Wardwick (restored in 1974) is an example of a seventeenth-century town house in brick, with stone dressings and mullioned windows. This was home to the wealthy Gisborne family (who were later to commission designs for St Helen's House from Joseph Pickford). What remains today is only a fraction of what was originally a much grander house. Three bays were demolished to make way for Becket Street in the 1850s. An arched passage, through which coaches once thundered into the Gisborne stables, has been enclosed, and the entrance converted into a window.

113. Curved Dutch gable, Ryan's Bar, Derby.

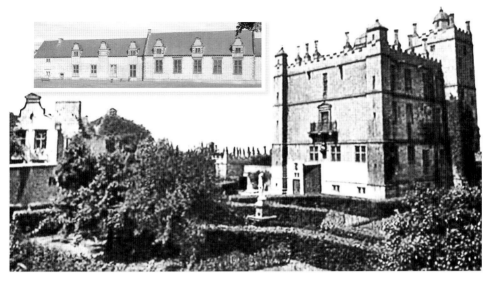

114. The dormers of a riding house (inset) and the gables of a separate terrace range (now roofless) – both built at Bolsover Castle in the early seventeenth century – feature pedimented Dutch gables.

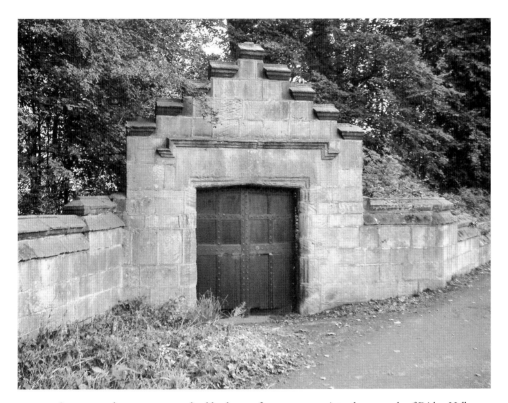

115. A seventeenth-century stepped gable above a former gateway into the grounds of Risley Hall.

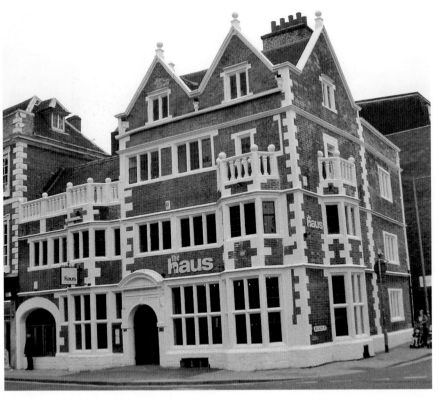

116. The Jacobean House, Derby – a seventeenth-century town house in brick with stone dressings and mullion windows. It was rebuilt to make way for Becket Street in the mid-nineteenth century.

Hardwick Hall, built for Elizabeth Talbot, Countess of Shrewsbury, but better known as Bess of Hardwick, is the epitome of a prodigy house. The architect was Robert Smythson (1535–1614, father of John Smythson), the pre-eminent practitioner of his time, but Bess was a knowledgeable and 'hands on' client, involved in every aspect of design and construction. After separating from her fourth husband, George Talbot, 6th Earl of Shrewsbury, Bess had returned to live in her old family home, a piecemeal development of rooms and ranges and now a shell known as Hardwick Old Hall. Work on the new hall began close by the existing house in 1590, the year Bess was widowed for a fourth time. After Queen Elizabeth – an equally strong, intelligent, and independent individual – Bess was the richest and most important woman in England. Hardwick Hall illustrates how effective architecture can be in proclaiming power and status. The initials 'ES' are repeated fourteen times on the parapet. Hardwick is all about show. There are no inward-looking courtyards and no gatehouse – the house looks proudly outwards. Use of glass, a rarity even in royal palaces a generation earlier, was becoming more widespread. Casement windows were hung within iron frames

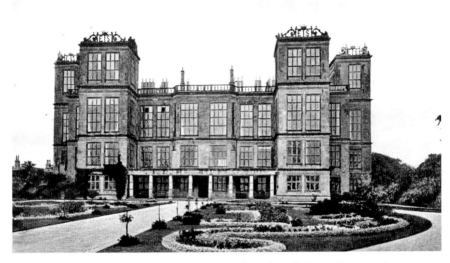

117. Hardwick Hall (1590), the ultimate 'prodigy house', is all about show and demonstrates how effective architecture can be in proclaiming power and status. The initials of Elizabeth Shrewsbury ('Bess' of Hardwick) are repeated along the parapet.

by simple hook-and-eye or 'peg' and 'pintle' mechanisms, glazed with small, square or diamond-shaped 'quarries' held by lead strips called 'cames', and wired into wrought iron frames. But glass was still an expensive luxury. At Hardwick, glass dominates. 'Hardwick Hall, more glass than wall,' as a famous old rhyme says. Huge mullion-and-transom windows, like jewels in a setting of golden stone, create a sea of glass that floods the interior with light. From outside, the symmetry and even spacing of the windows (some of which are false and front interior chimneypieces) disguise the layout of the rooms, and give the impression of a house larger than it really is. Hardwick essentially has eight main rooms and a number of private closets. Small rooms or closets, perhaps furnished with a desk and chair and affording a private retreat from the bustle of noisy houses, became increasingly fashionable in the seventeenth century. One influential architectural manual of the period recommended that all principal upstairs rooms should have a closet attached. A significant driver of this change was reform of the Church that had made English Bibles available for all to read. The Authorised Version of 1611 (the King James Bible), advocated 'true Christians' withdrawing to their closets for prayer and meditation twice each day, a practice known as 'closet duty'.

Hardwick Hall reflects both innovative architectural style and significant social change. Medieval hall houses, with their entrance through a screens passage dividing hall and smaller service area, were asymmetrical by design. Built to an H-plan with a long gallery on the upper storey, regularity was achieved at Hardwick by turning the hall at right angles and relegating its importance to a grand two-

storey entrance. Service rooms were accommodated on the ground floor. Bess received guests and entertained on two upper storeys, conducting official business from her Great Chamber on the second floor, and dealing with family matters and more informal affairs from a Low Great Chamber on the first floor. Both Great Chambers were connected to separate withdrawing rooms for everyday use. A grand, sweeping staircase hung with tapestries led to her ladyship's rooms, and a curve in the flight added to the processional ceremony of a visit by concealing Bess' presence until the last minute. In a medieval hall, the solar was more likely to have been accessed by a ladder or a spiral staircase set around a central newel post. Because the rooms were for private use only, a monumental approach was pointless. At Hardwick, the stairs reflect a newly emerged social prominence for the upper floors of a grand house – the beginning of a social distinction between 'upstairs' and 'downstairs'. It is during the Elizabethan period that the joinered timber staircase, now commonplace, first makes an appearance. The hall, once the main room, now served merely as the entrance. This arrangement is still with us in most modern houses.

E- and H-shaped house plans were ideal for incorporating that Tudor invention, the long gallery, a room that superseded the medieval hall as the social centre of a grand house. The long gallery was where family portraits were hung, guests were entertained, music and games were played, and where the ladies of the house exercised in bad weather.

Personal withdrawing rooms, private closets, and the novel idea at the time of a personal bedchamber, made for a new degree of privacy, but life at Hardwick Hall was still intimate. A large domestic staff lived in close proximity with their mistress. Bess's main attendant probably slept at the foot of her bed, other servants

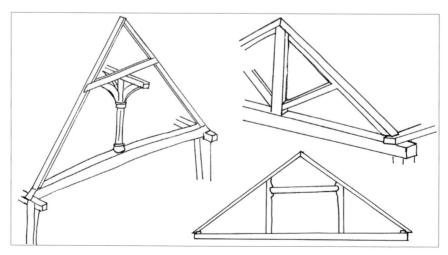

118. Types of roof truss construction: crown post (left), king post (above right) and queen post (below right).

on straw mattresses spread out on the great staircase – close at hand if needed in the night. Servants were still effectively part of the family. The sons and daughters of minor gentry often filled senior domestic positions. Bess herself started work aged eleven, as a servant in the household of Sir John and Lady Zouche at Codnor Castle. In a major social shift, this close and cosy master–servant relationship was about to change. The end of the communal great hall followed a few years later at Tissington Hall (*c.* 1610) and, on a smaller scale, in the three-storey tower-style North Lees Hall, near Hathersage (a manor house of around 1600, fictionalised by Charlotte Brontë as the house from which Mrs Rochester leaps to her death in *Jane Eyre*). The division of existing manor houses into upper and lower storeys began a trend that saw domestic staff go from a position of deferential familiarity to mere skivvies. This transformation found architectural expression in roof construction. Medieval halls had roofs in which a central post set into a tie-beam supported either a longitudinal ridge beam or a central purlin. From the fourteenth century, these were either 'crown post' roofs with radiating braces supporting a purlin and a collar secured between the principal rafters, or 'king post' roofs reaching from tie-beam to ridge with supporting struts. Making use of attic space created by adding storeys solved the question of where servants would sleep once the barrack room possibilities of the open great hall were eliminated. Crown and king post roofs restricted access in the 'garrets'. The solution was the development, in the late sixteenth century, of 'queen post' arrangements. Queen post design provided a central aisle, creating a more usable space and allowing servants to sleep in the eaves. Servants were now banished to their own mean quarters, out of sight unless needed.

O SWEET FANCY! LET HER LOOSE
Renaissance, Baroque and the Derbyshire Country House (*c.* 1640–*c.* 1730)

In the sixteenth century, the designs of Italian architect Andrea Palladio (1508–80) became a significant influence throughout Western Europe. Palladio recreated the style and proportions of classical Rome, introducing key elements from imperial temple architecture – including triangular pediments, smooth external surfaces (frequently stuccoed, and painted white or in a pastel shade), flights of stairs leading to grand entrances, open colonnades known as 'loggias', and semicircular Diocletian windows – into domestic Italian villa and palace designs. Palladio favoured plain, uncluttered pediments, but the decorative possibilities of this feature inspired others to creative adaptations, such as scrolling, curving (either 'segmental' or 'round'), and 'broken' (i.e. incomplete at the top or bottom) pediments. The theories underpinning the use of the main 'orders' – a complex set of rules governing the composition of various structural elements in Ancient Greece (Doric, Ionic and Corinthian) and Italy (Roman Doric and Tuscan) – were rediscovered and put to use. The relatively plain Doric and Tuscan orders were associated with strength, the Ionic order with refined elegance, and the more elaborate Corinthian order with beauty. Parapets, in which a series of individual curved balusters with a narrow 'vase' and a fat 'belly' support a rail or 'balustrade', hipped roofs (often capped with a cupola for interior air and light), rustication (where each masonry block was cut back, angling the edges to accentuate joints), projecting dormer windows with their own small gable roof, and arch-topped, Venetian and round *oculus* or 'bull's eye' windows, were inventions of the Renaissance rather than rediscoveries of the classical tradition.

Concessions to Renaissance ornament slowly found expression in Derbyshire as the seventeenth century progressed. Long-established building traditions – for example, protective dripstones, and mullion-and-transom windows – began to disappear. Resistance to change can be attributed partly to conservatism, partly to landlocked provincial insulation from Continental influence, and partly to the

119. Hopkinson's House, Wirksworth (*c.* 1630). The coursed rubble masonry, square-headed doorways and mullion windows could be dated to a century earlier but for the lack of dripstones, the two-storey-plus-attic design, and the single Venetian window on the ground floor.

strong tradition of building in stone. Because the span achievable with a heavy stone lintel is limited, windows required mullions.

Snitterton Hall, South Darley, near Matlock, is an archetypal Derbyshire gabled E-plan manor with mullion-and-transom windows beneath dripstones created by a continuous string course. The original house was rebuilt around 1630, retaining Tudor style, but with Ionic columns flanking a slightly off-centre entrance porch, which added a classical touch. Hopkinson's House, Wirksworth, generally dated by experts to around 1630, could easily be dated to a century earlier, with its coursed rubble masonry, mullioned windows, square-headed doorways and plain gables, but the two-storey-plus-smaller-attic floor design and the lack of dripstones point to a later date. This building was in a derelict state before restoration by the Derbyshire Historic Buildings Trust, which brought it back into use as commercial office space.

Swarkestone Pavilion, built around 1630 and believed to be the work of John Smythson, was the only building left intact when Parliamentarian forces demolished the Harpur family mansion at Swarkestone during the Civil War, punishment for Sir John Harpur's active support for the Royalist cause. Reminiscent in Tudor detail of the Elizabethan 'stand' or 'hunting tower' in

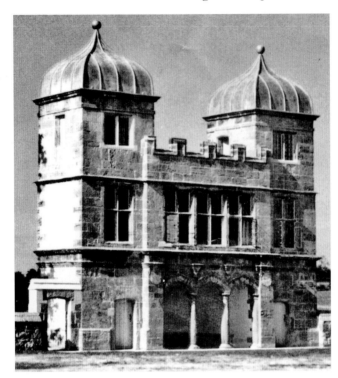

120. Swarkestone Pavilion (*c.* 1630). A pair of three-storey turrets with ogee-shaped caps connected by a classical loggia with Tuscan columns below a battlemented central floor.

the grounds at Chatsworth (by Robert Smythson, John's father), the pavilion at Swarkestone may have been intended as a spectator grandstand for whatever recreational activities took place in the surrounding walled enclosure (deer coursing was a trendy diversion at the time), or for playing an early form of bowls known as 'pell mell'. A battlemented central floor with mullion-and-transom windows links a pair of three-storey turrets crowned with ogee-shaped caps – a characteristic feature of Jacobean-period architecture. On the ground floor, the turrets are connected by a classical loggia with Tuscan columns.

The Peacock Hotel, Rowsley (1652), a traditional Derbyshire house with mullion-and-transom windows, plain gables and a roof of stone flags, has a projecting, embattled porch, drawing attention to an entrance surmounted with a simple semicircular pediment. An equally basic pediment crowns the doorway of the former Elton Hall, built around 1668 and until recently in use as a Youth Hostel. The central gable of the otherwise staid single-storey Sacheverell almshouses at Morley Moor (1656) – with their low, mullioned windows and Ionic pilasters (projecting piers attached to the wall) – supports a triangular pediment framing the Sacheverell family crest.

Eyam Hall, built in the 1670s, is solidly conservative with a plain façade, unadorned gables, concealed roof, and squat, mullioned windows, but pilasters flanking the doorway hint at a growing emphasis on entrances. Buxton's Tudor

121. Sacheverell almshouses, Morley Moor (1656). The traditional Derbyshire design is complemented on the central gable by a classical triangular broken pediment above Ionic pilasters framing the Sacheverell coat of arms.

Old Hall Hotel was originally the town house of Bess of Hardwick and her fourth husband, the Earl of Shrewsbury. Mary, Queen of Scots, stayed here while in the Earl of Shrewsbury's custody, visiting Buxton to 'take the waters' in an effort to relieve her rheumatism. When the house was turned into a hotel in 1670, it was given a contemporary makeover with the addition of a concealed roof, prominent quoins and Tuscan columns beside the entrance.

Etwall stonemason and architect George Eaton remodelled John Port's almshouses in his home village in 1681 in a style that could easily date from their Tudor foundation in 1550. Set around three sides of a courtyard, the two-storey brick building has substantial chimneystacks, small stone-framed mullioned windows, and four-centred flattened arches above individual dwelling doorways. Only an elaborate two-storey central porch topped by a broken, re-curved scroll-type pediment cupping a heraldic shield betrays the later period.

More complete Renaissance touches – including a forecourt (properly a *cour d'honneur*), tall semicircular arched windows (heavy, and incorporating rectangular framed mullions and transoms), scrolling broken segmental pediments above two stone doorcases, and a balustrade parapet (in cast iron but painted to resemble stone) above a moulded cornice, concealing the low hipped roof – distinguish the former county hall, now the magistrates' court centre in St Mary's Gate, Derby. This imposing building by George Eaton, begun around 1660, reflects the increasing availability of architectural pattern books that allowed architects to reproduce classical designs with a high degree of accuracy.

122. Eyam Hall (1675). Plain gritstone, with concealed roof and pilasters flanking the entrance.

123. Old Hall Hotel, Buxton, originally a town house belonging to Bess of Hardwick, was given a makeover in 1670 when Tuscan columns were added to emphasise the entrance.

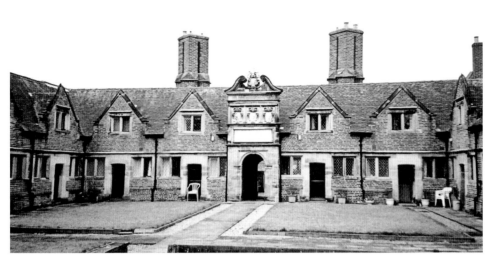

124. John Port's almshouses, Etwall, remodelled in 1681. Without the broken scrolling pediment above the central porch, the design could easily date from over a century earlier, when the almshouses were founded.

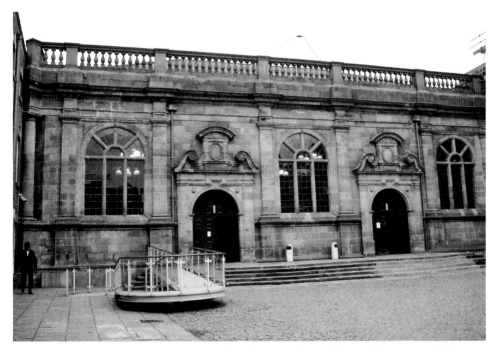

125. Increasing availability of pattern books illustrating classical design elements resulted in more fully realised Renaissance architecture. Derby's magistrates' court centre (*c.* 1660) features scrolling pediments, a hipped roof behind a balustered parapet, and tall arched windows set around a forecourt or *cour d'honneur*.

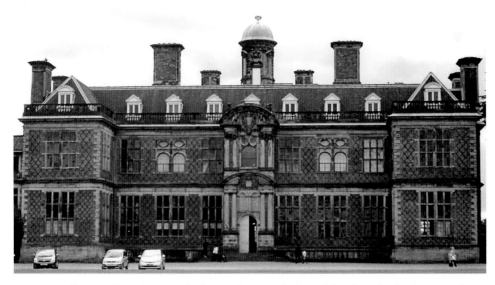

126. Sudbury Hall combines Derbyshire tradition with classical detail. Darker bricks are used to make a diaper pattern.

George Vernon began work on Sudbury Hall in the mid-1660s. The design, for which Vernon himself may be responsible, neatly straddles traditions, combining familiar aspects of grand Elizabethan/Jacobean houses with Italian Renaissance detail, and fashionable brickwork with time-honoured Derbyshire stone dressings. It is built to an Elizabethan E-plan, a ground layout well suited to Renaissance-style symmetry, which demanded a central entrance, using locally made bricks (some from Oaks Green, a hamlet a mile north-west of Sudbury Hall, where there is still a Brickyard Farm) with a decorative diaper pattern picked out in darker hues. Stone quoins reinforce the corners and provide decorative relief. Windows are stone-framed with mullions and transoms. A Renaissance preoccupation with accentuating entrances is confidently articulated. A short flight of steps leads to a two-storey porch with Ionic columns supporting segmental pediments, broken at the base to frame cartouches. A window above the entrance and two flanking first-floor windows, at first glance typically Elizabethan, include Palladian-style arches below oval or circular windows known as *oculi* (from the Latin *oculus*, or 'eye'), which add ornamental interest. The hipped roof with a stone cupola topped by a golden ball finial, the central 'tea caddy' chimneystacks, the balustrade parapet (a wooden parapet was replaced by stone in 1873), and the row of dormers providing light and space for an attic storey are pure Renaissance. A through passage linking north and south entrances operates in exactly the same way as a screens passage in a medieval hall house, here dividing parlour and grand chambers on one side from smaller, informal rooms and servants' quarters on the other, and giving access to a reception area, effectively a modified great hall. On the first floor is an Elizabethan-style long gallery.

Sudbury was built in the years following the Restoration, and its lavish interior reflects the mood of exuberance that replaced Puritan restraint and moderation. The exquisitely decorated great staircase is reminiscent of Hardwick Hall in imparting a processional quality approaching the upper storey great chamber (renamed 'the Queen's Room' in 1840 – Queen Adelaide had leased the hall for three years). Its carved limewood balustrade by Edward Pierce, best known for his collaborations with Sir Christopher Wren, is a riot of swirling acanthus leaves. On the underside, scrolling plaster garlands frame scenes from classical mythology. Elsewhere in the house there is woodwork by the most celebrated carver of the period, Grinling Gibbons.

Sudbury Hall's design idiosyncrasies do not distract from an overall essential unity, cleverly blending established values with George Vernon's desire to reflect sophisticated modern tastes and cultural awareness. In many ways, Sudbury marks a transition in Derbyshire, between the restrained introduction of Renaissance elements, and their free adaptation in what became known as Baroque style.

Unlike many grand houses that sit in splendid isolation, surrounded by parkland, or screened behind encircling walls, Sudbury is part of its village, open to the main street. George Vernon rebuilt the village along with the hall, demolishing existing cottages to improve his view, replacing them in the latest Continental terraced style, utilising party-wall fireplaces. He also added almshouses (1678) and a brick-built coaching inn, the Vernon Arms (1671), with Tudor-style mullion-and-transom windows, sandstone dressings, and decorative chimneys in a local design known as 'midland star'. Further rows of terraced cottages were added in the seventeenth and eighteenth centuries, some with raised coped gables and kneeler blocks.

Sudbury was a 'closed' village, occupied by agricultural workers and servants who depended on the estate for their livelihoods and who were required to play their deferential part. Country houses operated as corporate headquarters, servants merely part of the machine. A strict social hierarchy ruled, reinforced by architecture. Landed estates had become big businesses. The scale of the changes taking place in country houses is demonstrated in bold style at Chatsworth House, remodelled between 1688 and 1702 by Bess of Hardwick's great grandson, William Cavendish, Earl of Devonshire (1640–1707). Cavendish was among a small group who planned the Glorious Revolution that replaced James II with his daughter Mary and her husband William of Orange in 1688. The plotters met in the Cock and Pynot Inn, Whittington, Chesterfield (a 'pynot' is a local dialect word for 'magpie'), originally a typical sixteenth-century thatch-roofed Derbyshire stone house, one of a number clustered around the village green at Whittington, with two small rooms downstairs (a hall/living room and a parlour) and a tiny chamber above. Heavily restored, it is now Revolution House museum. Cavendish's reward for his leading role in ensuring the succession of William and Mary was his social status as one of a favoured inner circle of courtiers, and in 1694, a dukedom.

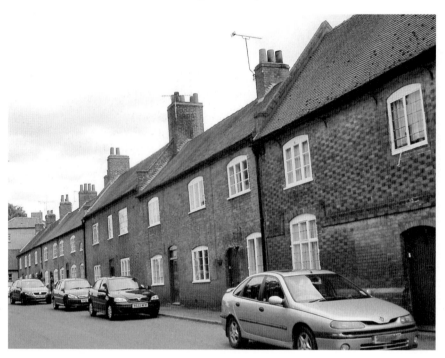

127. Brick-built terrace with party-wall fireplaces. Part of the Sudbury estate.

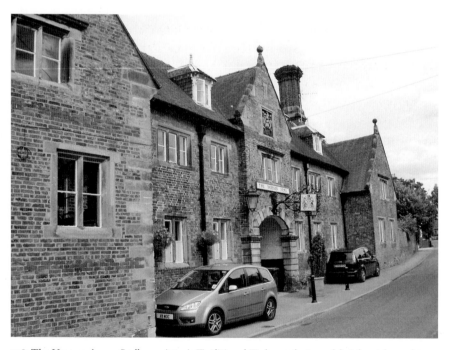

128. The Vernon Arms, Sudbury (1671). Traditional Tudor style in red brick with sandstone dressings and an elaborate chimneystack of local 'midland star' design.

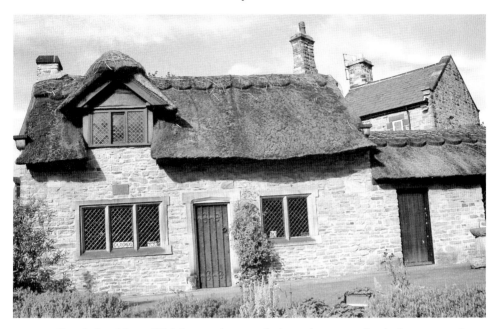

129. Revolution House, Whittington. A restored sixteenth-century thatched cottage and former inn of roughly coursed rubble.

At Chatsworth, William Cavendish had inherited a large mid-sixteenth-century quadrangular house with a central courtyard. Working with one of the pioneer architects of English Baroque, William Talman (1650–1719), he began the realisation of a country house of exceptional ornamental exuberance by rebuilding the south wing, incorporating what was essentially a home-from-home palace suite of state apartments in preparation for a visit by William and Mary. A new east wing, converting what had been the Elizabethan long gallery into a library, followed. After arguing with Talman, Cavendish turned to another leading Baroque architect, Thomas Archer (1668–1743), for technical expertise and assistance in completing the main west front and a north wing (since extended).

Having inaugurated a political revolution, it was almost as if Cavendish set about creating a revolution in architecture. Chatsworth brought new grandeur and flair to the country house, taking the Renaissance pattern book and applying its motifs without inhibition, adding entirely novel design touches. The central courtyard of the Elizabethan house was retained and a flat roof was preferred to the then-fashionable hips. A basement floor, hardly visible on the east side but forming a proper ground floor to the main west wing, solved the problem of a sloping site. Rustication of this bottom storey visually anchors the building and conveys an impression of sturdy solidity. Elsewhere, all is drama. Giant (a term applied where features extend beyond a single storey) fluted Ionic pilasters unifying the two upper storeys are crowned with a characteristic Ionic entablature of architrave,

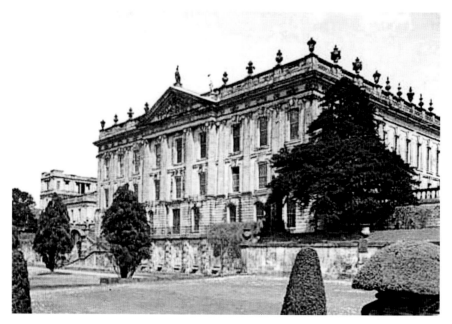

130. The main west front at Chatsworth House (*c.* 1698). A rusticated basement anchors the building. Giant Ionic pilasters unify the two upper storeys.

sculpted frieze, and a cornice bearing projecting square blocks or 'dentils'. Above a balustered parapet rises a series of enormous Greek urns. Stairs (originally horseshoe-shaped but since replaced with the present angular approach) lead to the main entrance on the west façade, where four giant Ionic columns support a richly decorated triangular pediment. Prominent 'dropped' (i.e. extending below lintel level) keystones highlight the window heads. Innovations at Chatsworth included flushing water closets, albeit of rudimentary design, and sash windows, a recent invention featuring a pulley mechanism concealed within a wooden box frame that allowed the window to slide up and down. Sash windows tend to be more upright than casement windows, vertical rather than horizontal rectangles (a profile accented at Chatsworth by the oversized, dropped keystones), and give a radically different appearance to buildings. Thick glazing bars are characteristic of the earliest sash windows. As glass quality improved and larger panes became available, glazing bars became progressively slimmer.

The scale of Chatsworth House was unparalleled. Where Hardwick Hall has just eight main rooms, Chatsworth boasts more than 120. Staterooms were equipped with anterooms and withdrawing rooms, forerunners of the domestic Victorian drawing room. Guests processed through a range of spaces, each more splendid than the last, before reaching the social centre of the house. New rooms such as the salon, the dining room and the library, which had not existed a century before, were introduced. Their use was defined by strict rules of etiquette. Social

graces had become increasingly nuanced, and Chatsworth's design reinforced this more mannered lifestyle.

Gardens were an integral part of the Baroque country house. Conceived as a series of outdoor 'rooms', glades and wooded groves provided escape from the formality of social proprieties. They were places of recreation and rendezvous, entered through a new invention, the French window. The 1st Duke of Devonshire spent as much time on the layout of his grounds as on the design of his house. The accession of William of Orange had triggered interest in the latest Continental garden fashions – water features and topiary. With the Chatsworth Cascade, the Duke of Devonshire created the finest water feature in England. At Melbourne Hall, Thomas Coke ambitiously chose the gardens surrounding the Palace of Versailles as his model. He added a pool, fountains, a yew tunnel, and lead statuary in sculpted yew niches. The focal point was a masterpiece of Baroque ironwork, the Birdcage Arbour by Derby-based ironsmith Robert Bakewell. Long rides provided scenic views from the east terrace.

For the medieval peasant, a small piece of land – a 'croft' attached to his 'toft' or cottage, independent of any agricultural strips held in a communal open field – was an opportunity to cultivate vegetables, herbs, soft fruit, and perhaps to keep a few hens or a pig. Monasteries had practical kitchen and 'physick' gardens supplying food and medicine. Recreational gardens were always the preserve of a rich elite. Castle courtyard gardens were filled with roses and herbs. Orchards and nutteries were tended as much for blossom as produce. Tudor pleasure gardens had outdoor dancing grounds with turf or camomile seats, and rose-covered trellises for shade. Turf and hedge mazes became popular. The Elizabethans used clipped box, rosemary or thyme to form 'knot' gardens, building artificial mounts as viewing platforms from which to observe the intricate patterns created. Gardens have suffered more than buildings from the vagaries of fashion. Constant makeovers have left few reminders of earlier styles. Haddon Hall escaped later landscaping fads and its Tudor garden layout has survived in part. Elsewhere there have been valiant attempts at recreating past glories, but little original has endured of early garden forms in Derbyshire.

After becoming the 4th Earl of Harrington in 1829, Charles Stanhope poured resources into landscaping 200 acres surrounding Elvaston Castle. His father had wanted 'Capability' Brown (1716–83) to do the work. After being turned down by Humphry Repton (1752–1818), who thought the flat, waterlogged ground made the site too difficult, Stanhope commissioned William Barron (1805–91). In the following two decades, Barron built a reputation as one of the best landscape gardeners in the country. He created at Elvaston an instant woodland and pinetum using pioneering techniques to transplant mature trees, installed complex but efficient drainage, and added a lake, themed gardens, rockeries, and spectacularly inventive topiary. Dotted about the park were various follies in Moorish style, and an assortment of romantic grottoes. Elvaston's gardens were a very private pleasure,

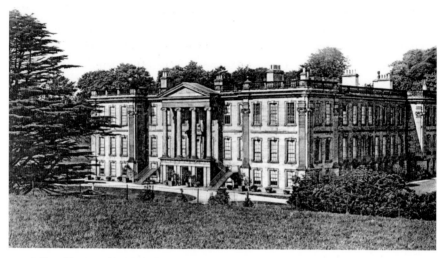

131. Calke Abbey (1701) is built on the same epic scale as Chatsworth House, but without an equivalent level of decorative embellishment.

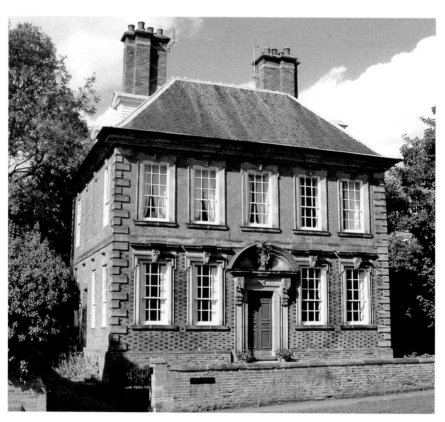

132. Latin House, Risley (1706). Renaissance with Baroque flourishes and featuring box sash windows.

a theatrical outdoor stage setting contrived for the enjoyment of Stanhope's wife, Maria Foote, a former actress. The 4th Earl's instructions were that no one was to be allowed into his garden uninvited with the single exception of Queen Victoria herself, should she ever visit. His brother reversed this approach after Charles' death in 1851. Following its joint acquisition by Derbyshire County Council and Derby Borough Council in 1969, Elvaston became a country park open to the public.

Calke Abbey was built for Sir John Harpur between 1701 and 1703 to replace the family mansion at Swarkestone, destroyed during the Civil War half a century earlier. In many ways Calke imitates Chatsworth House, but without the finishing flourishes. It is built on the same epic scale, and on the footprint of an earlier quadrangular building with a central courtyard. The low ground floor mimics the basement storey at Chatsworth. Behind a plain balustrade parapet is a flat roof. Window heads feature projecting dropped keystones. Giant Ionic pilasters are used, but not in the same profusion as at Chatsworth House and in a foreshortened form without the all-round decorative frieze. A loggia with four Ionic columns and a triangular pediment, echoing the west front at Chatsworth, is a late Georgian addition.

On a smaller scale, Latin House at Risley, built in 1706 as a school, exemplifies the adoption of a purer Renaissance style with its square plan, symmetrical elevation, basement, two storeys and garrets, hipped tile roof, decorative brickwork, rusticated quoins, and boxed sash windows. Yet there are still Baroque flourishes. A segmental pediment, lavishly decorated with acanthus leaves, is broken at the apex to display a carved bust, and rests on curved brackets known as consoles. Window architraves have protruding 'ears' at the upper corners, and window heads feature prominent keystones with sculpted faces. Stone dressings add a dash of Derbyshire flavour.

Stone frames typical of casement windows in Derbyshire were designed to fit flush, forming part of the wall. Wooden box-framed windows containing the sash mechanism followed suit until the increased fire hazard of flames leaping from window to window along the outside of a building was recognised. An ordinance requiring window frames to be set back in their reveals was passed in London in 1709 and the practice was adopted locally soon after.

6

An Elegant and Pregnant Texture
Georgian Derbyshire I (1715–1837)

The 1701 Act of Settlement ensured George, Elector of Hanover, succeeded Queen Anne, sister to Queen Mary and last of the Stuart monarchs, in 1714. Architecture in Georgian Derbyshire continued to be heavily influenced by Renaissance ideas and from the mid-eighteenth century by an increasing awareness of the structural design precedents of Ancient Greece. The 'Grand Tour', a Continental excursion that became an essential part of every gentleman's education, expanded cultural references, exposing the gentry to the treasures of antiquity and the splendours of European Renaissance architecture. Meticulous surveys of ancient buildings were undertaken, and accurate engravings published. Greater attention was paid to the strict theories of balance and proportion insisted upon by Italy's Renaissance master Andrea Palladio, which were rooted in the design principles of Marcus Vitruvius Pollio, engineer and architect of first-century BC Rome. This scholarly intellectual interest led to a purer adoption of classical architectural elements in new types of building, creating a style now referred to as Neoclassicism. It was as inventive and diverse as Baroque, but more restrained, and with more attention paid to form, scale and clean lines.

Although full emancipation for Roman Catholics was not conceded until 1829, support in Parliament was strong and growing from the late eighteenth century. In tune with the national mood, the Roman Catholic Eyre family of Hassop commissioned a private church from architect Joseph Ireland. Completed in 1818, the church is a scrupulous recreation of a classical Etruscan Temple, reminiscent of Inigo Jones' design for St Paul's church, Covent Garden. Four Tuscan columns form an impressive entrance portico. As lords of the manor for over three centuries, the Eyres' influence had ensured the inhabitants of Hassop were predominantly Catholic.

In the mid-eighteenth century, a Protestant sect from Moravia, in what is now part of the Czech Republic, was invited by Ockbrook farmer Isaac Frearson to escape religious persecution in their homeland by moving to Derbyshire.

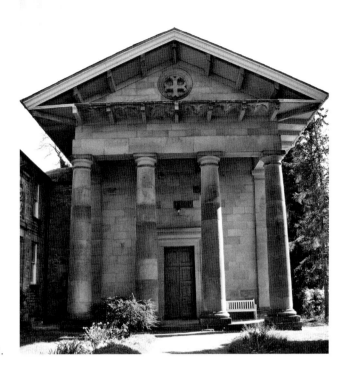

133. Tuscan columns form an impressive portico at All Saints' and English Martyrs' Roman Catholic church, Hassop (1818).

A settlement was established at Ockbrook in 1750. As a community, the Moravians were well-organised and self-sufficient. Individual members led austere lives. Single men and women were segregated. Over time, social life in the enclave changed and modernised, but the compact orderliness, neat spacious layout and simple elegance of the architecture echoes the sober formality of the settlement's founding principles. A red-brick chapel at the heart of the community is domestic in style and far removed from the buildings of the established Church. Round-headed windows have brick arches with central keystones and stone brackets. The low-pitched Welsh slate roof is surrounded by a stone-coped brick parapet and crowned with a cupola; a clock has been inserted into a plain, stone-edged, triangular pediment.

James Gibbs (1682–1754) studied in Rome. His subsequently published *A Book of Architecture* was instrumental in popularising authentic Palladian features, including the Venetian window – in which straight-headed side lights flank a taller central round-headed light, proportioned so that the overall width of the window matches the height – and the semicircular Diocletian window (named after an example found in Diocletian's thermal baths in Rome), divided by two mullions. These window styles were regularly used in combination, as in the early to mid-eighteenth-century brick frontage of the Red Lion, Wirksworth, a former coaching inn, and in the Mansion House, Church Street, Ashbourne, a late seventeenth-century house given a new Georgian façade in

134. The Moravian chapel, Ockbrook (*c.* 1760). Simple classical elegance in red brick with a cupola and low-pitched roof.

the 1760s, incorporating straight-headed gauged brick window heads. Specially manufactured soft bricks capable of being 'gauged' (that is, cut or rubbed into precise shapes), along with stone wedge lintels, were an emerging feature of window heads from the mid-eighteenth century. Gauged bricks can be fashioned to fit with such accuracy that little mortar is required and pointing lines are typically fine, although gauged, vertically-laid lintel bricks often carry scored lines that can be pointed to realistically replicate bonding.

Gibbs introduced a form of door and window surround that alternated large and small – or projecting and flat – masonry blocks. So frequent was his use of this motif that it has become known as a 'Gibbsian surround'. Examples adorn All Saints' Cathedral, Derby, rebuilt by Gibbs between 1723 and 1725. Gibbs added a single-storey nave and chancel with tall semicircular arch-topped windows to the existing three-stage 212-foot-tall Perpendicular Gothic tower of 1510–30, the tallest church tower in Derbyshire and originally worked on by the mason responsible for King's College, Cambridge. A Venetian window inserted by Gibbs at the east end of the chancel was removed when the chancel was extended in 1967.

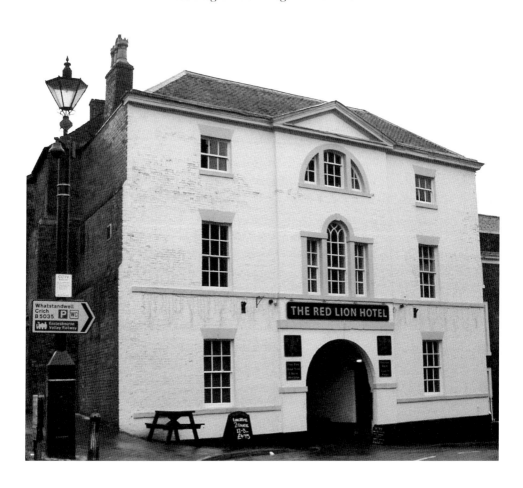

Above: 135. The Red Lion Hotel, Wirksworth, combines a first-floor Venetian window with a Diocletian attic window.

Right: 136. Mansion House, Ashbourne. A late seventeenth-century house given a Georgian facelift in the 1760s with a Tuscan porch, a Venetian and Diocletian window combination, a triangular pediment, a dentilled cornice, a parapet, and straight window heads of gauged brick.

137. All Saints' Cathedral, Derby, rebuilt by James Gibbs between 1723 and 1725. Gibbs added a new chancel (since extended) and a spacious single-storey nave to the existing early sixteenth-century Perpendicular Gothic tower. Arch-topped windows have trademark 'Gibbsian' blocked surrounds of alternating projecting and flat masonry.

Robert Adam (1728–92), the pre-eminent architect of the latter half of the eighteenth century, also studied diligently and widely in Europe, paying particular attention to the domestic architecture of the classical world. This grounding enabled him to apply the grammar of Neoclassicism with authority and ingenuity. Adam's virtuoso style is finely displayed at Kedleston Hall, which Adam played a major role in completing for Sir Nathaniel Curzon (Lord Scarsdale) in the 1760s, modifying a Palladian north front by Matthew Brettingham and James Paine that was already under construction, and designing a more adventurous south front. Both feature Corinthian porticos supporting pediments above a rusticated basement storey. From Adam's south front, the arms of curving entrance stairs reach out to the visitor in an embrace. Perfect proportions, based on cubes and circles, and a delicate entablature invest Kedleston Hall with a liquid, weightless grace. In common with Sudbury (and as would happen at Chatsworth with Edensor in 1838), an existing village was swept away to improve the view, leaving only the parish church of All Saints. Unlike Sudbury, where new cottages were huddled protectively alongside the hall like a chicks around a mother hen, Curzon took the opportunity to extend family privacy, surrounding his house with a great landscaped park, and tucking the replacement cottages out of sight, one mile distant.

138. The north front, Kedleston Hall (*c.* 1768). Designed by Matthew Brettingham and James Paine but modified by Robert Adam. Above a rusticated basement, Corinthian columns support a triangular pediment.

Joseph Pickford (1734–82) served an apprenticeship with his uncle, William Kent, an established and highly respected London-based architect, before moving to Derby. One of his first tasks in the local area was the completion of Foremark Hall for Sir Robert Burdett, following the sudden death of the building's designer David Hiorns in 1759. In London, under the influence of his uncle and other leading Neoclassicists, Pickford was instructed in the Palladian tradition. Foremark Hall (now a preparatory school) has a hipped roof, canted bays at the angles topped by cupolas, and a balustered parapet. Twin stairs lead from the drive to an entrance with a triangular pediment above a rusticated basement. Pickford secured his reputation as one of Derbyshire's finest architects with a series of Palladian-style buildings, including the following: Derby's old Assembly Rooms, largely destroyed by fire in 1963, leaving only the façade, subsequently rescued and moved to the National Tramway Museum, Crich; Grey House, Church Street, Ashbourne (1760s), a stone-faced brick building with Roman Doric porch, original fanlight, first floor Venetian and attic floor Diocletian window combination, a concealed roof behind a part-balustered parapet, dentilled eaves, canted side bays, a pedimented central bay and brick stables next door (now converted as living accommodation); St Helen's House, King Street, Derby; and his own home at 41 Friar Gate (now a museum), built on a plot of land made available by an Enclosure Act of 1768 that led to the development of former common land known as Nuns Green into a fashionable residential suburb.

Joseph Pickford built St Helen's House (at the time surrounded by 80 acres of parkland) in 1767, for local landowner and MP John Gisborne, one of the wealthiest

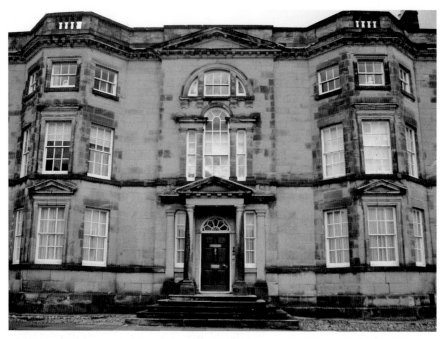

139. Grey House, Ashbourne (*c.* 1765), by Joseph Pickford, has a Roman Doric porch, Venetian and Diocletian windows, dentilled eaves, and a roof concealed behind a part-balustered parapet.

men in Derbyshire. Arcading on the ground floor – rusticated in the central three bays – frames sash windows and an entrance with a transom light (a rectangular fanlight). Ionic columns support a dentilled triangular pediment to form a central portico unifying the first and attic floors. Between the columns, a pair of triangular pedimented windows complements a central window with a segmental pediment.

The three-storey design of Pickford's House at 41 Friar Gate is typical of Georgian town houses from which those in the professions, commerce and industry conducted business. Until Turnpike Trusts began to make significant improvements in the late eighteenth century, Derbyshire's roads were often impassable quagmires in winter. Travel was tedious and unpredictable. Of necessity, people lived 'over the shop'. Generally the ground or 'rustic' floor was where customers were received and business managed, hence the need for a conspicuous entrance that set the tone and made the right impression. Social life, where the family lived and entertained, was focused on the *piano nobile*, the middle or 'noble' floor, often suitably enhanced by a feature window or similar architectural embellishment. Bedrooms were in a lower ceilinged 'attic' storey. Pickford's house, built around 1769, was the family home, the practice office, and an advertisement for his considerable architectural skills. In brick with stone detailing around sash windows, a round-headed stone arch defines a recessed central bay that combines with prominent attic storey windowsills on either side to create a profile suggesting

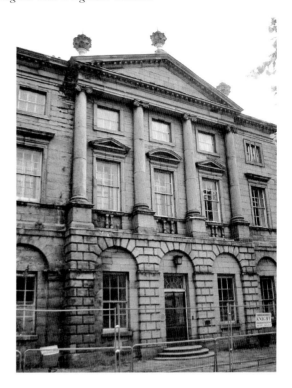

140. St Helen's House, Derby
(1767), by Joseph Pickford. Ionic
columns supporting a triangular
pediment form a central portico.

a Venetian window. Decorative balustered panels, an ornament Pickford also used
at St Helen's House, sit below the first-floor windows of the central bay. A low-
pitched roof has chimneystacks at each gable, a projecting cornice is supported
by a series of small brackets known as 'modillions', and a triangular pediment is
open at the base. Doric columns supporting a triangular pediment compose an
imposing entrance with a cobweb fanlight and side windows allowing natural
light into the entrance hall. A couple of doors away, at 44 Friar Gate, Pickford
rang subtle changes. He developed the central stone arch feature into an arcade
and installed Venetian windows on the ground floor, plus a simpler doorcase with
Doric pilasters and a broken pediment.

A stroll along Derby's Friar Gate presents a picture of Georgian architecture at
its most elegant, with classical entrances, decorative fanlights, wedge lintels above
sash windows (many carved and channelled to imitate keystones), and much
Palladian detail. The eighteenth century ebbs as one approaches Ashbourne Road
from the Wardwick. By Vernon Street, with its collection of neat, colour-washed
stucco houses punctuated by the imposing Doric frontage of the old gaol, designed
by Francis Goodwin (1784–1835), we are into the first quarter of the nineteenth
century. Signature Doric triglyph moulding, formed by a series of three upright
V-shaped grooves or 'glyphs' figuratively representing the ends of timber beams
in ancient prototypes, decorates the frieze of the old gaol façade that now stands

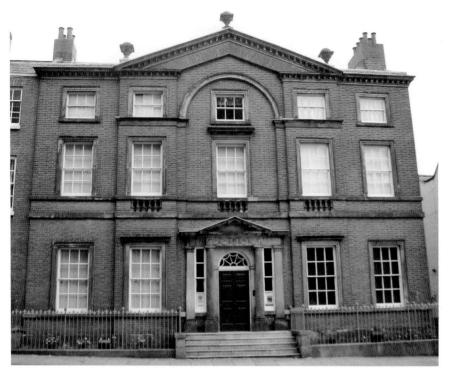

141. Pickford's House, Derby (*c.* 1769). A typical Georgian town house that served as family home and practice office.

sentinel to the Vernon Gate Development. Beyond the Georgian House Hotel with its Tuscan porch, we enter Victorian Derby.

In the eighteenth century, Wirksworth was, after Derby and Chesterfield, the largest and most important town in Derbyshire, with no less than fifty public houses vying for business. The town had grown rich on lead, and its wealth is reflected in the houses of the period. Symond's House, built around 1730 for a solicitor, is a typically symmetrical Georgian house of ashlar masonry with quoins, sash windows, plain pilasters supporting a pediment at the entrance, a moulded cornice below a roof-concealing parapet, and brick chimneystacks at the gable ends. Lining chimney flues with brick to protect limestone from fire damage became standard practice in the eighteenth century. A brick extension with stone detailing, in Palladian style and incorporating two Venetian windows, was added alongside around 1760, as an office, freeing the ground floor of the main building for private family use. A house in Blind Lane has seventeenth-century mullion windows on the upper storey, and Venetian windows on the ground floor. Servants employed at nearby Wirksworth Hall (since demolished) were housed here, and the unusually stylish fenestration in such a modest building may have been a whim to improve the aspect for their masters.

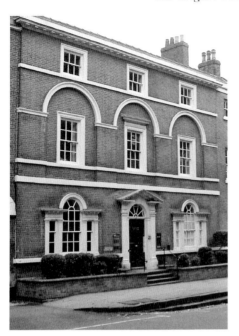

Above left: 142. 44 Friar Gate, Derby (*c.* 1769). A well-balanced Georgian town house by Joseph Pickford, featuring Venetian windows on the ground floor.

Above right: 143. Ionic columns emphasise the entrance to Friar Gate House School, Derby.

144. The imposing Doric frontage of Derby gaol now stands at the entrance to Vernon Gate – a business centre and housing development.

145. Georgian House Hotel, Derby: rendered brick with a stone porch carried on Tuscan columns.

146. Symond's House, Wirksworth (*c.* 1735). A Georgian town house of ashlar masonry with a brick extension.

147. A three-storey former town house, Ashbourne (*c.* 1780), with Venetian windows on the ground floor and rectangular sash windows set in recessed arches above.

Parwich Hall, Parwich, was rebuilt in 1747, with a Neoclassical façade in brick above a stone basement and with mullion windows retained from the earlier house. The core of Parwich remains a typical Peak District village of coursed rubble cottages with mullioned windows. Turning to brick in the stone towns and villages of the Peak District and North Derbyshire was an ostentatious way of asserting social one-upmanship, a means of displaying individualism, and a rejection of tradition in favour of a more fashionable approach. Longstone Hall, Great Longstone, built at the same time as Parwich Hall, is a similar oasis of brick. An early nineteenth-century dwelling in Eyam is so defined by its choice of material that it is still known as Brick House. Georgian Ashbourne, on the fringe of the Peak District, became essentially a town of brick buildings, with stone reserved for detailing and façades (as at Grey House, Church Street). By the last quarter of the eighteenth century, stone buildings – for example a three-storey ashlar town house (now a bank) in Compton Street, designed by Joseph Pickford for Francis Beresford, with Venetian windows on the ground floor, and rectangular sash windows set inside recessed arches on the first floor – were exceptions.

148. Eighteenth-
century stone
cottages, Derby.

Middle-class town house style was adapted to more modest dwellings. Most have long since disappeared. A few eighteenth-century cottages on Nottingham Road, Derby, are a reminder of what much of the residential town would have looked like in the Georgian period. The former Punch Bowl Inn dates from the 1750s, when Derby Porcelain Works was established nearby. The porcelain works moved to their present factory on Osmaston Road in 1878, shortly before becoming Royal Crown Derby. Punch Bowl cottage is brick-built with two storeys and an attic. The elevation is well balanced, exactly as children draw houses, with a door (now blocked) in the centre and matching windows either side. Sash window frames and the blocked doorway have segmental brick heads. Nearby, a couple of smaller, late eighteenth-century two-storey houses and The Peacock public house are of stone with wedge lintels.

'Taking the waters' became an increasingly popular diversion among the wealthy. According to prevailing medical wisdom, it offered relief from gout and other afflictions attributed to a rich diet and sedentary lifestyle. The Duke of Rutland built himself a personal bathhouse at Bakewell in 1697. It was rebuilt after the surrounding Bath Gardens had been laid out in 1818 as Haig House – a plain gabled house with mullion windows – and the Duke's original bath remains in the basement. Until recently, Haig House served as headquarters for the local British Legion branch. In the early nineteenth century, the centre of Bakewell was transformed in an attempt to develop the town as a spa. Rutland Square was created with the Rutland Arms, featuring a grand Tuscan porch, replacing an earlier inn on one side and stables opposite. Unfortunately, the cool temperature of Bakewell's natural waters gave rival spas at Matlock, and in particular Buxton, an advantage with which Bakewell was unable to compete.

Right: 149. Punch Bowl Cottage, Derby (*c.* 1750), a former inn.

Below: 150. The Rutland Arms Hotel, Bakewell, with its impressive Tuscan porch, was built as part of an attempt to exploit local springs and turn the small market town into a spa.

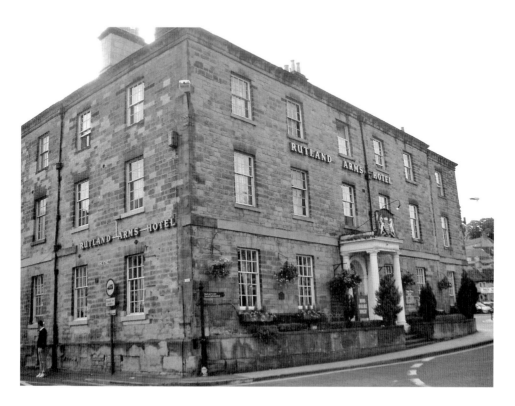

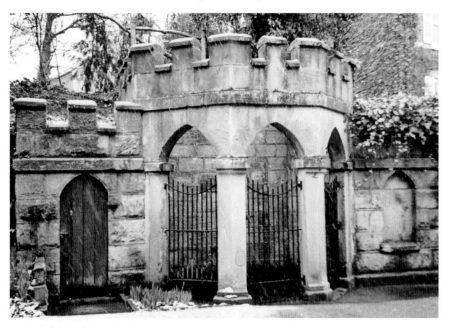

151. An elaborate Gothic frontage was built around a mineral rich spring at Quarndon, but plans to develop a spa in the area foundered when the water supply faltered in 1817.

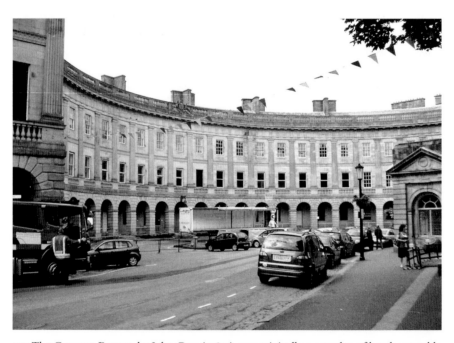

152. The Crescent, Buxton, by John Carr (1780s), was originally a complex of hotels, assembly rooms and associated buildings. It was remodelled for the changing times in the Victorian period to include a range of shops in the rusticated arcades of the ground floor. Forty-two giant Doric pilasters unify the upper storeys.

The bath that gave its name to Matlock Bath opened in 1698. A second 'New Bath' followed in 1745. In 1780, the 5th Duke of Devonshire invested profits from his lucrative copper mines into developing Buxton as a spa attraction to rival Bath, exploiting a geothermal spring rising at a constant temperature of 28 °C. Lord Curzon's plans for a spa adjacent to Kedleston Hall foundered when the mineral-rich village spring at Quarndon, around which an elaborate Gothic castellated façade had been added, unexpectedly dried up in 1817, just as the spa was about to be launched, leaving a bathhouse above a thermal spring in the grounds of Kedleston Hall (now part of the local golf course) stranded.

The attractions of Georgian spa towns extended beyond merely taking the waters. They were places where people came to dance, gamble, eat, drink, and take advantage of one of the few opportunities where individuals from all levels and classes of society could mix. Spas became places where business was transacted, political gossip exchanged, introductions made, and marriages brokered. Yorkshire architect John Carr (1723–1807) was commissioned to design and build the Crescent at Buxton, modelled on Bath's Royal Crescent, completed just five years earlier. Between 1780 and 1789, using locally quarried gritstone, and roofing slate transported from Westmorland, Carr created a complex with three hotels, public assembly rooms, and a range of associated buildings, including St Ann's Well, built to deliver water to the Crescent from a spring at the rear of Eagle Parade. Above a rusticated arcade, giant Doric pilasters unifying the upper storeys support a triglyph frieze, cornice, and balustered parapet. Substantial cruciform chimneystacks produce a distinctive silhouette.

THE PULSE OF THE MACHINE
Georgian Derbyshire II (1715–1837)

Derbyshire at the beginning of the Georgian era was a rural economy. Most people worked in agriculture, or domestic service. Industrial activity was largely confined to subsistence-level cottage-based crafts: nail making, needle and pin making, framework knitting, and small-scale weaving on hand looms. Thomas Cotchett of Mickleover engaged George Sorocold (*c.* 1668–1738), born in Derby following his father's move from Lancashire, to design a three-storey, water-powered silk mill beside the River Derwent in Derby. It was completed in 1702. The aim was for every process to be integrated in a single building around a central power source, effectively introducing the factory system. Called a 'mill' because it harnessed the power of running water to drive machinery in the established flour-milling tradition, the term was universally applied to all textile factories that followed. Cotchett's venture proved commercially unviable, but an enterprising former colleague, John Lombe, took over and turned the business around by smuggling the closely guarded secret of mechanised silk-throwing out of northern Italy and applying the method in Derby. Lombe employed Sorocold to build a new five-storey mill on the site in 1718. An Italianate tower may have been a deliberate attempt to associate his business with the recognised market leaders. Fire destroyed Lombe's pioneering mill in 1910 and the present building on the site, which later became home to Derby Industrial Museum, is a smaller reconstruction with only fragments of the tower and its foundations surviving from the earlier building.

By the mid-eighteenth century, the urban population of the county was well on the way to outnumbering rural residents. Derby had a prosperous silk industry. Jedediah Strutt, with a water-powered mill driven by Markeaton Brook, was among a number of local entrepreneurs. Strutt, born in South Normanton and a wheelwright by trade, married Elizabeth Woollat, whose family ran a hosiery business in Derby. In partnership with his brother-in-law William Woollatt, Strutt made his name with a gadget that adapted weaving machinery to produce 'Derby

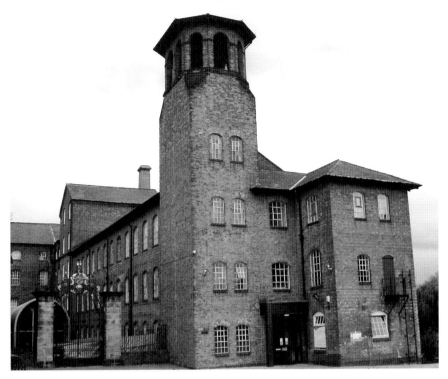

153. The Silk Mill, Derby, which became home to Derby Industrial Museum (mothballed at the time of writing). It is a smaller reconstruction of the early eighteenth-century mill that introduced the factory system to England. Only the foundations and parts of the tower survived a fire in 1910.

Rib', a stitch that made fine silk hosiery possible. In 1769, Strutt and a colleague, Samuel Need, provided financial backing for Richard Arkwright, then an itinerant barber, to exploit his patented 'water frame', a cotton-spinning machine developed with help from John Key, a clockmaker. The result was Cromford Mill, a complex of linked buildings now looked after by the Arkwright Society, which has carried out considerable restoration. Upper Mill was completed in 1771. A second mill was added at right angles facing Mill Road, with mullioned windows on the upper floors but no ground-floor windows on the street frontage, and a rounded end containing a staircase turret. The ground-level area was probably used as a warehouse to store cotton bales and did not require the same amount of light as the textile processing floors, but it has been suggested that windows opening onto the street were omitted in order to keep cutting-edge mechanised processes hidden from potential rivals, and to protect machinery from Luddite protestors. Over the next twenty years, the site was extended and further mills and workshops were added. Cromford Mill, a complex of large flexible spaces specifically designed to accommodate machinery and for maximum productive

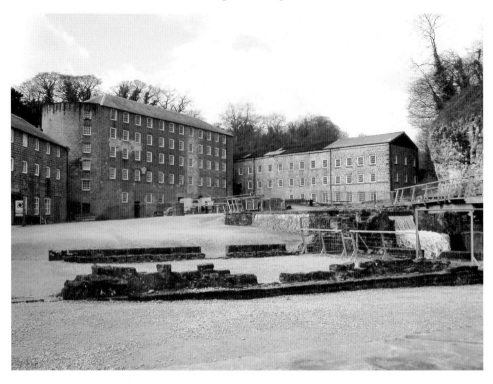

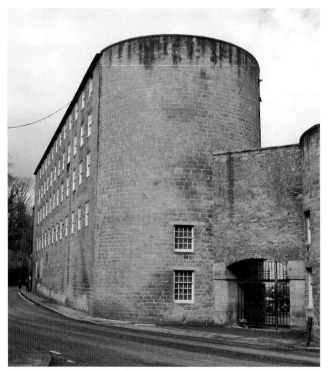

Above: 154. Cromford
Mill, the first successful
water-powered cotton
mill in the world. The
earliest mill building, of
coursed gritstone and
originally of five storeys,
began operating in 1771
(right). A second mill was
added in 1776 (left), and
the complex completed
by 1790.

Left: 155. Richard
Arkwright's second mill
at Cromford (1776) had
no windows on the
ground floor facing Mill
Road. The rounded end
contained a stair turret.

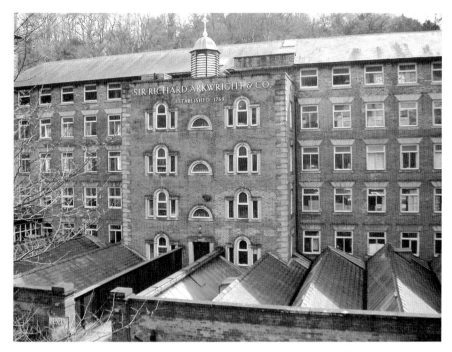

156. Masson Mill, between Cromford and Matlock Bath (1783), was built in Accrington red brick on gritstone foundations with Venetian windows flanking a tier of lunettes. The original mill is now the centrepiece of a complex containing nineteenth- and early twentieth-century extensions.

efficiency, was the first successful water-powered cotton mill in the world and a model for those that followed. Two upper floors of the original five-storey mill of coursed gritstone were lost to fire in 1930.

By 1784, Arkwright had added Masson Mill between Cromford and Matlock Bath, and built further mills at Cressbrook, Ashbourne, Bakewell, and Wirksworth. Masson Mill, in Accrington red brick on a gritstone foundation, is a less forbidding building than the original Cromford Mills. Bright brickwork gives it a polished appearance and contemporary architectural detail adds aesthetic touches. Where Cromford Mill is plain and utilitarian, the earliest block of Masson Mill (1783–4), has Venetian windows with heavy stone surrounds flanking a central tier of lunettes, and rusticated quoins. This attention to architectural detail reflects the growing importance of the textile industry, and the increase in wealth and status of mill owners. As Arkwright expanded, Jedediah Strutt developed his own pioneering textile mills at Belper and Milford; while at Darley Abbey, the Evans family built a cotton-spinning mill; and, under licence from Arkwright, John Gardom and John Pares invested in Calver Mill. Among other early mills were Christopher Kirk's at Bamford (1780), Samuel Unwin's at Tansley (1783), and Ellis Needham's Litton Mill (1780), later notorious for its inhuman treatment of child pauper apprentices.

Mass production had arrived and with it a huge demand for labour. Textile factories required nimble fingers. Arkwright sought to recruit women and children in the main. To attract employees, ideally with large families, to Cromford, two terraces of three-storey coursed rubble houses with heavy lintels above the doors, and tiled roofs, were built in 1777, creating North Street. Each house had an attached garden plot. Cheap loans were available to enable families to buy a cow. Living accommodation was a single room on the ground floor with a bedroom above, and an attic floor lit by large windows that extended to the moulded stone eaves. Open-plan lofts extending along the row were designed as workshop space, where men could be employed as framework knitters while their wives and children laboured in the mill. A single double-fronted house at the end of the row, with its own private attic, accommodated a foreman. A more spacious detached mill manager's house, of ashlar, with a low-stepped perron-style platform leading to the front door, was built opposite the mill, allowing the occupant to keep an eye on security and supervise his workforce arriving for work or leaving at the end of a shift.

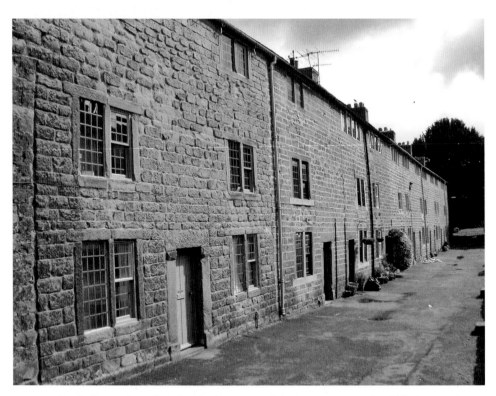

157. North Street, Cromford (1777). A terrace of three-storey coursed rubble houses. A foreman occupied the double-fronted house at the end of the row. Above the other houses, open-plan attics with windows extending to the eaves provided workshop space for male framework knitters whose families were employed at Richard Arkwright's cotton mill.

158. Mill manager's house, Cromford (*c.* 1771). Situated opposite the mill complex, this spacious detached house in ashlar enabled the mill manager to keep an eye on his workforce.

North Street, Cromford, marked the beginning of the first planned 'factory village' in the world. Properties were purpose-built to house industrial workers, made available at a reasonable rent, and kept in good repair. Some of the houses are now in the care of the Landmark Trust and have been carefully restored as holiday lets. Further mill workers' houses, St Mary's church, a chapel, and the Greyhound, a hotel incorporating a bank, followed. The three-storey Greyhound Hotel fronting on to the new Market Place was designed to impress visitors, with raised quoins and a pediment emphasising the central bay, a Doric doorcase, and prominent keystones. A charter was obtained and a market inaugurated to ensure a source of supplies for mill employees. Richard Arkwright junior added a school at the end of North Street in 1832, with houses next door for a schoolmaster and schoolmistress.

In the space of twenty-five years, Jedediah Strutt's investment at Belper, commencing with North Mill at Bridge Foot in 1776, transformed a rural village of farmers, subsistence-level nail makers and framework knitters into what was for a time the second largest urban centre in Derbyshire. As at Cromford, the mill workforce needed housing, and this Strutt provided, beginning with terraces of three-storey gritstone houses in Long Row in 1793. Long Row is paved with

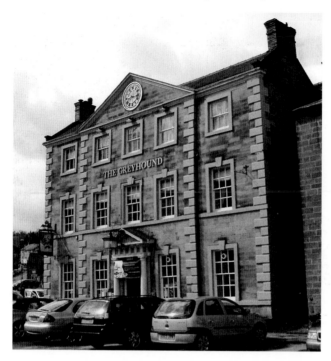

159. The Greyhound Hotel, Cromford (1778), was designed to impress with its classical triangular pediment, Doric doorcase, raised quoins and prominent keystones.

stone setts. Each house has a small front garden surrounded by a low stone kerb designed to carry iron railings (since removed), and protected from the wheels of passing carts by stone baulks that are still in position. In addition to small gardens, allotments were available. As with Arkwright's houses at Cromford, Strutt's terraces were built to a high standard, with workspace on the attic floor where men worked as stocking-frame knitters. Other men took up nail making, expanding a traditional local industry far beyond its cottage roots. Nails from Belper were soon being exported in huge quantities. A typical early nineteenth-century single-storey nail shop of coursed stonework, with a tiled gabled roof, and a small brick chimney at one end where a small forge was sited, survives in Joseph Street.

North Mill at Belper was destroyed by fire in 1803, and was replaced the following year on a T-plan, to a design by Jedediah Strutt's eldest son, William. The new mill had a pioneering iron frame partly encased in protective clay 'flower pots' to increase fire resistance. A schoolroom, to provide basic education on Sundays for children employed at the factory, was included on the top floor of the new building. William Strutt (1756–1830) was a talented mechanical engineer. In 1792 he had experimented with fireproofing techniques while overseeing the construction of a cotton mill at Derby. He supported floors on brick arches and iron columns, and coated exposed timbers with a layer of plaster. He developed these ideas in the mid-1790s in collaboration with Charles Bage (1751–1822),

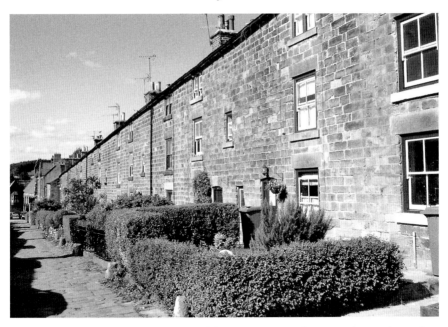

160. Long Row, Belper (1793). A terrace of three-storey coursed gritstone houses for workers at Jedediah Strutt's cotton mill.

161. An early nineteenth-century nail shop, Belper. A small brick chimneystack shows where the forge was located.

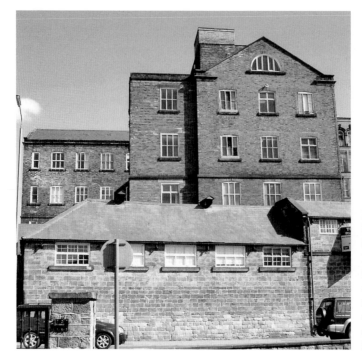

162. North Mill, Belper (1804), had a pioneering iron frame. Basic education for children employed at the mill was provided on a top-floor schoolroom on Sundays.

who grew up in Darley Abbey and contributed to the design of Ditherington Flax Mill in Shrewsbury, the world's first completely iron-framed building. The structure transferred the job of load-bearing from walls to an inner metal skeleton, paving the way for the first skyscrapers.

Thomas Evans developed mills at Darley Abbey, producing high-quality cotton thread under a Boar's Head trademark (the Evans family crest) in a complex that also included a paper mill, brickworks exploiting local clay deposits, and corn mill. The oldest building – Long Mill, begun in 1782 and rebuilt after a fire in 1790 – is a plain brick rectangle of five storeys. The attic floor was used as a schoolroom where children employed at the mill received basic education before a custom-built facility was provided. Iron-framed West Mill, built in 1821, pays homage to Georgian architectural ideals by having dummy windows painted in to maintain a symmetrical appearance.

Evans effectively provided a new village for his workers. Among the first houses built were the terraces of Flat Square and West Row (1792). Forming three sides of an open square – a design concept introduced to England by Inigo Jones following his travels in Europe in the 1630s – these three-storey red-brick houses have an eaves dentil course and slate roofs hipped at the open ends. By the Georgian period, the terrace of uniform houses in rows, squares and variations, such as the Crescent at Buxton, had become the accepted way of organising urban living.

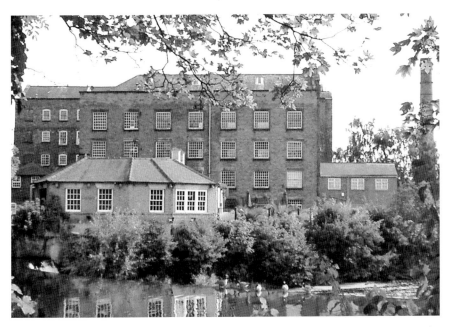

163. West Mill, Darley Abbey (1821), has several imitation windows painted in to maintain the building's symmetry.

164. Flat Square, Darley Abbey (1792). An open square of three-storey, red-brick terraced houses for the employees of Thomas Evans' Boar's Head Mills.

Brick Row, Darley Abbey (1797–1800), another brick-built terrace of three-storey houses for employees of the Boar's Head Mills, has slate roofs with gable ends. Attic space above the houses in the centre of the row was deliberately planned as a school, replacing the room in Long Mill, and was in use until nearby St Matthew's School was completed in 1826. Long windows that reach to the eaves show where the school was situated; the remaining windows in the terrace all have segmental brick heads. Party walls in Brick Row were planned to allow internal flexibility – capable of adjustment to cope with differing sizes of family. Further industrial housing at Darley Abbey followed in New Road, Lavender Row and Mileash Lane, all with yards or small gardens, outbuildings for privies and wash-boilers, and some with pigsties. To compensate for an incline, the individual houses of the Lavender Row terrace are stepped. At the junction of Mileash Lane and Lavender Row stand 'the Four Houses', four three-storey, rendered brick dwellings, each joined to its neighbour on two sides so that the whole forms a square block in an arrangement known as a cluster. Built in 1792 to accommodate the families of mill foremen, this group is almost certainly the oldest surviving example of cluster housing. Charles Bage is known to have built similar houses in Shrewsbury, but these have since been demolished. Among many who copied the format was William Strutt, who added cluster houses of coursed

165. Brick Row, Darley Abbey (1797). The attic space above the houses in the centre of this terrace of mill workers' houses was used as a schoolroom. Party walls were planned with flexibility in mind to cope with different family sizes.

166. A block of four three-storey houses at Darley Abbey (1792) for mill foremen and their families. This is the oldest surviving example of 'cluster' housing. Behind is Lavender Row (*c.* 1800), a terrace of mill workers' cottages 'stepped' to compensate for sloping ground.

167. A four-house 'cluster', Belper (*c.* 1805).

Above: 168. Two elegant terraced 'clusters' at Darley Abbey (1826) of white rendered brick, hipped roofs, and doorways set inside blank arches.

Left: 169. The White House, Darley Abbey (*c.* 1805). A semi-detached, rendered-brick house with a hipped roof, built for a senior mill employee.

stone in Joseph Street, Belper, around 1805. The idea also spread to industrial housing on the Continent.

Two unusual four-house terraced clusters were built on New Road, Darley Abbey, in the 1820s. Both blocks are of brick, with hipped roofs and white rendered façades in which the front doors are set in blank arches. Possibly the unusually elegant appearance was because the houses were visible from Darley House, the Evans' family home, since demolished. The Hollies and the White House in New Road are substantial semi-detached brick properties of two storeys, with hipped slate roofs, set within their own garden plots, and built around 1805 for senior level mill employees. The mill manager occupied a detached, painted-brick, two-storey house with a hipped slate roof, overlooking the mill complex from Dean's Field.

Designed by architect Moses Wood of Nottingham in 1818, St Matthew's School (now converted into offices) is in red brick, with a hipped slate roof, plain stone cornice and triangular pediments at the centre and above the side elevations. It has recessed round-headed windows on the ground floor, and incorporates houses for a schoolmaster and schoolmistress at opposite ends of the building.

The Arkwright, Strutt and Evans families, the most influential of Derbyshire's mill owners, were paternalistic employers whose control and influence dominated every aspect of their workers' lives. Strict discipline was demanded at work, and the observance of morality, thrift and sobriety was expected in private. There was

170. St Matthew's School, Darley Abbey, replaced attic schoolrooms in Brick Row in 1819. Accommodation for a schoolmaster and schoolmistress was incorporated at either end of the building.

no public house in Darley Abbey until 1970. Architecture reinforced social order
and factory hierarchies – foremen enjoyed better accommodation than mere
mill hands, and managers a higher standard still, with a greater degree of privacy.
The quality of housing provided for the mill workers of Cromford, Belper and
Darley Abbey was decent by the standards of the time, and rents were reasonable.
Various perks, including a coal allowance, were available to tenants. Mill-owned
farms supplied fresh local produce. Small gardens and allotments encouraged a
measure of self-sufficiency. It can be argued that such provision had to be made
if employees were to be attracted (mill hands worked a punishing seventy-hour
week servicing machinery), and that it served as both an incentive and a tie,
sentiments summed up in the refrain, 'I owe my soul to the company store' from
'Tennessee' Ernie Ford's 1950s chart topper 'Sixteen Tons'. But the scale and level
of benefaction across the generations, encompassing churches, chapels, schools,
water supplies, medical provision and care for the elderly, was a bond between
employer and employee that involved a degree of generosity far beyond what
was strictly necessary. Where there was work without a paternalistic employer to
provide dwellings, shantytowns grew up, as happened on the outskirts of Winster,
where a makeshift collection of shacks housing lead miners formed a shabby,
congested settlement known as 'Islington'.

 By the end of the eighteenth century, the introduction of efficient coke-fired
furnaces enabled Derbyshire's iron deposits to be exploited. A number of major

171. A row of restored two-storey stone cottages, Golden Valley, Riddings (1795) – built for
employees of the Butterley Company iron works.

172. Beside the entrance
to Rykneld Mill, Derby
(*c.* 1810), now converted
into apartments, are a
former inn (rendered) and
a mill manager's house
in red brick with wedge
lintels.

ironworks had been established, all requiring employees to live in housing close
to the workplace. A row of twenty two-storey cottages overlooking the Cromford
Canal at Golden Valley, Riddings – built by the Butterley Company in the 1790s
and restored by Derbyshire Historic Buildings Trust in 1978 – are soundly built
of coursed stone.

Throughout England, the smartest and wealthiest residential urban suburbs
tended to develop in the west, where prevailing winds kept away the smoke and
grime of industry – think Mayfair in London or Edgbaston in Birmingham –
leaving industry to expand in the east and north. In Derby, in the late eighteenth
and early nineteenth centuries, a number of mills were established in streets behind
the north side of Friar Gate, and a rather different 'West End' grew up behind the
graceful Georgian chic. Largest of the commercial buildings was Rykneld Mill, a
silk mill complex in red brick with a slate roof built between 1805 and 1811, in the
angle of Brook Street and Bridge Street. At the time it was the tallest building in
Derby, overshadowing its surroundings. The iron-framed South Mill was the first
silk mill to apply the pioneering fireproofing techniques developed by William
Strutt, and the small-paned rectangular cast-iron windows give the building a
distinctive appearance. Rykneld Mill is a rare, early nineteenth-century set of
mill buildings (converted into Brookbridge Apartments in 2003). Straddling the
main entrance on Bridge Street are a former inn (The Pheasant) with rendered
brickwork, a manager's house in red brick, with wedge lintels, and a counting
house. Attached to these is a short terrace of well-built spacious red-brick houses
for senior mill staff. A huddle of cheaper terraces grew up in the surrounding
streets. Built to house mill workers, the dwellings were densely packed with
shared privies, but the conditions were made even worse by overcrowding as
demand exceeded supply.

173. St John the Evangelist church, Derby (1826). A Commissioners' church with seating for 1,300 was designed to serve a rapidly growing population in Derby's West End. Architect Francis Goodwin chose a Perpendicular Gothic design with cast-iron tracery for the windows.

Population growth swamped parish facilities in industrial areas. Pew rents (common at the time and phased out only slowly, lingering in some places into the 1930s and beyond) reinforced social snobberies and placed demands on poor families. Many turned to Nonconformism, and in some cases abandoned religion altogether. Under the direction of a government-appointed body of Church Commissioners, a national church-building programme was instigated, for which an initial £1 million budget was voted by Parliament. A grant of £2,500 was given by the Commissioners towards the cost of a new church in Derby's West End. A further £4,300 was raised locally, and in 1826 architect Francis Goodwin began work on St John the Evangelist, on the corner of Mill Street and Bridge Street, on land donated by the Hurt family, who lived nearby in Friar Gate. Despite resource constraints, Goodwin produced an impressive Perpendicular Gothic building, with prominent turrets at the angles, well-defined battlements, and paired windows featuring cast-iron tracery. Externally, the profile of St John's church is reminiscent of King's College chapel, Cambridge (begun in 1446), and which almost certainly provided Goodwin's inspiration. A short, narrow chancel was extended in 1871. St John's had seating for up to 1,300 people, half of the seats were free, and the new church was soon at the centre of community life.

By the mid-Victorian period, conditions at Rykneld Mill were better for employees than at home, with good ventilation and separate water closets for men and women on each floor. Despite, and perhaps because of, shared deprivation, a warm community spirit and neighbourly attachment developed that lingered through subsequent generations. Improvements over time eliminated problems, and many mourned the passing of Derby's West End when it was bulldozed in 1964–65.

Whispering from Her Towers the Last Enchantments of the Middle Age
Victorian Derbyshire (1837–1901)

The everyday conveniences of modern home life were slow to arrive. At the beginning of the nineteenth century, most large houses might have had a brick-lined oven for baking, but meat was still spit-roasted, and cooking for most was carried out over an open hearth. Domestic lighting was by oil lamp and wax or tallow candle. During the Victorian period, cooking ranges with ovens were introduced. Gas lamps illuminated streets in Derby and Chesterfield from the 1820s, but it was mid-century before domestic supplies became available via penny-in-the-slot meters, and 1880 before electricity provided an option. In the opening decade of the nineteenth century, William Strutt designed a cast-iron stove known as the 'Cockle' or 'Belper' stove, to run a hot-air heating system. A cockle stove was installed in the Derbyshire General Infirmary when it was built in London Road, Derby, in 1807, and Strutt fitted Cockle central heating apparatus in his own home, St Helen's House, Derby (purchased in 1803 from the Gisborne family), in 1819. Rudimentary pipe and radiator heating using hot water from a boiler appeared in the 1830s. In 1874, gasworks were built in School Lane, Sudbury, to supply Sudbury Hall. Probably to a design by George Devey (1820–86), the brickwork has diaper patterns reflecting those of the hall, Dutch gables, brick dentils at the eaves, and diamond-shaped chimneystacks – a mix of architectural elements fashionable in the late nineteenth century. Gas was produced here until the 1930s.

Privies progressed from vertical shafts emptying into a cesspit at Old Hardwick Hall, via closet stools with a removable chamber in the 1590s replacement built alongside, to primitive flushing water closets at Chatsworth a century later. Joseph Bramah patented the first efficient water closet in 1778. Earth closets and privies with cesspits remained the norm for many, particularly in the countryside. In the mid-nineteenth century, closets depositing a thin layer of dry ash each time the lid was raised were introduced. Ash shovelled from the grate was loaded into removable drawers to keep the closet 'primed'. Night soil carts doing their rounds

174. Gasworks (1874) built to supply Sudbury Hall. The building has Dutch gables, diamond-shaped chimneystacks and diaper-patterned brickwork.

collecting the contents of emptied privies were a regular feature of late Victorian town life.

No single architectural approach defines Victorian Derbyshire. A blend of styles emerged as different sections of society sought to assert an identity. Architects sampled and remixed elements from ever more diverse sources. Readily available pattern books offered design variety. Improved transport links, significantly the railway, made a wider range of materials available. Collectively, these conditions swamped local traditions, replacing the vernacular with a degree of standardisation. A burgeoning cotton industry at Glossop created a huge demand for additional housing. In the early part of the nineteenth century these were signature Derbyshire, built of coursed gritstone with locally quarried sandstone flag or gritstone slate roofs. And there was an even more localised convention – timber guttering or 'trows', initially made of elm but latterly of imported red deal, carried on stone corbels. By the mid-Victorian period, Welsh blue slate had replaced stone as the roofing material of choice and cast-iron rainwater goods were taking over.

Shop frontages took their cue from classical architecture, framing display windows with pseudo pilasters and entablatures in timber, the frieze proving a useful casing for sign writing and a jutting cornice providing protection from the elements. Neoclassicism, with its overtones of formality, authority and dignity, continued to be popular for civic and public buildings, but the subsequent reaction to conventional classical formality was predictable. Turrets and

battlements at Willersley Castle, built on the slopes of Wild Cat Tor, Cromford (1789–90, to designs by William Thomas for Richard Arkwright), at Bretby Hall (an early nineteenth-century design by Jeffry Wyatville for Philip Stanhope, 5th Earl of Chesterfield), and at Elvaston Castle (1815–29, planned by James Wyatt for Charles Stanhope, 3rd Earl of Harrington), anticipated a revival of Gothic and Tudor style, both authentic and imaginative, linked to a rosy-hued interpretation of medieval courtliness and splendour. In its early stages, this romanticism emerged in a style known as Picturesque, an eclectic architectural movement embracing variety, striking contrasts and irregularity. It was not based on any scholarly reinterpretation of medieval conventions, but used a range of motifs to create an attractive external profile. Interiors tended to remain determinedly Neoclassical.

At Tissington, the Fitzherbert family rebuilt estate cottages in the village in traditional Derbyshire style. Other landowners transferred the fashion for Picturesque to their estates, building or refashioning workers' cottages in which features – typically including leaded windows, mock-Tudor timber studding,

175. Shop frontages took their cue from classical architecture, framing display windows with pilasters and (inset) supporting friezes with curving brackets or 'consoles'.

176. Willersley Castle, Cromford (1790). A Picturesque confection of turrets and battlements built for Richard Arkwright.

177. Bretby Hall. Early nineteenth-century Picturesque design by Jeffrey Wyatville for Philip Stanhope, 5th Earl of Chesterfield.

oversized ornamental chimneys, thatched roofs and elaborate bargeboards – were combined to give an idealised rustic flavour to villages, creating a quaint 'chocolate box' style accessory to the 'big house'. Edensor, begun on the Chatsworth Estate in 1838, is a fine example of such a 'model' village. Designed by Derby-born architect John Robertson and architect and engineer Sir Joseph Paxton (1802–65), who had begun his career as a gardener at Chatsworth House, and drawing inspiration from

178. Edensor, part of the Chatsworth Estate (1838). Each house was designed to a different plan by Joseph Paxton and John Robertson. St Peter's church is Gothic Revival by Sir George Gilbert Scott.

a range of architectural periods and sources, each house was to an individual plan. George Gilbert Scott (1811–78) was responsible for St Peter's church overlooking Edensor's village green, which mixed Early Gothic with Decorated Gothic features, and reused fragments from an earlier Norman building.

In the 1840s, Francis Wright of Osmaston Hall, owner of the Butterley Company ironworks, employed London-born architect Henry Isaac Stevens (1806–73) – who had married a local girl and based himself in Derby – to modernise Osmaston village in a range of contrasting styles. Brick, thatch and mock-Tudor timber studding for some houses – stone for others. Rock-faced limestone with sandstone dressings was used for a well-balanced row of three cottages, with a projecting central block, tile roofs, substantial chimneystacks, mullion windows, and steep gables crowning the end elevations. The same materials were used for St Martin's church, and also for a school and schoolhouse, although subtle changes were rung – tiles were replaced with Welsh slate and raised gables with kneeler blocks were added to the school building.

For small houses, particularly those in rural locations, Picturesque style culminated in the cottage *orné*. Elm cottage, Osmaston, is a good example – originally two cottages given a radical makeover in the 1840s, probably by H. I. Stevens, and now a single L-shaped house. A cruck truss of around 1500, applied rather than structural, is exposed in one gable, beneath lacy bargeboards. The rest of the cottage is box-framed, with diamond-pane leaded windows, tiny eyebrow dormers peeping below a thatched roof, and a stone hood carried on substantial brackets above a central entrance. Twin chimneystacks emerging at

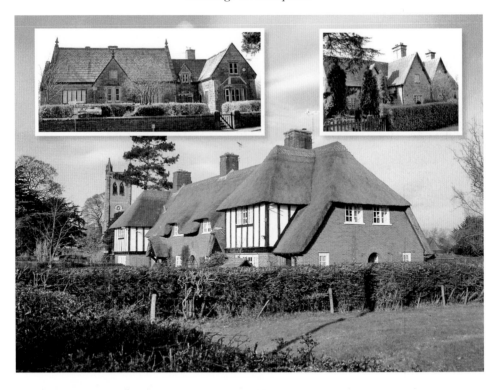

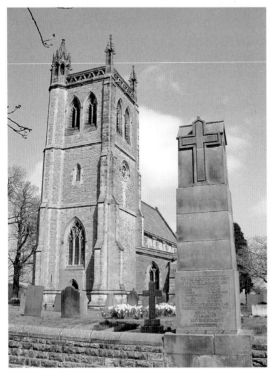

Above: 179. Osmaston village was largely rebuilt in a mix of contrasting styles in the 1840s.

Left: 180. St Martin's church, Osmaston (1845) in Decorated Gothic style. The 11th Earl Ferrers designed the war memorial (1921).

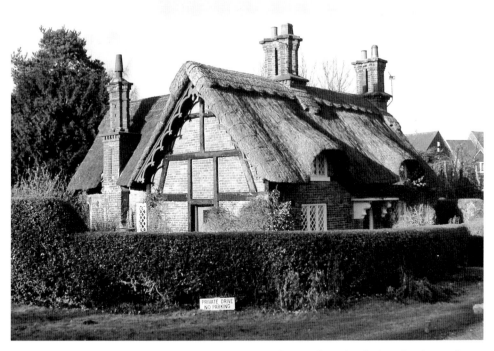

181. Cottage *orné*, Osmaston. Eyebrow dormers peep from under a thatched roof, and a cruck truss is exposed at one gable beneath lacy bargeboards.

the ridge, and a smaller side stack, are an adaptation of vernacular Midland Star design.

At Cromford Station, George H. Stokes (1804–70), son-in-law of Joseph Paxton, parlayed his experience of working in France into a single-storey, chateau-style waiting room (*c.* 1860), incorporating a cat-slide roof, diamond-pane windows, and a clock tower beneath a slender pyramid turret,. Following an award-winning restoration project completed in 2009, the former station waiting room is now a holiday cottage.

Charles Stanhope commissioned influential architect James Wyatt (1746–1813) to transform his early seventeenth-century manor at Elvaston in Picturesque Tudor Gothic style. Robert Walker (b. 1771) implemented the designs following Wyatt's death in a riding accident, cloaking the brickwork in smooth ashlar masonry, and adding a new great hall and an east façade to plans by Lewis Cottingham (1787–1847). Exposed brickwork at the eastern corner of the main south front is a reminder of the original Jacobean manor. Cottingham espoused Picturesque Gothic with the lightest of touches. His best work in the county was for Derby lawyer and businessman John Harrison, at Snelston, in the late 1820s. Snelston Hall was largely demolished in 1951, leaving only one wall together

182. Station waiting room, Cromford (*c.* 1860), in French chateau-style, and with diamond-pane windows.

with outbuildings and stables that have since been converted into dwellings, but Cottingham's work survives in two former lodges, the former Stanton Arms (now Oldfield House), and the Old Post Office. Cottingham combined a variety of medieval architectural features at Snelston – including four-centred arches, oriel windows, mullion-and-transom windows with label dripstones, diamond-patterned leaded lights, decorative brick chimneystacks, mock timber framing and heavy studded doors – to achieve a compelling Tudor Gothic effect. The lodges also have carved and pierced bargeboards, decorative elements that became increasingly popular in the later nineteenth century.

'The rich man in his castle, the poor man at his gate,' wrote Cecil Alexander in 'All Things Bright and Beautiful'. In between was the lodge, housing the gatekeeper of the castle – more usually a country mansion set at the end of a long drive. Lodges controlled access and represented the estate to the outside world. South Lodge, Longford, combines refined elements (gauged brick window heads, brick dentil eaves), with a practical canted bay that has a full-width stone sill below three sash windows, allowing a clear view of the drive leading to Longford Hall, and Picturesque motifs, including a decorative terracotta band, a keyed *oculus*, and a small verandah-cum-porch.

At Chatsworth House, Kedleston Hall, and elsewhere among the moneyed classes, weekend parties for guests were regular events in Victorian Derbyshire. Social rooms in these grand country houses assumed increasing importance. In addition to a formal dining room there might be a breakfast room-cum-

183. Former Stanton Arms, Snelston (*c.* 1828). Mullion-and-transom leaded windows with label dripstones and tall decorative chimneystacks imitate late Tudor style.

184. The Old Post Office, Snelston (*c.* 1828). Picturesque mock Tudor with a four-centred arch above the porch, applied timber studding, leaded casement windows with label dripstones, and diamond-shaped chimneystacks.

185. Applied timber framing and intricately decorated bargeboards decorate this lodge cottage at Snelston (*c.* 1828). A large porch stretches below the steeply pitched roof of graded stone slates.

186. South Lodge, Longford. A Picturesque, single-storey lodge with terracotta decoration, a keyed *oculus*, brick-dentilled eaves, and a small verandah.

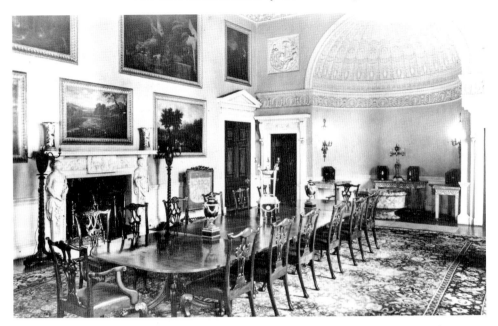

187. State dining room, Kedleston Hall. The dining room was the centre of country house social life in the nineteenth century.

morning parlour. The master of the house had his study for privacy and intimate conversation. A library offered tranquillity, a billiards room convivial recreation. Country house weekends were relaxed and primarily about enjoyment, though also potentially useful for making social and business contacts or pursuing political intrigue. Dinner was the one ceremonial occasion. Guests dressed formally and gathered in an anteroom or saloon before processing to their places at table to be waited on with considerable ritual. Once the evening meal was finished, ladies retired to a (with)drawing room, and the dining room became a male province. A new great dining room was created at Chatsworth House in 1832, in readiness for a visit by the thirteen-year-old Princess Victoria. For centuries, dinner, the main meal of the day for all social classes, had been eaten around noon, with a light snack of cold leftovers for supper. By the eighteenth century, dinner for the gentry had been put back to mid-afternoon, and in the Victorian period, with the availability of more efficient artificial lighting, to between 7.00 p.m. and 9.00 p.m., necessitating the introduction of a sit-down luncheon and tea to fill the gap between breakfast and the evening meal.

Derbyshire's coal reserves were progressively exploited in the nineteenth century. Clay was invariably dug alongside coal. As mining expanded to feed the voracious machines of the steam age, brickworks took advantage, firing their kilns with 'slack' and low-grade coal, and thereby changing the stone-to-brick balance in the county. New buildings in rapidly expanding mining towns such as

188. Cinder House, West Hallam (1833). An experiment in building with clay 'clinker'.

Swadlincote, Heanor, Clay Cross, Bolsover and Clowne were predominantly built of brick.

One of the most unusual houses in Derbyshire, Cinder House, West Hallam (1830), was originally two cottages. It is built of clay 'clinker' 30 inches thick, burned to a rusty red colour, with rock-faced stone quoins at the angles, tall chimney stacks, and lacy bargeboards that owe something to the prevailing whimsy of Picturesque style. Local squire and businessman Francis Newdigate was the inspiration behind this potential application for the abundant local clay deposits.

Industrial growth drove demand for workers' housing countywide. Some was cheaply built and densely packed. In general – and perhaps to an extent this was a legacy of the earlier Arkwright, Strutt and Evans benchmarks – the standard of industrial housing in Derbyshire was above that found elsewhere in Victorian England, and the best was exemplary. The Guinness Housing Trust has renovated around 200 workers' dwellings at Riddings. James Oakes took over the ironworks at Riddings in 1809, subsequently purchasing Riddings village and the surrounding farmland. Around 1850, a fresh street pattern was laid out and new houses were built, all with good-sized vegetable gardens. In 1880, a model farm was added in Church Street, with terraced cottages alongside for those employed

189. Mid-nineteenth-century estate cottages, Riddings.

190. Octagonal granary in the yard of the former model farm at Riddings (1880). Converted as Park Mews in 1984.

191. 'Piano Row' in the shadow of Bolsover Castle, part of the model village that aimed to dissolve the difference between town and country for the employees of Bolsover & Cresswell Colliery Company (1890s).

on the Oakes' agricultural estate. The farm buildings, including an eye-catching octagonal granary, were converted as Park Mews in 1984.

New Bolsover model village, built by the Bolsover and Cresswell Colliery Company in the 1890s, was a self-sufficient community complete with chapel, school (since demolished), orphanage, co-operative store, institute (now a public house), co-operative pig farm and sports fields. All the designs show the decorative impact of the Arts and Crafts Movement. 200 houses, some of three-storeys featuring terracotta bands, were built with bricks from the company's own brickworks, in a double row around three sides of a large green. An unusually wide road between the rows was designed to accommodate a tramway that delivered a weekly coal allowance. A central terrace, occupying a slightly elevated position with views of Bolsover Castle to the rear, was dubbed 'Piano Row', the inference being that if a family could find the few extra pennies to rent one of these houses, they would also be able to afford a piano for the front room. Every house had a garden, and large allotments were available. The aim at New Bolsover was to soften and dissolve the differences between town and country, providing urban amenities without losing green space and connection to the land.

Combining the role of landlord and employer gave companies social control. As in the Georgian period, architecture was used to reinforce administrative hierarchies. At New Bolsover, colliery managers lived on Villas Road, in superior semi-detached houses and bungalows set in generous plots. Street nicknames in Clay Cross illustrated the pecking order of employees occupying houses belonging

192. Three-storey terraced houses at New Bolsover with brick-dentilled eaves, decorative terracotta bands, and small front gardens.

to the Clay Cross Company – founded as George Stephenson & Company in 1837 to mine coal discovered when driving a tunnel for the North Midland Railway, and by the mid-nineteenth century a thriving iron foundry and brickworks. The company's general manager, Charles Binns (George Stephenson's son-in-law), lived at Clay Cross Hall, a large detached house set in spacious grounds (now a Day Care Resource Centre for Derbyshire County Council). 'Gaffers' Row', 'Office Row' and 'Elbow Row' housed the rest of the workforce. Clay Cross Company workers' houses had two upstairs rooms and two downstairs rooms, a significant improvement on the one-up-one-down arrangement typical of earlier industrial cottages. 'Office' and 'Elbow' Rows were demolished in the mid-twentieth century. 'Gaffers' Row', a four-house terrace with small front gardens, survives at 166–172 Market Street.

In Derby, work began in 1840 on a triangle of streets (formerly open land) intended to accommodate railway staff. The initial letters of North Street (now Calvert Street), Midland Street and Railway Terrace reflected the initials of North Midland Railway. Plans for the site by Francis Thompson (1808–95) included terraced properties, four shops, and the Brunswick Inn. The largest houses on Railway Terrace nearest the station were allocated to engine drivers. These two-storey homes with cellars are of red brick on a stone plinth with stone doorcases and cornices, transom lights, and flat, brick window heads. A stone string course separates the storeys, and the slate roof has a flat, stone-coped parapet. Along with developments at Wolverton, Buckinghamshire, and Swindon, Wiltshire, they were the earliest houses built for

193. Villas Road, New Bolsover. Semi-detached, late nineteenth-century houses occupying generous plots were built for colliery foremen and their families.

194. Clay Cross Hall (*c.* 1855), former home of Charles Binns, general manager of the Clay Cross Company, and son-in-law of George Stephenson.

195. 'Gaffers' Row', Clay Cross. A four-house early Victorian terrace built for foremen employed by the Clay Cross Company.

railway company employees in the country. Their survival is due to the efforts of the Derbyshire Historic Buildings Trust and the Derby Civic Society. Many large commercial companies of the period employed their own architects. John Sandars, working for the Midland Railway Company, was responsible for Highfield Cottages, Chaddesden (1865). Built for employees working at nearby sidings, these attractive terraces have small dormers spanning party walls.

Derby's three-storey Midland Hotel, designed by Francis Thompson and completed in 1842, was the first purpose-built railway hotel outside London. In the same red brick and slate as the contemporary employees' houses, it also draws inspiration from Georgian classicism. Projecting outer bays have first-floor balconies with balustrades, balanced by balustered panels in the centre bays. A stone string course takes in the first floor windowsills, and a hefty stone cornice underpins the attic.

Daylight and the seasons had governed pre-industrial life. Now, mechanisation, the factory system, and, most significantly, the railway brought a new importance to timekeeping. By 'natural' solar time, midday in Buxton arrives two minutes later than noon at Chesterfield. Countrywide time differences were much wider. Standard Time, introduced in 1840 and adopted across the rail network by 1847, was a fixture nationally by the 1850s. Derby's guildhall of 1828 – designed by Matthew Habershon (1789–1852) in sober Neoclassical style, with a rusticated arcade and Ionic columns supporting a pediment – caught fire in 1841 and had to be rebuilt. Derbeian Henry Duesbury (b. 1807) – a great-grandson of the founder of the porcelain works that became Royal Crown Derby, and borough architect from 1841 to 1854 – was charged with reconstruction. He replaced the pediment with a 103-foot-high bell tower sporting a prominent clock. Practical inasmuch

196. The Brunswick Inn, Derby (*c.* 1842). Part of a development for employees of the North Midland Railway.

197. Railway Terrace, Derby (*c.* 1842). Red-brick houses on a stone plinth with stone doorcases and cornices and a string course separating the storeys, built for engine drivers and their families.

198. Highfield Cottages, Derby (1865), built for Midland Railway Company employees working at Chaddesden sidings.

199. The first purpose-built railway hotel to be built outside London, Derby's Midland Hotel (*c.* 1842) is red brick with balustrade balconies, balustered panels, a string course taking in first-floor windowsills, and stone dressings that include a substantial cornice underpinning the attic floor.

200. Guildhall Derby. A
restrained Neoclassical design
of 1828 rebuilt after a fire in
1842 with the addition of a tall
central tower and a prominent
clock.

as the tower made the clock visible and the chimes were audible over a great distance, it was also an authoritative presence in the marketplace.

At Ashbourne, by now a predominantly brick town, civic pride demanded the dignity of traditional stone for a new town hall. Built in 1861 to a design by architect Benjamin Wilson, who had moved to Derby from Sheffield in 1859, it has a clock set inside a curved pediment above the roof, and a large porch with a balcony from which public proclamations can be made.

Chesterfield's impressive market hall of 1857 reflects the town's Victorian affluence and growing sense of importance, but is firmly Georgian in style, all symmetrical orderliness in red brick, with stone quoins and a hipped roof behind a parapet. Only the lofty clock tower reflects prevailing fashion. Chesterfield's other face lay between Low Pavement and the River Hipper, where 200 dilapidated houses crowded in on each other in densely packed yards known collectively as 'The Dog Kennels', which were cleared and redeveloped in the early twentieth century.

Picturesque architecture gave way to a more authentic Gothic revival, kick-started by the new Houses of Parliament, commissioned after a catastrophic fire destroyed the old building in 1834. The design, by Charles Barry (1795–1860) and the champion of English medieval architecture A. W. N. Pugin (1812–52), drew on Perpendicular Gothic roots to evoke nostalgia for past greatness and make an unequivocal statement about national pride. Gothic architecture's associations

Right: 201. Ashbourne Town Hall in traditional stone (1861) has a large porch with a balcony above for public announcements as well as a prominent clock.

Below: 202. Chesterfield's market hall (1857) reflects the town's growing prosperity in the mid-nineteenth century.

with pre-Reformation traditions and values made it the ideal style for Roman Catholic churches, and chimed with an emerging High Anglican movement that sought to realign the Church of England with its medieval roots. Pugin designed St Mary's Roman Catholic church, Derby (1838), in Perpendicular Gothic style, with panel tracery for the windows, and a tower with crocketed pinnacles. Henry Stevens shared Pugin's belief that Gothic architecture best symbolised the Christian faith. Stevens' churches of the 1840s and 1850s are fully realised Gothic Revival designs. At St George's church, Ticknall, and St Mary's church, Coton-in-the-Elms, he incorporates signature Derbyshire recessed spires inside battlemented towers. At Christ Church, Belper, and St John's church, Hazelwood, Stevens draws his inspiration from Early Gothic, but with hammerbeam roofs recalling one of Perpendicular Gothic's eye-catching innovations.

Nonconformists had been allowed their own places of worship following an Act of Toleration in 1689. Initially these tended to be simple meeting houses. By the mid-nineteenth century, dissenters were keen to stamp a recognisable architectural identity on their chapels. Aware of the High Church connotations of Gothic style, many turned to Neoclassical models. Chesterfield's Central Methodist chapel, Saltergate (1870), with Ionic columns supporting a triangular pediment, dentil eaves and a concealed roof, is an example. Differences in liturgical approach are reflected inside. An emphasis on seeing and hearing the minister made pulpits the focus of attention. A central aisle, traditional in Anglican and Catholic churches, was dispensed with, and seating was arranged to give all a clear view. Victorian

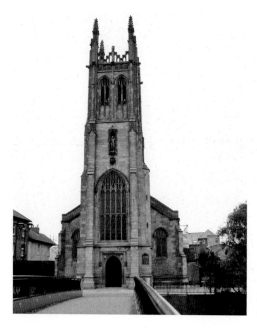

203. St Mary's church, Derby (1838), designed by A. W. N. Pugin. Perpendicular Gothic with crocketed pinnacles.

204. St George's church, Ticknall (1842), designed by H. I. Stevens with a typical Derbyshire spire recessed behind battlements.

205. St John the Evangelist church, Hazelwood (1840), by H. I. Stevens. Simple Early Gothic with a hammerbeam roof.

206. Chesterfield's Central Methodist Church (1870). Neoclassical architectural features, including Ionic columns and a triangular pediment, helped to set Nonconformist places of worship apart from buildings of the established Church.

notions of propriety led to modesty boards around some elevated pulpits, to guard against an accidental glimpse of ankle should the preacher be a woman.

Ashbourne Methodist Church, Church Street (1880), adopted a singularly Italianate freestyle approach, integrating leaded windows – some with brick arches, others with slender keystones, and two shouldered windows beneath prominent moulded sandstone lintels – and terracotta panels and friezes, in a Neoclassical façade of brick with stone detailing. Corinthian columns flank an entrance with Ionic columns and pilasters above, and there are side bays with balustered towers on either side of a central bay with a triangular pediment.

Serving as Mayor of Derby, textile magnate Joseph Strutt gave land for an arboretum – the first public park in the country. When it opened in 1840, the whole town took an afternoon off work to celebrate. A fanciful Neoclassical-inspired Italianate entrance lodge in brick with stone dressings (leading from Arboretum Square), added around 1850 to designs by Henry Duesbury, included a sculpture of Strutt gazing imperiously down from a niche beneath the central segmental pediment, lending a suitably cultured tone to a Sunday afternoon promenade.

In the confident mix and match of Victorian Derbyshire, architects increasingly fused English with Italian Gothic. Italian medieval architecture had absorbed Byzantine influences, notably the practice of incorporating different-coloured materials to produce striking polychrome effects. A commercial building in Green Lane, Derby, and a row of four cottages at Osmaston, built around 1870 – in which yellow brick has been used beneath the eaves, at the angles, and around mullioned windows – are among several local examples.

An architectural trend emerging in the 1870s, known as 'Queen Anne Revival', despite having little connection with that brief interlude (1702–14),

Right: 207. Ashbourne Methodist Church (1880). An Italianate Neoclassical façade decorated with terracotta panels and friezes.

Below: 208. Arboretum Square, Derby (c. 1850). A Neoclassical Italianate lodge in red brick with stone dressings at the entrance to Derby Arboretum. Textile magnate Joseph Strutt, who gave the land, gazes down from a sculpted niche.

Left: 209. The influence
of Italian medieval
architecture is on show
in the polychrome
brickwork and design
detail of this late
nineteenth-century
building in Green Lane,
Derby.

Below: 210. Yellow, blue
and red bricks give a
polychrome effect in
this row of four cottages
at Osmaston (*c.* 1870).

was enthusiastically embraced by the wealthy middle classes who, with rising social confidence and keen to assert themselves, found inspiration in Matthew Arnold's preface to *Culture and Anarchy* (1869), which encouraged 'the pursuit of sweetness' (i.e. culture in the sense of the creation and admiration of beauty) and 'light' (wisdom and its acquisition). Queen Anne style took elaboration and irregularity above the roofline to the point of eccentricity, borrowing widely from Gothic and Baroque as well as Dutch, Flemish and French-château styles, preferring steep, pitched roofs with decorative gables and bay windows to the classical tradition of concealed roofs and flat façades. Below the roofline, greater reserve prevailed. White woodwork is typical, and sash windows with small panes in the upper half, or casement windows with leaded lights, are common. Derby's Midland Railway Institute Building (1894), by the company's chief architect Charles Trubshaw (1841–1917), is a confection of Queen Anne Revival coupled with Italianate polychrome terracotta detail and banding.

At the beginning of the Victorian era, only the children of the privileged few received anything more than a rudimentary education. Half the population could not read or write. Growing social consciousness recognised the value of education as a basis for moral and cultural as well as intellectual improvement. The gradual spread of literacy led to reading rooms, Athenaeums (after Athena, Greek goddess of wisdom), and Mechanics' Institutes, providing education for skilled workers.

211. The rising confidence of an upwardly mobile middle class found expression in this example of late nineteenth-century Queen Anne Revival style in Derby. Below the roofline, symmetry prevails. Above, a dormer, pediments, tall decorative chimneystacks, a Dutch gable, and a polygonal turret vie for attention. White woodwork and windows with small panes in the upper half are typical.

212. Midland Railway
Institute, Derby (1894).
Victorian eclecticism
with muted polychrome
banding.

An Athenaeum with a reading room that made newspapers available, together
with a museum, was incorporated in the classical-style Royal Hotel (1840),
wrapped around the corner of Victoria Street and Corn Market, Derby. It was
designed by Robert Wallace in stone and stucco, with paired pilasters framing
attached Ionic columns and a hefty cornice below the attic floor. A canopy was
added in 1920. Mechanics' Institutes covered education in a broad sense, from
basic literacy and numeracy to cultural and personal development, social events,
musical concerts, and organised excursions. Joseph Strutt was instrumental in the
formation of a Mechanics' Institute at Derby in 1825. From rented rooms, the
Institute acquired its own premises before commissioning a new building from
architects Sheffield and Hill in the newly developed Wardwick. A three-storey
classical design in ashlar includes considerable decorative detail, with free-form
pilasters, a balustrade parapet, cornices at the attic and eaves, and semicircular
arched windows on the first floor that have prominent figurehead keystones and
baluster panels beneath. The frieze of the eaves cornice is carved with 'egg-and-
dart' motifs. A Mechanics' Institute established in Melbourne in 1841 proved so
successful that a purpose-built Athenaeum in Potter Street, housing an infants'
school and savings bank as well as the Institute, opened in 1854 to designs by
Henry Stevens. Lord Palmerston, a campaigner for better working conditions,
laid the foundation stone. He returned for the official launch. The brick building
is one of modest classical formality, with stone quoins and dressings, prominent
keystones, a hipped roof and a square Italianate tower.

Above: 213. Royal Hotel, Derby (*c.* 1840). A classical design in stone and stucco with a hefty cornice beneath the attic floor and paired pilasters framing attached Ionic columns.

Right: 214. Mechanics' Institute, Derby (1883). Purpose-built in classical style.

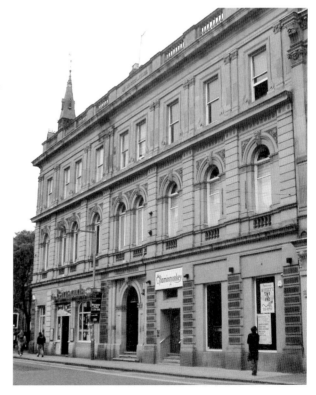

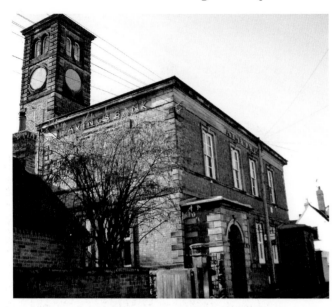

215. Athenaeum,
Melbourne (1854).
Classical formality
with an Italianate
tower.

There was demand from industry for a more skilled workforce, but it was not until 1870 that the government stepped in, establishing school boards in areas where no voluntary schools existed, and making elementary education compulsory in 1880. A flurry of school building followed, typically Gothic Revival, in red brick, with high windows designed to prevent pupils from being distracted by the world outside.

Derby's 1876 College of Art on Green Lane, by Frederick William Waller (1846–1933), is a confident reinterpretation of Gothic style for the Victorian age, featuring pointed arches and a projecting polygonal tower broached onto a rectangular base and lit by mullion-and-transom windows.

Tudor Gothic was Richard Knill Freeman's (1838–1904) main architectural inspiration for Derby's Central Library on the Wardwick, completed in 1879. Derby MP and head of the Bass brewing empire Michael Thomas Bass, whose statue stands outside, was the benefactor. In red brick with stone dressings, the imaginative design combines oriel windows, canted bays, mullions and transoms, pointed Gothic arches, battlements, and a clock tower with a spire. Moulded terracotta tiles and stained glass add an Arts and Crafts flourish.

The technical skill and finish of the best craftspeople of the Victorian age was outstanding and architecture was becoming much more professional, with proper training and high standards introduced by the Institute of British Architects, which was formed in 1834 and later became the Royal Institute. But build quality in the period was variable. The term 'Jerry-built' to describe shoddy workmanship first appears in 1869. In Victorian Derbyshire, urban terraces, once the epitome of civilised town living, were becoming irretrievably associated with downmarket

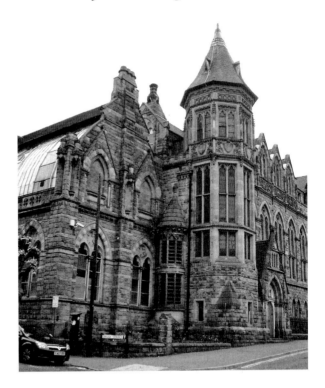

216. Derby College of
Art (1876). Confident and
innovative Gothic Revival. A
projecting polygonal tower is
broached onto a rectangular
base.

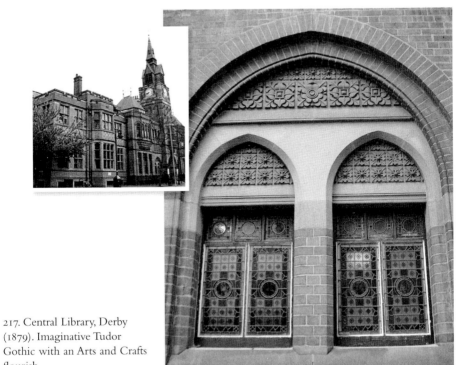

217. Central Library, Derby
(1879). Imaginative Tudor
Gothic with an Arts and Crafts
flourish.

workers' housing, the worst with tumbledown deprivation, overcrowding and poor sanitary conditions. Smoky, smelly, noisy industrial processes blighted towns. Efforts to culvert open drains were only slowly being realised. Cast-iron boot scrapers found beside the entrances to many town houses of the eighteenth and nineteenth centuries were extremely practical additions. Improvements to transport enabled the wealthiest townspeople to move to and develop country estates, where division between 'upstairs' and 'downstairs' was now total. Ideally, the domestic staff were not to be seen unless wanted. They were summoned by bell pulls from quarters situated as far away as possible from family rooms, and used separate servants' stairs. The middle classes sought escape in suburbia. Saltergate Terrace, Chesterfield, built around 1830, marked the end of an era for the Georgian middle-class terrace. Hartington Street, Derby, updated the concept in the 1870s, introducing a new style of posh suburban villa terrace – with houses large enough to accommodate a family and small domestic staff – set along a tree-lined parade. The three-storey dwellings with modillion cornices, canted bow windows and small front gardens surrounded by iron railings attracted Derby's gentry and commercial elite. Gates once stood at the entrances from Normanton Road and Osmaston Road, to emphasise the street's exclusivity.

The Arts and Crafts Movement introduced touches such as acid-etched or stained-glass detailing to modest houses, the first time the working-class home was deemed worthy of decoration. 'Arts and Crafts house' is a convenient shorthand description often applied, but it is difficult to define such houses with precision, since the movement was more about adherence to values and principles than to common design. Typical are an emphasis on relating structures to their setting through integrity of design, the use of good-quality local materials, traditional construction methods, and attention to vernacular style. Where Georgian houses were planned from the outside, beginning with a façade that in turn dictated the layout of internal rooms, Arts and Crafts devotees took a more organic approach, allowing an interior designed for convenience, comfort and repose to shape exterior elevations – a method that produced highly individual houses. Common features included leaded windows, decorative glass and terracotta detailing, gables finished with bargeboards, and design elements such as part-rendering, protective porches, and steep-pitched tile roofs with wide eaves – intended to impart a cosy, warm, welcoming feel.

Beginning in 1896, architect Alexander MacPherson (1847–1935) created a red-brick and terracotta Arts and Crafts oasis on the Liversage Estate in the Nottingham Road area of Derby. The largest houses on Nottingham Road have a decorative stone string course, stuccoed gables, and ornamental plasterwork known as 'pargeting'. More modest terraces on Keys Street have a simple string course, and either plain stucco or terracotta-hung gables, moulded stone door and window lintels, dripstones above round-headed entries, and inverted contrasting 'V' patterns in upper-storey brickwork.

Right: 218. Boot scrapers, such as this example in Church Street, Ashbourne, were commonplace in towns throughout the Georgian and Victorian periods.

Below: 219. The servants' hall, Chatsworth House. By the nineteenth century, domestic servants were part of the machine, summoned by bell pulls from quarters situated well away from family rooms.

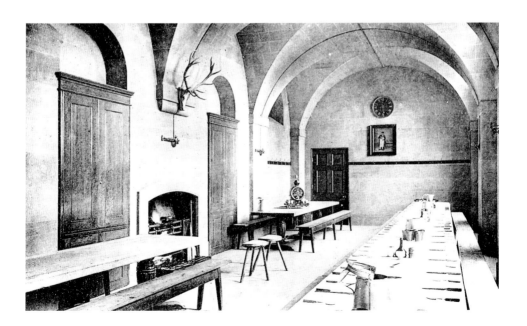

220. Saltergate Terrace, Chesterfield (*c.* 1830). A last fling for the Georgian middle-class terrace.

221. Hartington Street, Derby. A mid-Victorian update of the middle-class terrace. These three-storey suburban villa houses with canted bay windows, modillion cornices and small front gardens were designed to accommodate well-to-do families with a small staff of domestic servants.

Right: 222. Arts and Crafts-style houses, Nottingham Road, Derby (1899), in red brick with a stone string course, tile-hung and stuccoed gables, and decorative pargeting detail.

Below: 223. Arts and Crafts-influenced terrace, Keys Street, Derby (*c.* 1897).

The industrial age introduced new building materials. Improved manufacturing processes made good-quality plate glass available. Joseph Paxton used his experience of greenhouse and conservatory design as head gardener at Chatsworth House to create the Crystal Palace in Hyde Park for the Great Exhibition of 1851. In collaboration with Derby-born civil engineer Charles Fox (1810–74), whose company Fox & Henderson manufactured the ironwork, Paxton crafted a magnificent structure in iron and glass. The opening of the exhibition coincided with the abolition of window taxes that had been in place in one form or another since 1697, boosting the popularity of glass as a building material. The Crystal Palace had the first public conveniences, and it is here that the expression 'to spend a penny' is said to have originated. Visitors to the exhibition were charged one penny to use what were euphemistically called 'the retiring rooms'. Each customer received a comb, a towel, and a shoeshine. Paxton's apprentice at Chatsworth and his assistant on the Crystal Palace project was Edward Milner (1819–94), who went on to design Buxton's elegant iron and glass pavilion in 1871. Derby's market hall, opened in 1866, to designs by architect L. T. C. Thorburn (with later modifications by George Thomson), is a perfectly proportioned (220 feet by 110 feet) galleried tunnel vault of cast iron (manufactured locally by the Haywood engineering company) and glass, supported on iron columns.

224. Buxton Pavilion (1871). Elegance in iron and glass.

225. Market hall, Derby (1866). A perfectly proportioned tunnel vault of iron and glass with a gallery (inset).

Derbyshire's first steel-framed building was built on Friar Gate for Derby Gas Light & Coke Company, in 1889. This two-storey, red-brick building has steeply pitched gables flanking a central Jacobean-style Dutch gable, stone cornices above the ground floor and at eaves level, and a brick frieze bearing the company name.

The arrival of the railway in 1863 boosted the spa at Buxton. The Crescent was reconfigured to include town houses, a ballroom, and shops set inside rusticated arcades on the ground floor. Buxton's population trebled to more than 6,000 within two decades. Joseph Paxton advised on designs for twin railway stations to serve the Midland and the London & North Western railway companies. A large fan window survived demolition when the stations were replaced in 1970. The coming of the railway was not an unmixed blessing for the spa industry. Buxton and Matlock became more accessible, but an expanding rail network widened the choice for potential patrons, increasing competition by putting the seaside within reach for a large part of the population.

For the Victorians, the social aspects that were so much a part of the Georgian spa no longer presented the same attraction. In 1853, John Smedley (1803–74), born in Wirksworth and owner of a successful textile mill at Lea, spotted an emerging trend and took over a recently opened 'Hydro' at the top of Matlock Bank. Hydrotherapy – invented in the 1820s by Dr Vincent Priessnitz, an Austrian

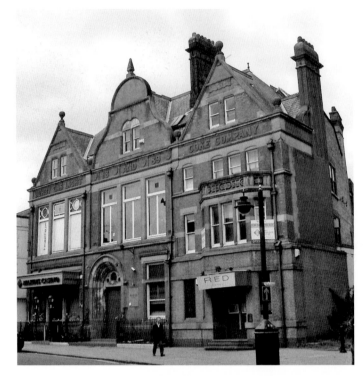

Left: 226. The Derby
Gas Light & Coke
Company building
(1889). Derbyshire's
first steel-framed
building.

Below: 227. Fan
window, preserved
when Buxton's twin
railway stations were
replaced in the 1970s.

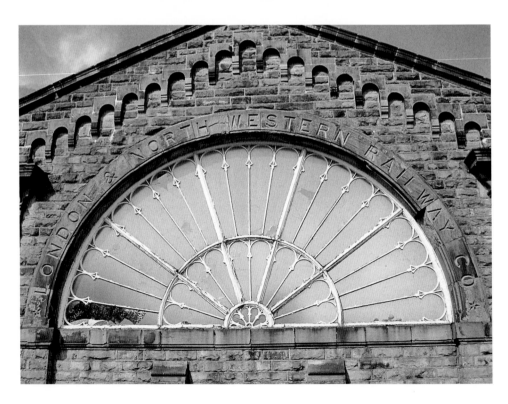

Right: 228. Smedley's Hydro, Matlock, now Derbyshire County Council HQ. A large Neoclassical extension with Tuscan columns defining a grand entrance was added in the 1880s alongside a Gothic Revival building complete with battlements of twenty years earlier.

Below: 229. Riber Castle (*c.* 1865). Fanciful Gothic Revival prominent on the Matlock skyline.

farmer, and introduced to England by Dr John Wilson at Great Malvern, offering water cures for a range of fashionable Victorian ailments – became hugely popular. Treatments could be fairly drastic, particularly for an invalid. At Matlock, Smedley offered hydro 'lite' in luxurious surroundings. The complex – which originally included a chapel (since demolished), reflecting Smedley's own devout Christian beliefs – was an immediate success, and in subsequent years it was considerably extended. Smedley's initial building was Perpendicular Gothic in style, complete with battlements. Additions by his successors from the mid-1880s show diverse Continental and Neoclassical influences. After the Hydro closed in 1955, the buildings were bought as headquarters for Derbyshire County Council.

Riber Castle, a Gothic Revival fantasy of battlements and angled turrets planned by Smedley as a family home and built in the 1860s on the summit of Riber Hill, overlooks Matlock to the north from its elevated perch. Unoccupied for much of the early part of the twentieth century, it slowly degenerated, and today presents a crumbling, eerie silhouette. In the 1960s it became a wildlife park and it is now subject to plans for development into apartments.

THE ART OF THE POSSIBLE
Modern Derbyshire

A second generation of architects carried the banner for Arts and Crafts ideals into the twentieth century. Raymond Unwin (1863–1940) began his career designing workers' cottages for Staveley Iron & Coal Company before joining Chesterfield-born Barry Parker's (1867–1947) Buxton-based practice. Best known for designing the first Garden City, at Letchworth (1903), the pair were responsible for a number of notable buildings in Derbyshire, including St Andrew at Barrow Hill, Staveley, and private houses in Chesterfield (The Homestead), Derby (Austwick, Duffield Road), Buxton (Greenmoor, Carlisle Road), Matlock and Repton. Austwick features a row of tall, narrow upper-floor windows reminiscent of a traditional weaving attic. John Sydney Brocklesby's (1879–1955) design for St Andrew's church, Langley Mill (1911), draws inspiration from Early Gothic, with lancet windows and a nave arcade of pointed arches carried on piers with scalloped capitals. Craftsman-made carpentry fittings including transept screen, pulpit, and turned wood balusters supporting the altar rail, reflect Arts and Crafts values. Locally quarried stone (coursed rubble for the main building, dressed blocks for the quoins and chamfered window surrounds) anchors this simple sturdy church in the surrounding landscape. For St Bartholomew's church, Addison Road, Derby (1927), Derby-born architects Percy Heylyn Currey (1864–1942) and Charles Clay Thompson (1865–1942) produced a red-brick building with cream render, leaded windows and a steeply pitched tile roof, reminiscent of suburban Arts and Crafts-influenced houses.

Architects absorbed Continental influences from the world of decorative art and design. An Art Nouveau flourish has been attributed to the flowing ornamental stonework on the ground floor of what is now the RBS bank in Chapel-en-le-Frith. Guttering at the New Inn, Ilkeston (1904), designed by local architect Harry Tatham Sudbury (1877–1959), is supported on slender, sweeping Art Nouveau iron brackets. Matching brackets suspend a hood above the entrance. Ilkeston Library, built as the Carnegie Library in 1904 to designs by Belper architects

230. Austwick, Duffield Road, Derby (1902–03), designed by Barry Parker and Raymond Unwin. In rendered red brick, with angled bays, a pyramidal roof, and a row of single-light upper-storey windows reminiscent of traditional Derbyshire weaving attics.

231. St Andrew's church, Langley Mill (1911). Locally quarried stone and craftsman-made furnishings reflect Arts and Crafts values.

232. St Bartholomew's church, Derby (1927). A church in domestic Arts and Crafts style of red brick and cream render with a steeply pitched roof.

Hunter and Woodhouse, in brick and ashlar, incorporates four Art Nouveau sculpted relief panels between the central windows above the entrance. A range of classical elements are freely combined in the library, including a row of five keyed *oculi* and a rusticated basement visible towards the rear from the side of the building – reminiscent of Chatsworth House in that its purpose is to overcome the problem of a sloping site. Hunter and Woodhouse went on to design Belper River Gardens, including the Swiss-style tearooms, in 1906. The Italianate towers on an extension to Masson Mill added by the English Cotton Sewing Company around 1912, and on the 1928 seven-storey Accrington red-brick East Mill, Belper, have distinctly Art Nouveau lettering.

Influenced by the Arts and Crafts Movement but more concerned with form, beauty and aesthetics than practicality, Art Nouveau – with its elongated, 'whiplash' lines – remained chiefly about embellishments and interiors. But at York Chambers, 40 Market Place, Long Eaton (1903), architects Edmund Herbert Child (d. 1938) and James Gorman (1876–1920) of Child, Gorman & Ross, showed what could be achieved. This distinctive building (commissioned by the Midland Counties Bank) has a segmental window with a massive double keyblock on the ground floor. On the first floor, timber studs and brick nogging set off a series of four tall, slender, ultra-modern oriel windows. Above a second storey is a shaped gable with an arch of green, blue and cream tiles framed by overhanging eaves and plain bargeboards.

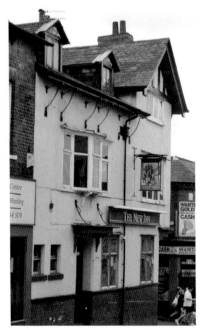

Above: 233. Art Nouveau-inspired decorative stonework, Chapel-en-le-Frith.

Left: 234. Typically elongated Art Nouveau iron gutter brackets on the New Inn, Ilkeston.

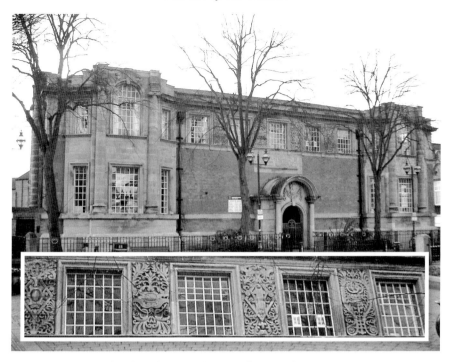

235. Art Nouveau sculpted panels (inset) decorate Ilkeston Library (1904).

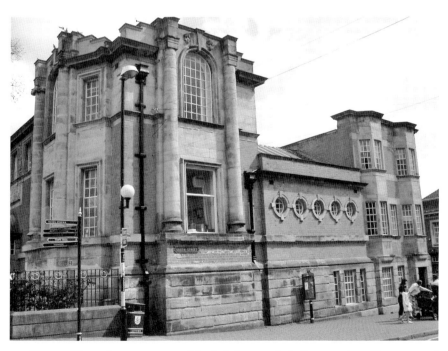

236. Ilkeston Library features a range of classical elements, including a rusticated basement and a row of keyed *oculi*.

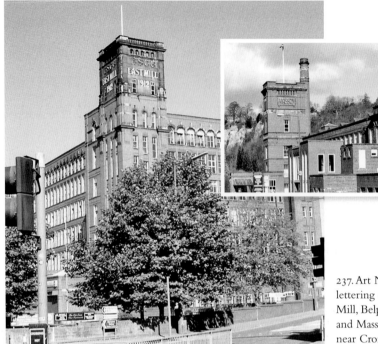

237. Art Nouveau
lettering on East
Mill, Belper (1928),
and Masson Mill,
near Cromfrod
(1912, inset).

Exaggerated vertical lines, flowing curves and coloured tiles are quintessential
Art Nouveau. James Gorman had moved to Long Eaton from Scotland to set up
an architectural practice with Child and Ross in 1900. The trio designed new
offices for themselves next door to the Midland Counties Bank building as part
of York Chambers at No. 38. Their adoption of fluid Art Nouveau lines can also
be seen in the ironwork detail of the Carnegie Library, Long Eaton, but the
partnership was a brief one, ending in 1904 when Gorman moved abroad to
work in Penang.

There was little demand in Derbyshire for the startling modernity of Art
Nouveau. The affluent, middle-class, house-buying public wanted 'period'
properties. Georgian rectories became desirable. Sir Edwin Lutyens (1869–1944)
understood his clients, and mixed Queen Anne eclecticism with Arts and Crafts
fundamentals to produce distinctive modern properties such as Easton House,
Repton (1907), and Ednaston Manor, Ednaston (for tobacco magnate W. G. Player
in 1912). These houses were inventive, yet reassuringly rooted in tradition. Lutyens
also worked on park buildings at Renishaw Hall.

Charles F. A. Voysey (1857–1941) brought an equally original touch to his
highly influential designs rooted in Arts and Crafts principles. Hailed as 'the father
of suburbia', Voysey turned his very English palette not only to country houses
and suburban villas (a Voysey-esque house in Doveridge with white rendered

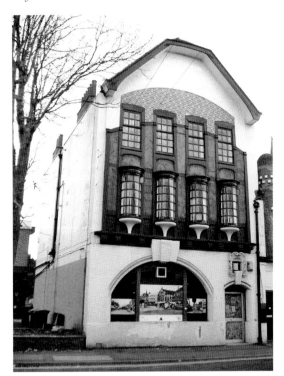

Right: 238. York Chambers, Long Eaton (1903). Exaggerated vertical lines, flowing curves and the use of coloured tiles are quintessential Art Nouveau.

Below: 239. The influence of Charles Voysey is visible in the white render, sloping buttresses and the wide, welcoming entrance of this charming house in Doveridge.

walls, a wide, welcoming protective entrance and sloping buttresses is typical of his style), but also to cheerful, economical designs for artisans' houses and terraced cottages. Comfort and cosiness was at the heart of Voysey's work.

Derbyshire's population had increased sharply in the latter half of the nineteenth century, largely as a result of expansion in the coal industry. In 1902, an Act of Parliament transferred responsibility for education from school boards to county councils and borough authorities. A countywide programme to refurbish existing schools and build new schools followed, driven partly by a rise in the number of children, but also to meet demands for higher standards of health and hygiene in education, and in anticipation of plans to raise the school leaving age to fourteen. Leading efforts was George H. Widdows (1871–1946), appointed architect to Derbyshire Education Committee in 1904, and from 1910 to 1936 chief architect to the County Council. Widdows had radical ideas. That he was able to put these into practice is testament to the confidence he inspired. His most experimental design was for Ilkeston School (then a secondary school, now a specialist arts college), which opened in 1914. Rows of classrooms in four single-storey, part-cement-rendered, red-brick blocks form a quadrangle linked by four covered walkways with cloister-like verandahs to a central octagonal hall. The hall is red brick with a concrete dome and the interior is filled with light from seven large Diocletian windows and eight *oculi* in the lantern of the dome. Slim pilasters, a patterned frieze and a dentilled cornice around the quadrangle reinforce a plain, classical look. Ornamental tile strips and pebbled panels owe something to Arts and Crafts principles. Gateposts echo the building's profile. Dramatically different from its dark, Gothic Revival predecessors, Ilkeston School was spacious, light and well ventilated. Opinion on how successful the building was is divided. Fresh and airy in summer all too easily translated into cold and draughty in winter. Widdows repeated the design, with different decorative detail, for New Mills Grammar School, completed in 1915.

The confidence and order of Edwardian England was shattered in 1914. No one was untouched by the First World War. Zeppelin airships unloaded a deadly payload on Derby over two nights in 1916. Derbyshire's war memorials make grim reading; some villages effectively lost a generation of young men. Sir Edwin Lutyens designed the Midland Railway war memorial on Midland Road, Derby, in 1921. The euphoria of peace was followed by depression and unemployment. Over 90 per cent of homes were privately rented, and a housing shortage drove rents up as a proportion of wages. In Derby, urban sprawl had conferred a legacy of unhealthy, overcrowded conditions – problems made worse by an antiquated, inadequate infrastructure that deterred private developers. Public authorities had to intervene, but simply clearing defective houses without making replacements available would have been counterproductive. Planning permission for an initial tranche of council houses in Derby was granted in 1920. Progress was slow, picking up when the council pioneered the building of semi-detached

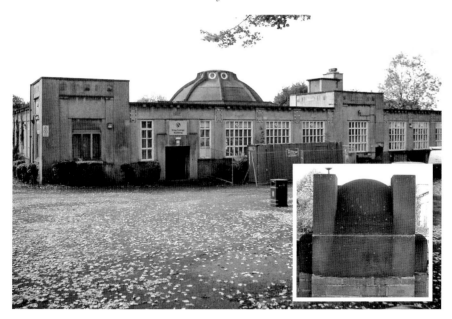

240. Ilkeston School (now a specialist arts college), built in 1914. Rows of classrooms in four single-storey, part-cement-rendered red-brick blocks form a quadrangle linked by four covered walkways to a central octagonal hall with a concrete dome. *Inset:* Gateposts emphasising small towers at the corners of the quadrangle reflect the building's profile.

homes with cast-iron frames. The first estates to use this innovative technique grew up at Allenton and off Osmaston Park Road. These were not high-density developments. Generous garden plots, intended as an encouragement for tenants to grow vegetables for the table, were a key feature.

Economic downturn in the 1920s led to a questioning of received values. People sought change, a break with the past, a new vision signifying hope for a brighter future. Experimental architectural forms appeared that owed little to earlier precedents. Instead, the designs looked forward to a new environment fit for a progressive modern society in which technical innovations such as electricity, telephones and cars were becoming part of daily life. Architects deliberately drew attention to their use of modern materials such as metal window frames and rendered cladding. Aiton & Company's two-storey office block in Stores Road, Derby, completed in 1931, was the first industrial building in a Modernist style in Derbyshire, and among the first anywhere in the United Kingdom. Planned by Elizabeth Whitworth Scott (1898–1972) with contributions from Norah Aiton, it was an exercise in cutting-edge design. The steel frame has a blue-brick ground floor below a rendered upper floor and parapet. Continuous glazing bands light the interior. Recessed windows at one end of the building define the former boardroom. Semicircular tubular steel brackets hold a cantilevered hood above the entrance.

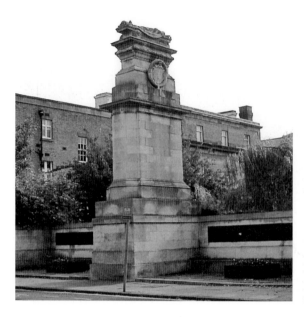

Left: 241. Midland Railway war memorial, Derby (1921), by Sir Edwin Lutyens.

Below: 242. Semi-detached council housing in the Allenton and Osmaston Park Road area of Derby (1920s) pioneered the use of cast-iron frames to speed construction.

In a changing world, art too found new directions. Art Nouveau failed to make much of an architectural impact in England, but Art Deco patterns, based on stylised geometric figures, concentric arches, and angular ornaments (lightning bolts and zigzag motifs are typical), were a major influence on building design. Enthusiastically adopted in the USA and dusted with Hollywood glitz, Art Deco spread worldwide. Epitomised by a clean, horizontal linearity, the style's freshness and modernity perfectly caught the progressive spirit of the age. Cinemas, such as the 1934 Gaumont in London Road, Derby (later converted

243. Former Aiton & Company's two-storey office block, Derby (1931). The first 'modernist' industrial building in Derbyshire.

into Zanzibar nightclub), by specialist architect William Edward Trent, were perfect vehicles for Art Deco expression. Even less exotic designs such as Swadlincote's New Empire, rebuilt in 1930, had a scale and sweep that conveyed an air of glamour, providing affordable weekly excitement, a welcome escape from reality, and courting opportunities. Ilkeston's former Ritz (1938), designed by celebrated cinema architect Reginald Cooper of Nottingham, drew liberally from the designs pioneered in this country by the Odeon chain, and is an elegant example of a 1930s 'picture palace', featuring a slender tower, clad with Doulton Carraware tiles, that rises like the fin of a shark above the building's sleek curves.

Retailers were quick to espouse Art Deco style. Derby Co-operative Society's own architect Sidney Bailey employed continuous glazing strips to emphasis flowing horizontal lines. At Woodville, the Clock Garage struck a modern pose.

Rolls-Royce's main site on Nightingale Road, Derby, evolved from its origins in 1907 as a series of modular steel-framed, red-brick buildings into a massive factory and office complex. When the central entrance block was remodelled to include a slender balcony in 1938, architects Arthur Easton & Son gave essentially classical features a contemporary twist. Within a distinctively Art Deco profile, Portland stone facings with bevelled edges on the ground floor recall rustication; the roof is concealed behind a parapet decorated with a reed-moulded frieze; and a pair of giant pilasters unify the upper storey.

Above: 244. Art Deco expression. The former Gaumont cinema, Derby (1934).

Left: 245. The former New Empire cinema, Swadlincote, rebuilt (1930) in Art Deco style.

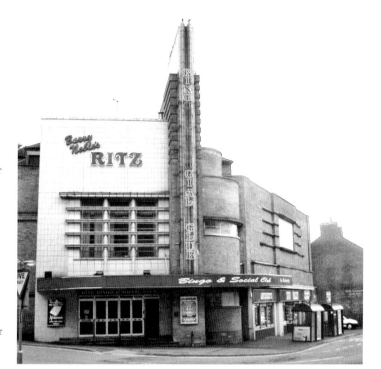

Right: 246. Former
Ritz cinema,
Ilkeston (1938),
with distinctive
fin tower clad in
Doulton carraware
tiles.

Below: 247. Art
Deco store, Derby
(1930) designed by
Robert Lutyens for
Marks & Spencer
Ltd.

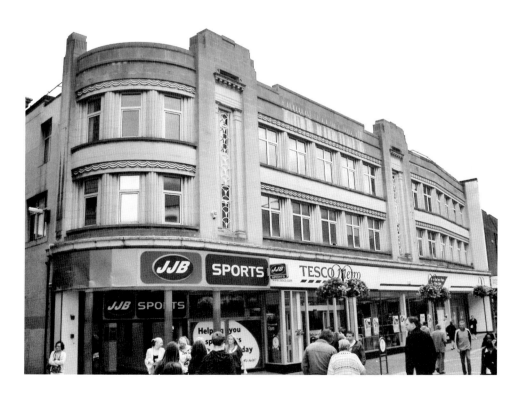

Above: 248. Geometric Art Deco lines, Long Eaton.

Left: 249. Art Deco store, Chesterfield.

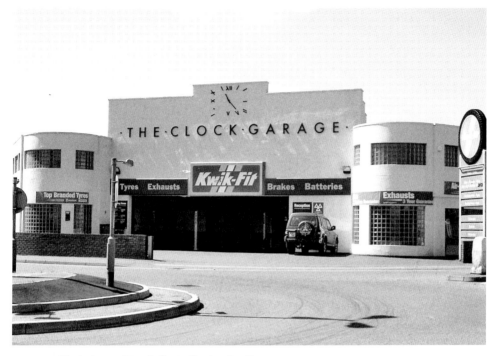

250. Clock Garage, Woodville. Utilitarian Art Deco.

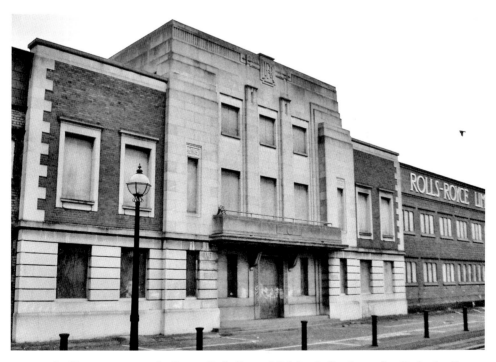

251. Art Deco entrance to the former Rolls-Royce Nightingale Road complex, Derby (1938).

Civic pride in Derby was given a boost in 1927 when a new see was carved out of the dioceses of Southwell and Lichfield. All Saints' church became a cathedral, and Dr Edmund Pearce was appointed Bishop of Derby. Problems associated with economic recession remained. Public investment was one way of tackling unemployment, and plans to improve central Derby, spearheaded by borough architect Charles Herbert Aslin (1893–1959), were drawn up. His blueprint for a new council house was an unimaginative throwback to eighteenth-century reserve – red brick with ashlar dressings, and a two-storey classical portico. Elsewhere in Derby, Aslin embraced Streamline Moderne, a parallel movement to Art Deco with an emphasis on rounded, sweeping lines.

Streamline Moderne proved the perfect accompaniment to Derby's essentially sinuous layout. The heart of Derby is distinguished by gentle curves, most obviously in The Strand, a formal crescent complemented by a Neoclassical terrace, but also in Victoria Street, Albert Street, St James Street, Full Street, Queen Street, Sadler Gate and Iron Gate. Waves of platforms rippling through Charles Aslin's recently redeveloped 1930s bus station mirrored this. Wrapped around corners, the frontages of Derby Building Society (originally Barlow & Taylor's, 1925), the Charles Aslin-designed Queen's Leisure Centre (1932), and the former Ranby's department store (1962, later Debenhams), harmonise beautifully with the city centre's flowing lines.

252. The Strand, Derby, was laid out in 1878 after Markeaton Brook was culverted.

253. Curving lines define Derby city centre.

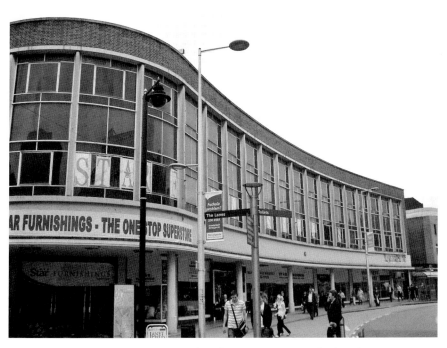

254. Recurved sweep of the former Ranby's department store, Derby (1962).

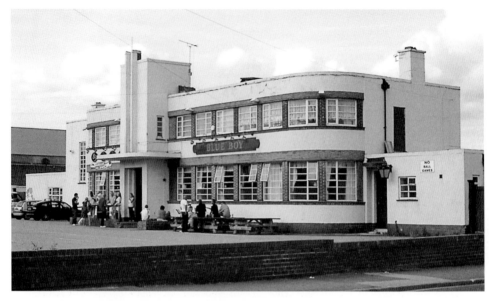

255. Blue Boy, Chaddesden: suburban Streamline Moderne.

Streamline Moderne reached into outer Derby with three 'blue' public houses: Blue Boy, Chaddesden; Blue Peter, Alvaston; and Blue Pool, Sunnyhill. Derby College's four-storey Joseph Wright Centre (by Cedar House Investments, 2005) seductively swept around Chapel Street to a frontage on St Alkmund's Way. Derby's Westfield Centre (2007) – a square block on the skyline but sensitively cambered around the angle of London Road and Traffic Street – put a twenty-first-century spin on the same theme.

An underlying theme throughout this look at the buildings of Derbyshire has been the gradual shift away from the norm of communal living, influenced by both social and economic factors. It is a trend that has gained pace and momentum in the first decade of the twenty-first century. One in every three households is a single-person household. Coupled with a rising population, this has led to a boom in house building to meet increased demand, with affordability and eco-friendly sustainability elusive touchstones.

An emphasis on sustainable resources was a key consideration in the commissioning of the Quad Building, a community arts and media centre in Derby, embracing a gallery, two cinemas, exhibition space, workshops and a café bar. It was completed in 2008. The successful design by the Feilden Clegg Bradley Studios – an architectural practice formed in 1978 by Richard Feilden (d. 2005), Peter Clegg, and Keith Bradley – uses mostly locally sourced materials, including stone for the individually designed tile cladding. A three-storey building of canted columns and jutting, oblique angles, the Quad elbows its way dramatically into the corner of Derby's Market Place.

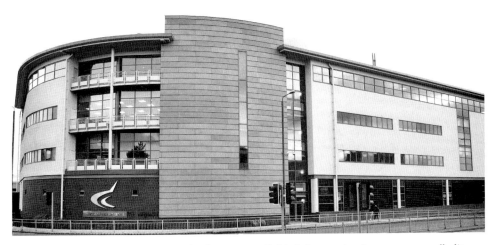

256. Derby College's Joseph Wright Centre, 2005. Behind the curving frontage, a naturally lit atrium reaches the full height of the four-storey building.

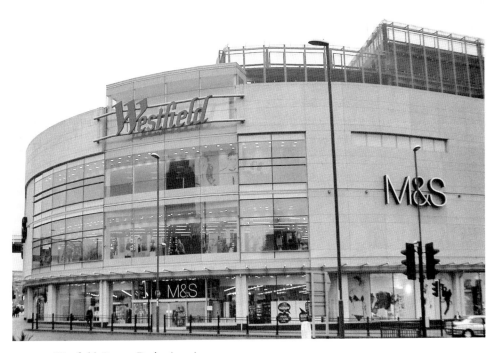

257. Westfield Centre, Derby (2007).

258. The Quad Building (2008) makes a dramatic statement in Derby's Market Place. Tilting angular storeys house a gallery, two cinemas, a café bar, workshops and exhibition space. Designed by the Feilden Clegg Bradley Studios with sustainability in mind, the structure employs locally sourced materials, including Derbyshire stone for the tile cladding.

Modern buildings no longer spring from centuries-old traditions, and the Quad Building is something of an exception with its local materials. In any case, quarrying is a contentious business, however sustainably pursued, and alternatives such as ferro-concrete and glass are flexible and practical. What perhaps counts most is build-quality and bespoke designs sensitive to context and character. One of Derbyshire's most unusual contemporary buildings, with an exemplary functional and sensitive design, is the multi-award-winning David Mellor Round Building, Hathersage (1990), a circular cutlery factory by Sir Michael Hopkins (b. 1935). Perfectly at ease in an area of outstanding natural beauty, it is built from local gritstone, and has a stunningly conceived lead roof. The circular shape derives from its reuse of the foundations of a demolished gasometer. Ignoring local integrity and distinctiveness leads to architecture that is arbitrary, inferior, artificial and boringly uniform. Contact between architect and customer tends to be mediated by developers, who apply a degree of 'off the shelf' standardisation that satisfies few.

Change is inevitable, but too much fine architecture has been lost. Our system of 'listing' buildings of special interest, the establishment of designated Conservation

259. The David Mellor Round Building, Hathersage (1990), occupies the site of a former gasometer.

Areas, and an increasing awareness of the need to safeguard buildings that preserve a valuable physical record of the age and society that produced them, have helped to stem the tide and should ensure recognition and protection for significant buildings in the future. Comprehension of old structures helps us treat them more sympathetically. True appreciation requires seeing them in their historic and social context, not simply as bricks and mortar or stone and glass. Old buildings are both of their time and of the present; they are a tangible link with the past that we can explore today. 'If only these walls could talk,' is a commonly heard saying. Perhaps, if we understand the language, they can. We can't visit Bess of Hardwick or Joseph Pickford in person. We can't talk to one of the Clay Cross Company foremen from 'Gaffers' Row', or a factory hand from Richard Arkwright's pioneering mill at Cromford, but seeing where and how they lived brings us close, and provides valuable insight into their world and our shared past.

Vernacular building in particular sets the character of a place, reflecting, and to an extent defining, our landscape, society and way of life. Derbyshire Historic Buildings Trust, local civic societies and other charitable institutions have protected, preserved or rescued many 'at risk' buildings, guaranteeing them a new

lease of life. Protecting buildings by 'listing' distinguishes what is internationally or nationally significant in terms of architectural merit and historic interest from that deemed of merely local importance. Ideally, 'listing' also offers a framework for the sensitive management, development and future use of buildings. Conservation Areas recognise the importance of local character, and provide additional planning constraints that control and guide development. What we must not overlook is the value of architecture in engendering pride and a sense of place. Millions of people visit Derbyshire annually; the vast majority are 'repeat customers'. The contribution of tourism to the local economy is inestimable. Visitors are attracted to the whole package, countryside and buildings combined. Derbyshire retains a collective coherence, individuality and texture to a greater extent than many other counties. In a world that is increasingly homogenous, it is a pleasing conceit to look around and think, 'This couldn't be anywhere else.'

APPENDIX I

THE MAIN ARCHITECTURAL PHASES AND THEIR DEFINING FEATURES

Anglo-Saxon (*c.* 500–1066)

- long-and-short work
- small doors with rounded tops
- small windows (narrow slits), some cut from single block of stone, others with a simple flat lintel or semicircular/triangular head

Norman/Romanesque (*c.* 1050–*c.*1190)

- semicircular arches
- splayed windows
- 'orders' of arched mouldings and colonettes decorating doorways
- massive walls
- herringbone masonry
- circular piers
- cushion capitals, capitals with waterleaf and scallop decoration
- barrel vaults
- bold chevron, lozenge, beakhead, billet, cable decoration
- blank or 'blind' arcades

Early Gothic (*c.*1190–*c.*1250)

- pointed arches
- slimmer piers with clustered columns or shaped profiles, e.g. octagonal
- 'X' ribbed vaults
- lancet windows
- steeples
- stylised stiff-leafed carving and crocket ornament
- dogtooth and nailhead ornament

Decorated Gothic (*c.*1250–*c.*1350)

- complex window tracery (shaped stone bars)
- rich surface treatments

- dramatic decorative and naturalistic carving
- ballflower ornament and more elaborate crockets on sloping surfaces

Perpendicular Gothic (*c.*1350–*c.*1540)

- larger windows, panel tracery
- flattened arches
- flatter, concealed roofs, battlements
- raised walls, insertion of clerestories
- fan vaults
- hammerbeam roofs

Tudor/Elizabethan/Jacobean (*c.*1540–*c.*1640)

- ostentatious 'prodigy' houses, crenellations
- E-plans, H-plans
- long galleries
- use of brick
- chimneys
- shaped gables
- oriel windows

Renaissance (*c.*1640–eighteenth century)

- classical columns/orders
- balustered parapets
- loggias
- pediments
- hipped roofs
- rustication
- arch-topped and round windows
- cupolas

Baroque (*c.*1690–*c.*1730)

- extravagant decorative embellishment
- freely interpreted classical influences, e.g. broken pediments, curved pediments, exaggerated keystones

Georgian themes (1715–1830)

- Palladianism; Venetian and Diocletian windows
- Neoclassical invention, elegance and symmetry
- town houses, terraces, squares, crescents, circuses
- sash windows with wedge lintels and flat or segmental gauged brick heads
- industrial housing

Picturesque (*c.*1785–late nineteenth century)

- irregularity
- applied timber studding

- leaded and diamond-paned windows
- elaborate bargeboards
- porches and verandahs
- oversized chimneys
- square Italianate towers
- follies

Gothic Revival (*c.*1830–*c.*1900)

- irregularity
- dramatic impact
- pointed and four-centred arches
- turrets and battlements
- Venetian Gothic polychrome brick and stone work

Queen Anne Revival (late nineteenth century)

- irregular rooflines with decorative turrets and gables
- sash windows, small-paned in the upper half
- casement windows with leaded lights
- white woodwork
- fancy brick and terracotta tile detail

Arts & Crafts (late nineteenth century–early twentieth century)

- vernacular traditions, local materials
- stained glass and terracotta detail
- steep pitched roofs
- bargeboards
- part rendering

Art Deco (*c.*1910–*c.*1930s)

- angular geometric shapes and curves
- stepped profiles, chevrons, zigzags, lightning bolts

Streamline Moderne (*c.*1930s)

- emphasis on curving lines
- architectural use of electric light

Modernism (twentieth century)

- abstract designs
- lack or ornamentation
- use of manmade materials such as ferro-concrete and steel
- attention deliberately drawn to materials

APPENDIX II

Glossary

apse: curving or polygonal east end of a church

arcade: row of arches supported on columns; **blank** or **blind** if attached to a wall and filled

arch: method of spanning an opening without use of a **lintel**

architrave: frame around an opening, e.g. a door; or the lowest part of a classical **entablature**

ashlar: regular, smooth masonry

attic: top storey of a house, lower in height than the floors beneath

ballflower: carved stone ornament of three petals enclosing a ball

baluster: upright post, often vase-shaped, supporting a rail

balustrade: horizontal rail supported by a series of short, upright posts or **balusters**

bargeboard: wooden strip protecting/decorating the angled **eaves** of a **gable**

beakhead: carved stone ornament of bird/beast heads biting a **roll moulding**

billet: carved stone ornament of raised blocks or cylinders

blank/blind arcade: a series of arches without openings attached to a wall for decoration

bond: pattern of laying bricks or regular stonework

box frame: timber building skeleton constructed of roof trusses on a framework of upright posts and horizontal **tie-beams** and **wall plates**

bracket: projecting support

broach: sloping masonry connecting an octagonal spire to a square tower

broken: (of a **pediment**) an opening or interruption of the base or apex

cable moulding: carved stone ornament resembling a twisted cord

capital: stone block on top of a column

cartouche: decorative panel used as a framing device

casement: window attached to its frame by hinges

castellation: parapet shaped like the battlements of a castle with crenellations, i.e. regular spaces (embrasures) between raised sections (merlons)

chamfer: bevelled, sloping surface created by shaping the edge of a block of stone or wood

chevron: carved stone zigzag decoration

clerestory: range of high-level windows, usually either side of a nave in a church

cob: walling of clay/mud strengthened with pebbles/straw/horsehair/etc.

collar: auxiliary **tie-beam** between the principal rafters of a roof

colonnade: row of columns

colonnette: small column, decorative rather than structural

console: a curved supporting **bracket**

coping: covering course of masonry

corbel: projecting supporting stone

corbel table: series of **corbels** beneath the **eaves** of a roof

cornice: decorative projecting **moulding** along the top of a building; in classical architecture, the top part of the **entablature**

cour d'honneur: forecourt

coursed masonry: stonework built up in regular, even levels

crenellation: castle-like battlement (see also **castellation**)

crocket: projecting carved stone foliage ornament

crown post: central roof post arrangement with a braced vertical post rising from a high-level **tie-beam** to the underside of the ridge

cruck frame: A-shaped building frame

cupola: small decorative dome

cushion capital: a capital with a flat top and rounded off beneath as if pressed down from above, properly sculpted from a cube but also used of flatter versions

dentil: small square block used in series to form a decorative **moulding**, usually at the eaves

diaper: chequered or diamond pattern

Diocletian window: semicircular window with two **mullions** (see also **lunette**)

dogtooth: carved stone ornament resembling a stylised four-petalled flower raised in the centre

dormer window: vertical window set in a sloping roof

drip moulding/dripstone: projecting **moulding** to throw off rainwater

eaves: overhang of a roof

egg-and-dart: decorative **moulding** with alternating oval shapes and arrowheads

elevation: any vertical face of a building

entablature: in classical architecture the **architrave**, **frieze** and **cornice** above a column

fanlight: window, generally semicircular, above a door

frieze: decorative band; in classical architecture, the central band between **architrave** and **cornice**

gable: triangular end of a pitched roof

gauged brick: soft brick that can be moulded, rubbed or cut to an exact size and shape for use in arches or ornamental work

Gibbs surround: alternating large and small or projecting and flat masonry blocks around a door or window

groin/cross vault: intersecting barrel or **tunnel vaults**

half-timbered: building with exposed wood frame

hammerbeam roof: roof in which short hammerbeams support timber **trusses** and **purlins**

hipped roof: roof pitched on all four sides

hoodmould: projecting **dripstone** above a window or door opening, with a short vertical 'leg' at each end to throw off rainwater (see also **label**)

impost: projecting block supporting the end of an arch

jetty: overhanging or oversailing upper storey

keyblock/keystone: central locking stone in an **arch**

king post: roof arrangement with a vertical post rising from a **tie-beam** to the ridge

kneeler: projecting stone at the base of **gable**-end **coping**

label: straight **dripstone** or drip moulding; see also **hoodmould**

lancet window: tall, slender window with a pointed top

light: vertical division of a window

linenfold: pattern of wood panelling carved to look like folded cloth

lintel: stone or wooden beam above an opening

loggia: covered gallery or passage open on one or more sides and often with a **colonnade** on one side

long-and-short work: Anglo-Saxon method of using alternating vertical and horizontal blocks around door/window openings and at the angles of external walls

lunette: semicircular window (see also **Diocletian window**)

modillion cornice: cornice supported by a series of small brackets

moulding: carved decoration

mullion: upright post dividing a window into **lights**

nailhead: pyramid-like decorative carving

narthex: covered porch at the entrance to a church

nogging: brick or tile filling between timbers

oculus: oval or circular window

order: one of the main styles of classical columns and **entablature** or one of a series of decorative steps around a door/window

oriel window: projecting upper window

parapet: edge of a wall projecting above roof level

pargeting: ornamental plasterwork

pediment: decorative gable, especially above a **portico** or over doorways and windows; may be triangular, curved and/or **broken** at the base or apex

perron: platform or steps at an entrance

piano nobile: main floor of a house, usually the first floor

pier: large supporting masonry column

pilaster: flat column attached to a wall

plinth: projecting bottom section of a wall

portico: projecting covered area with a **colonnaded** front

post and truss: construction method using upright posts with horizontal **tie-beam** and **wall plates** to support a triangular roof frame

purlin: beam running the length of a roof, supporting the rafters

queen post: roof arrangement with two vertical posts rising from a **tie-beam** to a **collar** at approximately ⅓ span

quoin: large block of masonry used to form and strengthen the corner of a building; sometimes the angle of a building itself

reed moulding: a series of parallel convex ridges

render: various durable coverings applied to external walls for decoration, weatherproofing, or to cover a rough finish; early forms included simple sand and lime mixes; **stucco** originally combined lime with powdered marble; **roughcast** included pebbles or aggregate.

respond: half **pier** attached to a wall carrying the end of an arch

rib: projecting **moulding** supporting an **arch**

rock-faced: stone dressed except for the exposed face

roll moulding: raised cylindrical **moulding**

roughcast: render incorporating graded pebbles or aggregate

rubble: rough, irregular stone blocks

rustication: masonry blocks **chamfered** at the edges to emphasise joints

rustic floor: lower floor or basement

sedilia: set of stone seats, usually three and often stepped, for priest, deacon and sub-deacon, set into the south wall of a chancel

solar: upstairs family room in a medieval hall

stiff-leafed carving: stylised ornamental carving of foliage

string course: raised horizontal band defining a storey

stucco: originally a render of lime and powdered marble; from the eighteenth century, used generally for internal and particularly external plasterwork

terrace: row of attached buildings

tie-beam: horizontal timber connecting the sloping sides of a roof

timber framing: construction using a timber framework infilled with e.g. brick **nogging** or **wattle and daub**; sometimes **half-timbered**; typically **box framed** or **post and truss** with a triangular roof carried on a rectangular box frame; also **cruck framed**, like an inverted 'V'

trabeate: built of posts and lintels without use of arches

tracery: intersecting ribs in the upper half of a window

transom: horizontal dividing strip in a window

truss: horizontal beam supporting roof timbers

tunnel/barrel vault: vaulted ceiling, semicircular in section

tympanum: area between a door lintel and an arch above

vault: arched ceiling

Venetian window: window in three parts with straight-headed **lights** flanking a taller central arched window

volute: a projecting spiral or scroll

voussoir: individual stone of an **arch**

wall plate: horizontal timber laid along the top of a wall

wattle and daub: interwoven rods or laths plastered with clay or mud

A NOTE ON THE AUTHOR

Richard Stone is an extramural lecturer whose previous books include *Moats, Boats and Other Notes* (1999), *Hidden Derbyshire* (2001), *A Stone's Throw of Burton* (2002), *Tamworth: A History* (2003), *Burton upon Trent: A History* (2004), *The River Trent* (2005), *Rich Pickings* (2007), *The Collieries and Coalminers of Staffordshire* (2007) and *Exploring History in and around Derbyshire* (2009).

INDEXES

1: Architects

2: Places